I0235513

IMAGES
of America

MILFORD

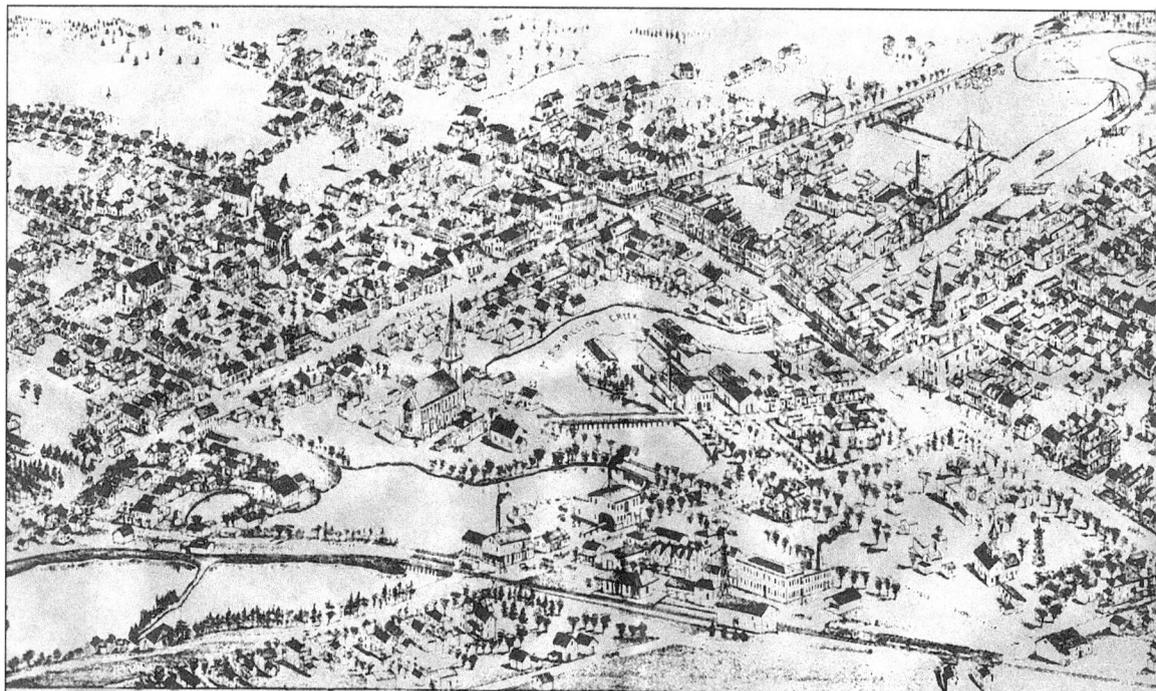

1885 LITHOGRAPH OF MILFORD. This map of early Milford provides a detailed replica of every structure and landmark in Milford when the population was 2,500. The Mispillion River begins at the original Silver Lake tumbling-dam site at the peninsula. The river meanders eastward past Hiram Barber's saw mill, Draper-Reis Cannery, Walnut Street Bridge, and east to the South Milford shipyards. The Causey mansion is visible at the corner of S. Walnut and Causey Avenue. The business district is centered on Walnut Street on both ends of the drawbridge over the Mispillion.

IMAGES
of America

MILFORD

Dave Kenton

ARCADIA
PUBLISHING

Copyright © 2001 by Author Name.
ISBN 978-1-5316-0954-2

Published by Arcadia Publishing
Charleston, South Carolina

Library of Congress Catalog Card Number: 2001096799

For all general information contact Arcadia Publishing at:
Telephone 843-853-2070
Fax 843-853-0044
E-Mail sales@arcadiapublishing.com
For customer service and orders:
Toll-Free 1-888-313-2665

Visit us on the Internet at www.arcadiapublishing.com

*This book is dedicated to Mrs. Catherine Downing Holcombe,
without whose inspiration and tireless efforts neither the
Milford Historical Society nor the Milford Commission
on Landmarks and Museums would exist today.*

Catherine Downing Holcombe and Dave Kenton welcome guests to the Parson Thorne Mansion during Heritage Days in 1998. Mrs. Holcombe assigned Dave the task as editor of the Historical Newsletter in 1989 that has led to his continued interest in Milford and this pictorial history of Milford.

CONTENTS

ACKNOWLEDGMENTS

The authors gratefully acknowledge the Milford Historical Society and the Milford Museum for providing the vast majority of historic photographs that appear in this book. Many citizens and families have trusted these two organizations with their private collections and credit is given to the organizations while thanks is extended to those who made the original donations, usually anonymously. Photographs are our link to past generations and we thank those who have provided these "windows to the past."

——Dave Kenton and Sam Marshall

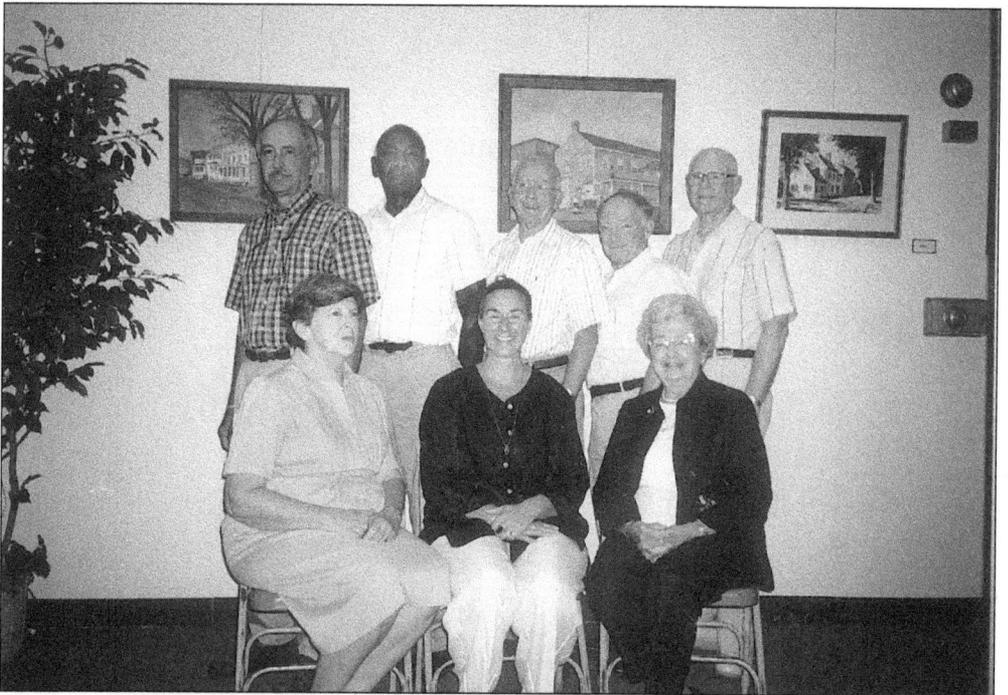

MILFORD MUSEUM COMMISSIONERS. The commissioners of the Milford Commission on Landmarks and Museums are pictured from left to right, (front row) Audie Wilkins, Leslie Progar, and Marjorie Poore; (back row) Marvin P. Schelhouse, Douglas Gibson, John Huntzinger (president), Don Abrutyn, and S.M.D. "Sam" Marshall Jr. (Absent from photo: R. Calvin Clendaniel and David W. Kenton).

INTRODUCTION

The earliest permanent settlers to establish roots in Milford came to Kent and Sussex Counties between 1664 and 1676 after the English took control of Delaware from the Dutch and Swedes. Most early settlers came from old Somerset and Accomac Counties in Maryland and Virginia where English families were staking claims to small land grants of 200 acres on Maryland and Virginia's eastern shore. Other families moved north from Lewes after that town was founded in 1631 by the Dutch West India Company.

Henry Bowman obtained a patent from the Duke of York in 1680 to settle a 2,000-acre tract of land called "Saw Mill Range" that now encompasses Milford. Alexander Draper settled in Slaughter Neck in 1677, Luke Watson was granted land in Cedar Neck in 1676, Mark Manlove moved to Milford Neck in 1677, and Isaac Mason settled along Canterbury Road about 1685.

Milford was settled at the headwaters of the Mispillion River at a location called "Three Runs," at the confluence of the Mispillion River and Bowman's and Clark's branches. These early English settlers were industrious millers, farmers, merchants, and sailors. Milford got its start as a landing site and trading post built by a mariner-turned-trader, Joseph Oliver. Oliver was born about 1727 in Slaughter Neck near the plantations of Alexander Draper and Nehemiah Davis. He migrated north to the Mispillion River headwaters and during 1771–1773 purchased a 115-acre tract of farmland on the north side of the Mispillion River, where he established his home and wharf.

In 1787, Oliver divided his farm into a town grid and began offering lots to newer settlers , costing from $3 to $8 per year under the old English system of ground rents. The first lots were sold along Northwest Front Street in December 1786 and January 1787. By 1790, Milford had more than 80 structures built on Oliver's 115-acre farm extending from the river to the present location of Banneker School on North Street.

By 1791, Oliver had petitioned the General Assembly in Dover for a drawbridge over the Mispillion to be constructed along "Kings Highway" leading from Kent to Sussex County. The bridge permitted traders and travelers easy access to Sussex County along the road leading to the court at Lewestown. At the same time in 1787 that Oliver was selling lots for his new village, Parson Sydenham Thorne, rector of the Savannah Church located three miles west of Milford, decided to relocate his church to a plot of land donated by Oliver along Church Street in Milford. Parson Thorne married a wealthy widow, Betty Crapper, and purchased the stately "Silver Hill" mansion and 263-acre farm owned by the Cullen family. He soon built a gristmill just west of Oliver's landing. Together, these two enterprising leaders assured the survival of Milford as a new town through their tireless efforts to bring business, culture, religion, and civility to a primitive area.

Milford obtained its town charter in 1807, the same year Joseph Oliver died. New merchants established stores, wharves, and granaries along North Walnut Street, extending the business district two blocks to the Mispillion River.

The Mispillion River was the primary avenue of trade throughout the 19th century and it is not surprising that Milford became a major shipbuilding town around 1790, with John Draper's shipyard located on the north side of the Mispillion at Northeast Fourth Street where it meets the river. Between 1790 and 1815, William DuPrey operated another shipyard near New Wharf east of Milford, and by 1815, Nathaniel Hickman was building wooden sailing vessels farther east at his farm near Delaware Bay, known as Hickman's Landing. By 1860 Milford boasted seven shipyards employing hundreds of carpenters, loggers, caulkers, and scroll workers.

Following the Civil War improvements in technology ushered Milford into the lucrative era of canning and fruit drying. Before the invention of refrigeration there was no efficient and safe method of preserving and transporting perishable vegetables and fruits to city markets in Wilmington, Philadelphia, and New York. The first boiler-powered fruit drying machines were introduced in 1870 and the effect on local farm products was immediate and dramatic. When the railroad finally reached Milford in August 1859, a new method of transportation provided a reliable alternative to steamboats and sailing ships. Milford grew to a town of 3,500 inhabitants by 1900. The town boasted new electric lighting installed in 1887 and a public water system completed in 1892.

In 1900, two local dentists brought a fledgling dental supply business to Milford after the death of the owner, Levin D. Caulk, in 1896. Drs. Frank and G. Layton Grier saw the need for new advancements in the development of synthetic porcelain for tooth repairs. They started a new manufacturing plant in Milford that expanded in 1908 and again in 1912 to become the most advanced research facility of its kind in the field of dentistry.

Drs. William (II) and Sam Marshall, guided by their mother, Mary Louise, led a drive with support from the Grier brothers to establish a hospital in Milford between 1907 and 1921. The Milford Emergency Hospital was incorporated in 1913. It was located at 110 Northwest Front Street in the former Purnell Lofland home; it was relocated across the street in 1921 in the remodeled Reynear Williams home. In 1938, the hospital was moved to its present location on Clark Avenue and was reincorporated as the Milford Memorial Hospital.

Milford and its local environs have been home to nine governors since 1787. Some of its most historic homes were built and owned by these community leaders over the past two centuries. Today, Milford claims the first woman governor in the history of Delaware, Ruth Ann Minner, elected in 2000.

As Milford enters the 21st century it has grown to a town of 7,500 citizens, proud of a heritage that extends back to the earliest period of European settlement. Delaware is one of the original 13 colonies and the first to ratify the federal constitution on December 7, 1787. The historic district, riverfront greenway, and civic-minded residents lend a quality of life to Milford that is not found in every small town. As Milford enters the 21st century, it will continue to treasure its past and preserve the best examples of its early history. We hope this pictorial history of Milford will keep the past alive for the next generation proud to call Milford home.

——Dave Kenton

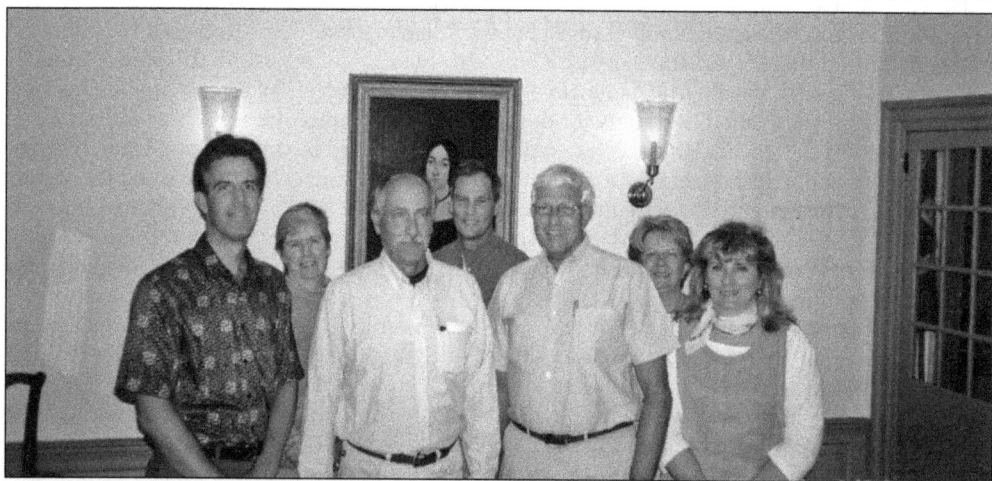

The 2001 Milford Historical Society Trustees are, from left to right, (front row) Ralph Prettyman, treasurer; Carolyn Humes; Marvin P. Schelhouse, president; Dave Kenton; Dr. Ed Hendel, secretary; Dawn Willis; and Susan Emory. Absent from the photo are Barbara Jones, F. Brooke Clendaniel, and Mort Whitehead (deceased).

One

EARLY LAND GRANTS AND LANDMARKS
1676–1776

Milford was settled gradually after 1680 when Henry Bowman was granted a patent for a 2,000-acre plot called "Saw Mill Range." Between 1680 and 1787, when the first lots were plotted, many patents were granted in the eight-mile area surrounding Milford. Early mills were constructed and landings were established along the Mispillion River. The following diagrams, maps, plots, and photographs attempt to describe Milford during the colonial period prior to the American Revolution.

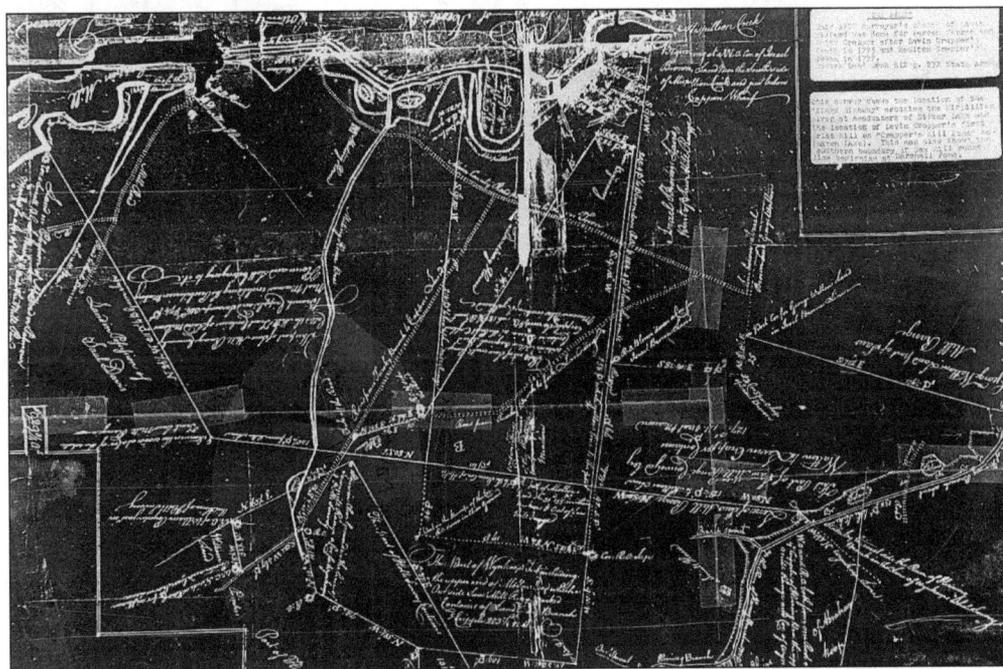

THE 1778 PLOT. The earliest detailed survey plot of the Saw Mill Range and South Milford was done to divide Levin Crapper's plantation among the heirs following his death in 1775. This plot shows the location of "King Highway" (dotted-line road) crossing the Mispillion River at the headwaters of Silver Lake, and the location of Levin Crapper's first mill built in 1768 at Crapper's Mill Pond, now Haven Lake. Presbyterian branch is shown in the center flowing into Silver Lake at the former site of the old Presbyterian Meeting house (Jack and Mary Lou Shaeffer's home today).

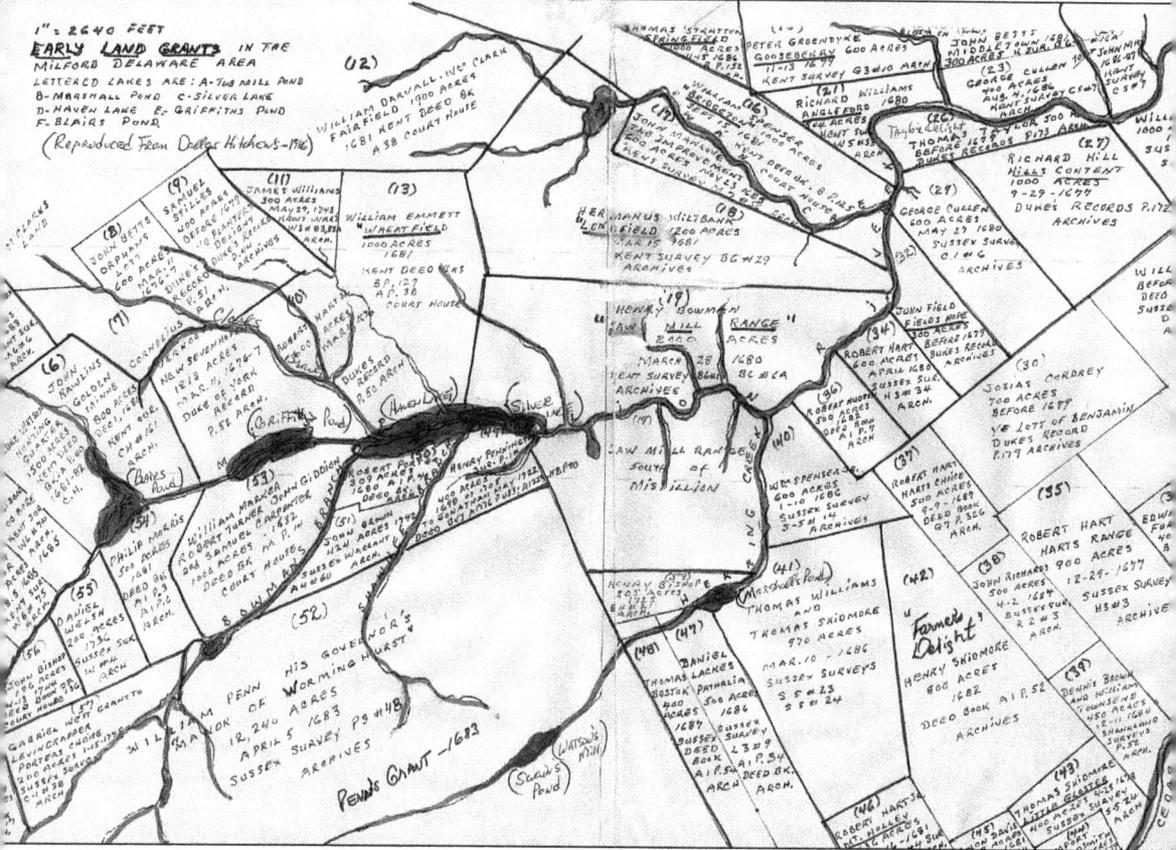

EARLY LAND GRANTS. Dallas Hitchens prepared this early land-grant map for his book titled *Milford, Delaware and Vicinity Before 1776* (reproduced with consent). It is a rough approximation of the early grants issued during the Duke of York period of Delaware History (1664–1682) until the arrival of William Penn in 1682. The chart extends from the headwaters of the Mispillion River at Blair's Pond, eastward to Griffith's Lake, Haven Lake, Silver Lake through the town of Milford, and out to the Delaware Bay at the right edge of the chart. In April 1683, William Penn set aside a 12,240-acre block of land for his future use. This tract was known as "His Governor's Manor of Worminghurst" and encompassed an area four miles square, westward from South Walnut Street extending to Lincoln and westward to Staytonville. These grants were gradually broken down into smaller plots as successive generations bequeathed portions of their estates to their children and relatives.

JOSEPH OLIVER GROUND RENT PLOT, 1787–1825. This map represents the earliest known plot of Milford's first lots, sold by Joseph Oliver in December 1786 and continuing until his death in 1807 and later. This plot was drawn on linen cloth and passed down through successive generations of owners who purchased the rights to ground rents under the early English legal system. The map depicts West Street at the left and lands of tanner Isaiah James (Avenue Church lands) and Ralston Alley (Church Street); the homes of Moulton Rickards and Elias Shockley ("Purity Row," home of Earl and Kay Francis today); Shockley Alley (west side of Banking House Inn); and lands of David Walton and later Martinus DeWaele (site of New Windsor Hotel today). Along Northwest Second Street is a sketch of the original "Academy" school building that was constructed in 1810 and served until demolition in 1962. This plot was loaned to the Historical Society by the late trustee Sarah Nutter Snyder, and is owned by her children Elizabeth and Jeffery today. Joseph Oliver's son sold the map to Elias Shockley in 1808. It was later sold to Purnell Lofland about 1840, then to Peter L. Lofland and descended to his daughter, Mrs. Lizzie Nutter (1920), her daughter, Sarah Nutter Snyder (1940) and to her children in 1990.

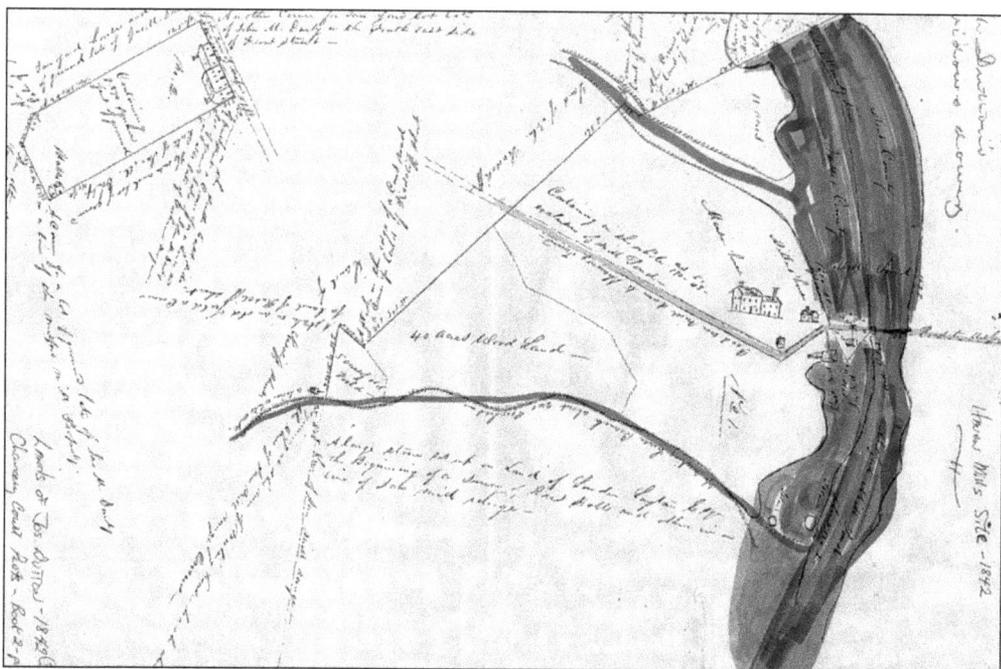

CRAPPER'S MILL AND POND. This orphan's court plot from 1842 provides the earliest map of Levin Crapper's first mill, located at Haven Lake dam site. Crapper first constructed his sawmill in 1768 and built a gristmill the following year. This map shows the location of the sawmill in the middle of the dam and the gristmill positioned to the south.

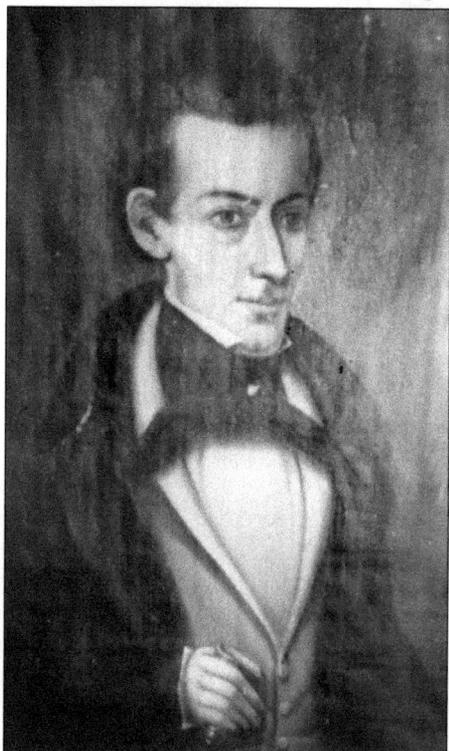

LEVIN CRAPPER JR. This portrait was painted *c.* 1840 by a member of the Dorsey family who was descended from Levin Crapper Sr. Levin Jr. was born in 1765 and died during a trip to England in 1790. His only surviving son, Jabez Crapper, was born on board a ship returning to America with his mother. Jabez Crapper became a tailor and lived behind St. Paul's Methodist Church at the corner of Church and Fourth Streets.

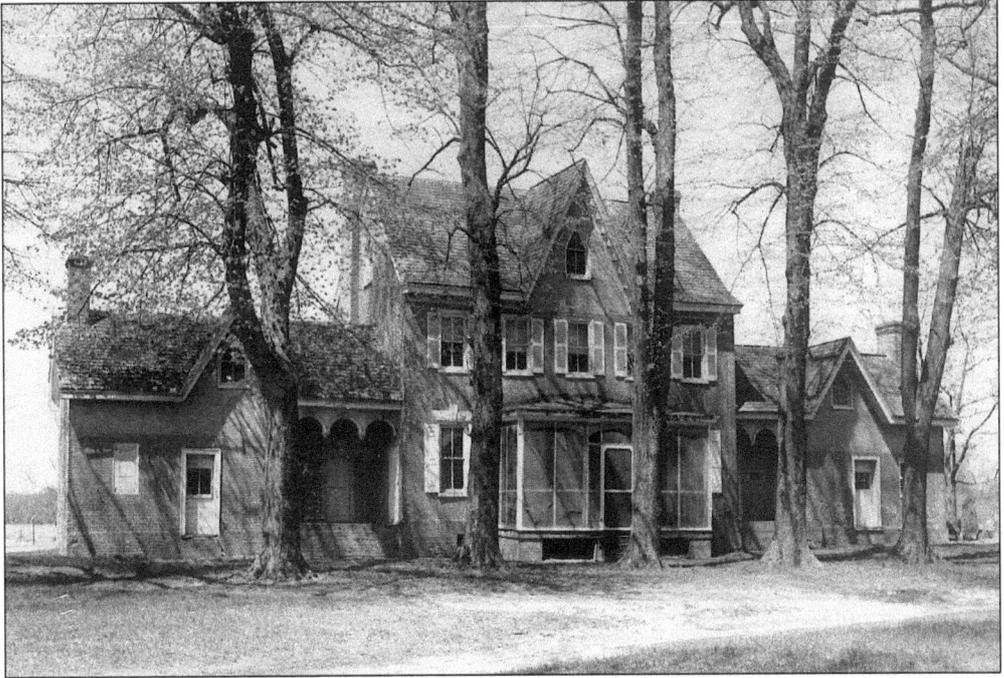

PARSON THORNE MANSION. This photo was taken in 1960 just prior to James R. Draper gifting the home to the newly formed Milford Historical Society. This home is the oldest structure standing in Milford today. Joseph Booth built the rear, frame-section of this home before 1735. This home has had a succession of owners.

CHARLES FLEMING MAP, 1829. This early map of Milford was drawn by a noted surveyor and shows the town limits shortly after it was incorporated in 1807. The western side of the plot shows Cullen's branch that flows along Truitt Avenue and behind Avenue Methodist Church today. This stream was called "Tanner's branch" later when three tanneries were operating along its banks. In the 20th century, the stream was called Mullet's Run.

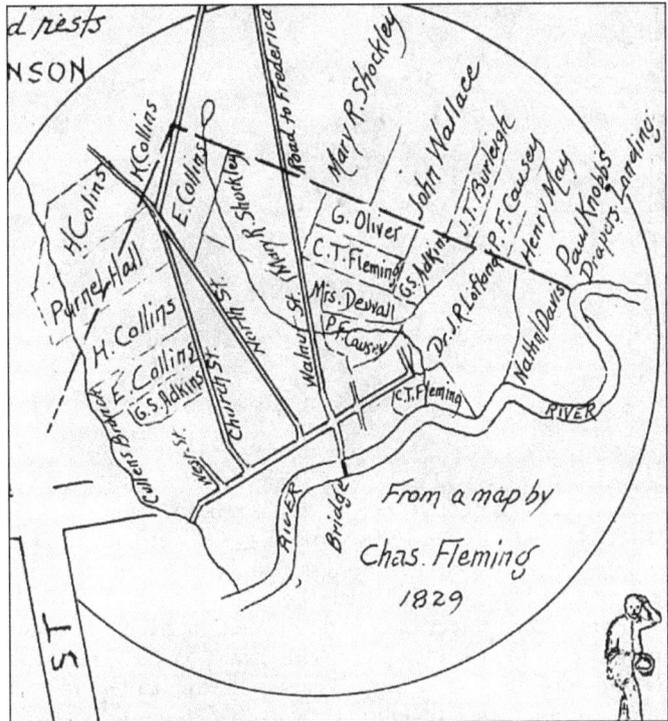

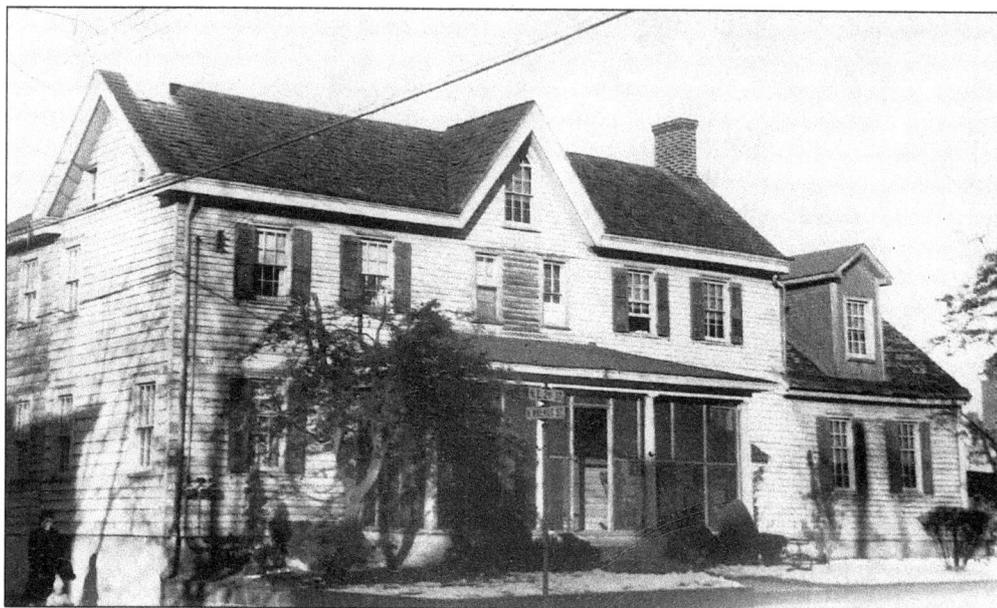

CHARLES T. FLEMING HOME. This home formerly stood at the northeast corner of North Walnut Street and Northeast Second Street. The noted surveyor Charles T. Fleming (1805–1888) built this home and resided here until his death in 1888. Sallie Rickards Davis, who had a beautiful rock garden in the rear, later owned the home. It became an apartment building during the 1950s and was razed about 1975.

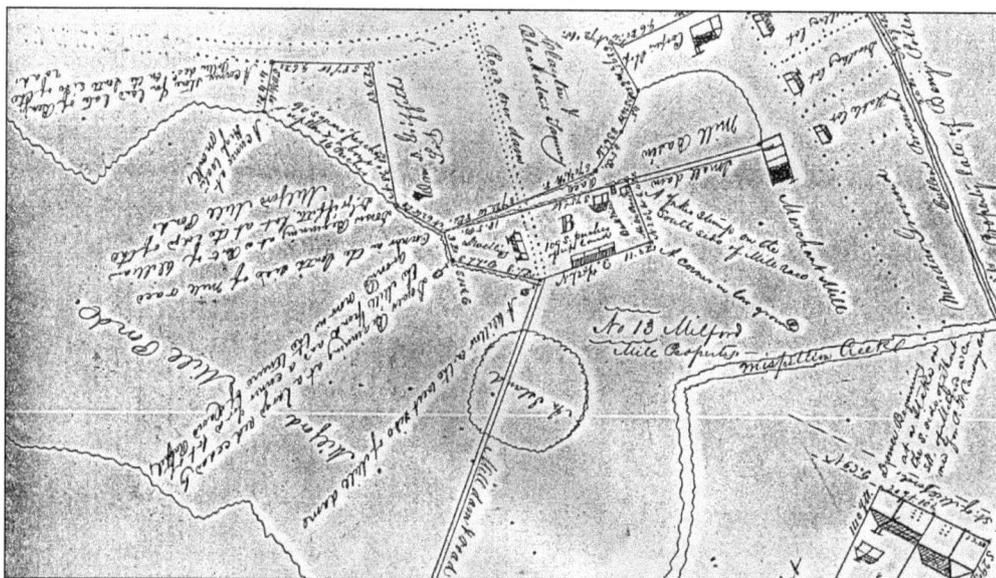

MILFORD MILLS PLOT, 1848. This plot of Silver Lake shows the site of Parson Thorne's early mill in 1787 establishing Milford as a vital trading center on the Mispillion River. The mill dam and road leading from the "island" (peninsula today) to the high ground on the south side of the river formed Silver Lake and provided the necessary water level to power Parson Thorne's mill. The dotted road leading to the dam is Maple Avenue. The original mill built by Parson Thorne was replaced by James Clayton during his tenure and is shown on this map as a two-story gristmill owned by John Darby in 1848.

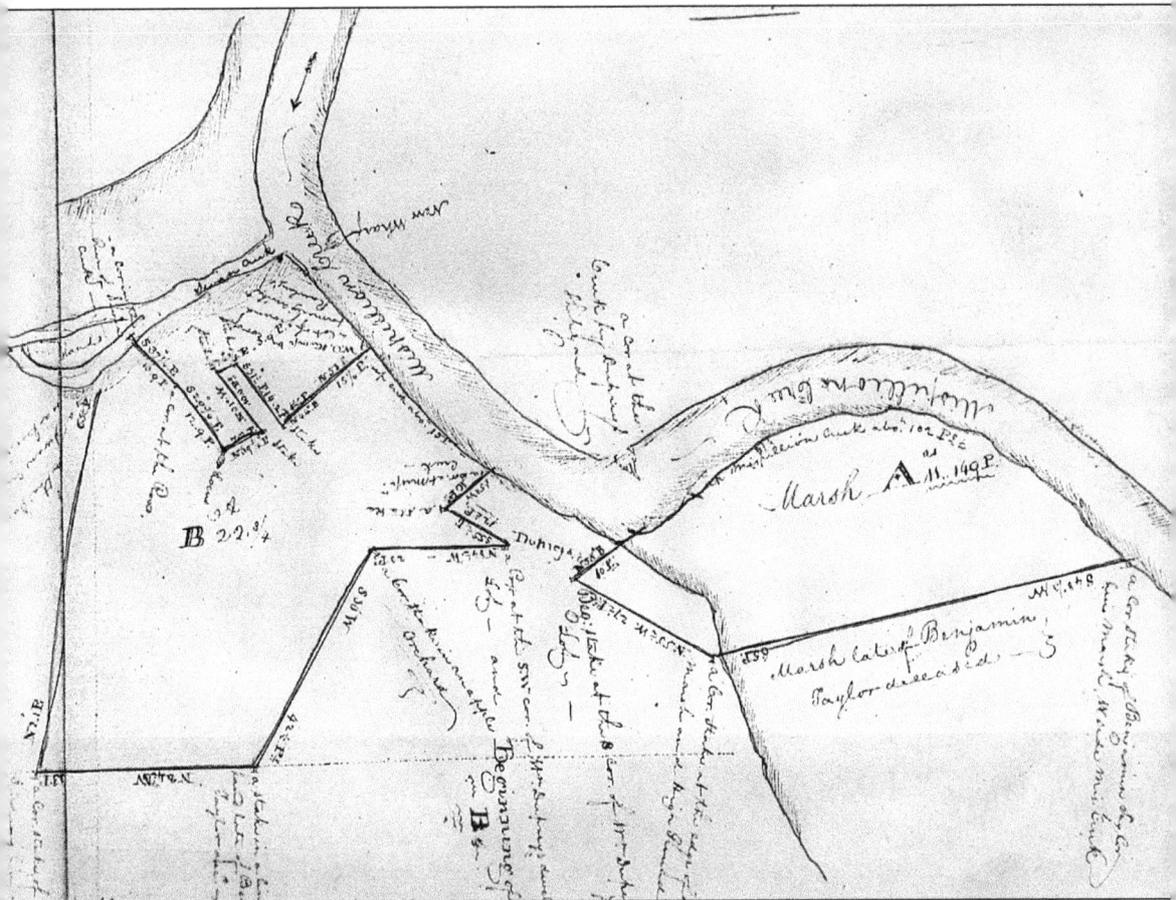

WILLIAM DUPREY'S SHIPYARD, 1813. This orphan's court plot shows the site of Milford's second shipyard operated by William DuPrey from 1795 until his death in about 1820. DuPrey's shipyard was located near the site of an earlier shipyard called Millstone Landing. This site is located on the east side of New Wharf Road about 200 yards upstream (southwest) of the New Wharf Bridge over Swan Creek. New Wharf was established in 1768 as a trading site along the Mispillion, but the land selected by DuPrey and his predecessors was a better embankment for launching ships. It was situated at a sharp curve in the Mispillion formed by the "Skull," a one-mile loop in the river that was eliminated in 1924 when the Mispillion was straightened and dredged by the government. DuPrey's shipyard was the one that was raided by British soldiers during the War of 1812. After the citizens of Lewes rebuffed Admiral Beresford in April 1813, his raiding parties sailed up the Mispillion and destroyed a ship on the stocks at DuPrey's yard.

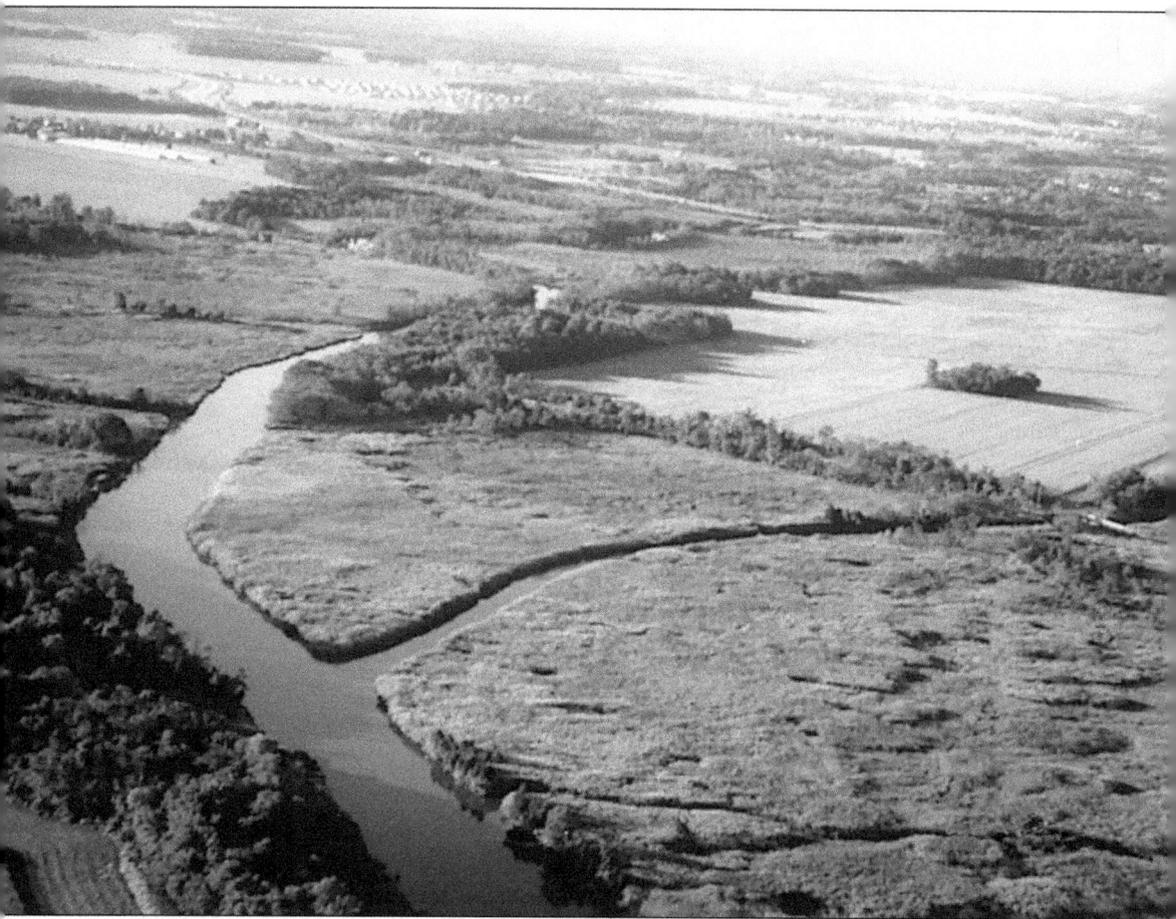

AERIAL PHOTO OF MISPILLION RIVER AT NEW WHARF. This photo shows the Mispillion River as it winds upstream toward Milford. The site where Swan Creek separates and flows westward to Tub Mill Pond is known as New Wharf and has operated as a trading site since 1768. DuPrey's shipyard was located just upstream from New Wharf at a former sharp turn in the river.

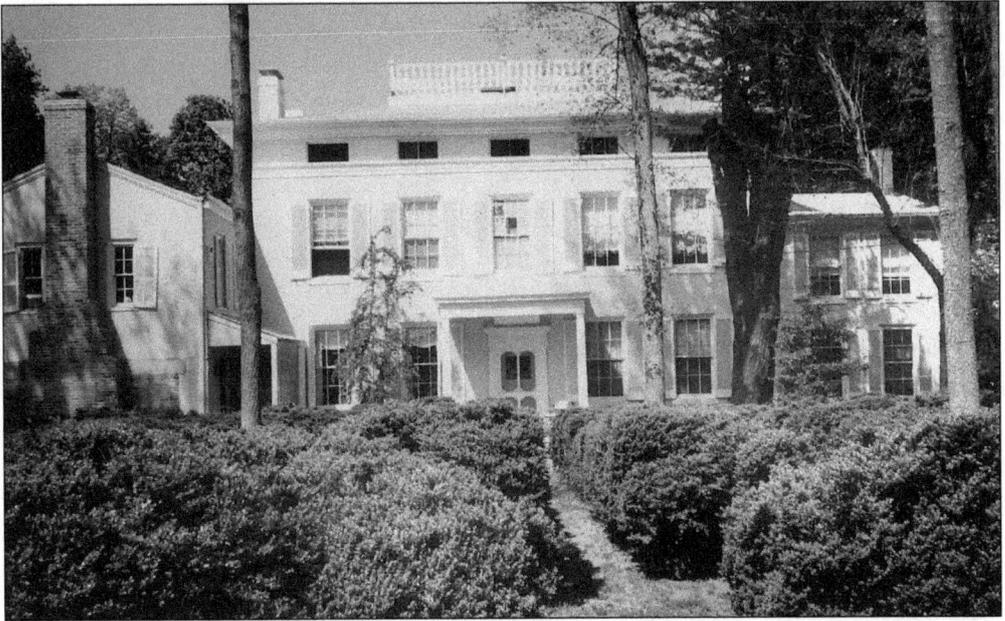

LEVIN CRAPPER MANSION. The Crapper Mansion was designed in a five-bay, Georgian-style architecture and constructed in 1763. The front door formerly faced southwest, overlooking the 500-acre plantation that encompassed nearly all of South Milford. In 1850, when Gov. Peter F. Causey purchased the old home, the front was changed to face the Mispillion River and Walnut Street. Wings were added to the early structure and the architecture was changed to Greek Revival style, popular in the 1850s.

COLONIAL VIEW OF PARSON THORNE MANSION. Architect R. Calvin Clendaniel did a sketch of the Parson Thorne Mansion for the Milford Historical Society. The drawing represents what the brick section of the Thorne Mansion may have looked like between 1746, when it was built, and 1879, when it was modified to Victorian styling by banker Henry Fiddeman. This view shows the mansion in classical Georgian style without an elevated roofline and without three distinctive gables that are familiar to us today.

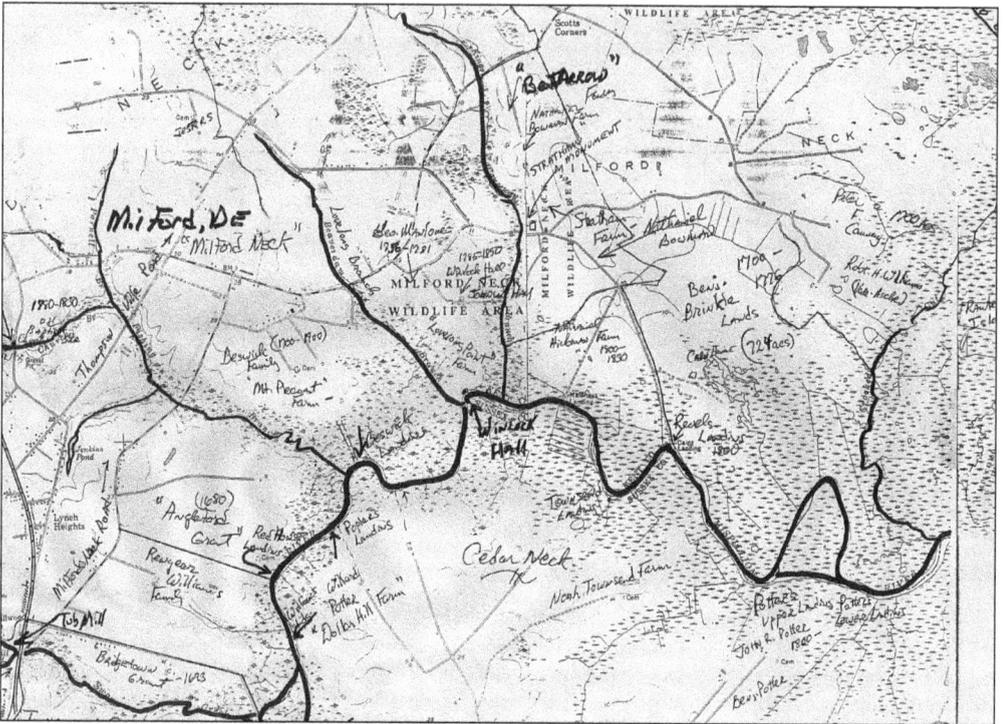

EARLY LANDINGS ALONG THE MISPILLION RIVER. A map of the Mispillion River shows the early land grants and farms located along the section of river starting at New Wharf at the left margin and progressing eastward past "Red House Landing" at Angleford, Beswick's Landing at Mt. Pleasant farm, Winlock Hall's Landing at Lovelong Point Farm, Hickman's Landing at Hickman farm, Reville's Landing on the Brinkle plantation, Potter's Landing at John R. Potter's farm, and the Mispillion Lighthouse landing at the entrance to Delaware Bay. This map also shows the location of the first Baptist Meeting House on the DeWeese tract at Baptist Branch and the "Bent Arrow" farm settled by Nathaniel Bowman in 1750 at the "Stratham" monument deep in Milford Neck.

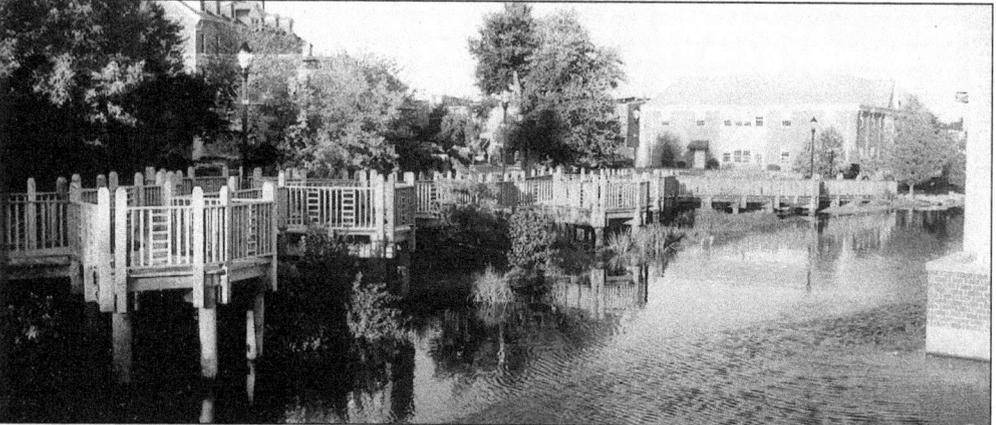

MISPILLION WALKWAY, 2001. The walking bridge built as an extension of the Mispillion greenway project allows residents to walk the banks of the Mispillion River from Thorne-Oliver Bridge at Walnut Street, westward to Silver Lake and the site of Thorne's original gristmill built in 1787.

18

Two

Revolutionary War The Federal Period
1776–1860

The beginning of the Revolutionary War period in 1775 marked a critical point in Milford's early history. The year 1775 saw the death of Milford's wealthiest merchant, Levin Crapper, and the end of the colonial period. Crapper owned the majority of all lands located south of the Mispillion River and within the Saw Mill Range grant. His widow, Betty, married a new preacher who had moved to Milford in December 1774, Parson Sydenham Thorne. By 1785, Parson Thorne and Betty had purchased the "Silver Hill" brick home sold by the Cullen family on the north side of the Mispillion. Thorne's neighbor, Joseph Oliver, is credited with founding the town of Milford when he began selling lots in December 1786 under the old English system of yearly ground rent charges. The new town began to flourish and had 80 structures by 1790. The federal period of American history began just as Milford became a town in 1787. Our growth in Milford paralleled the growth of the nation from 1775 through 1860. The photos in this chapter depict Milford during this period.

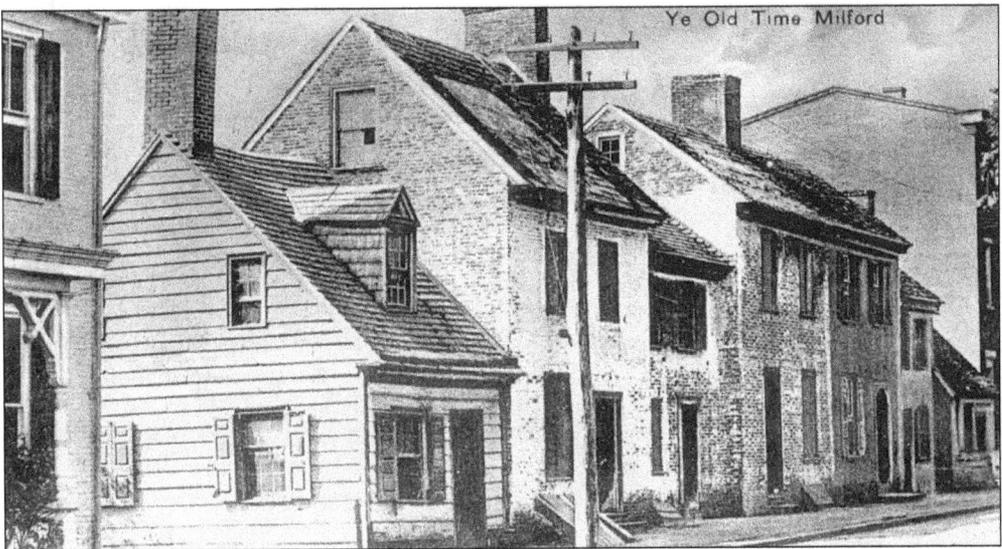

PURITY ROW. This postcard shows the earliest brick homes built by merchants and traders after Milford became a town in 1787. "Purity Row" was home to Elias Shockley and Molton Rickards, both early merchants who became successful trading behind their homes on the Mispillion. Elias Shockley's home is in the foreground and Molton Rickards's home is the four-bay brick structure farther west on Northwest Front Street.

BLAIR'S MILL. This is the only known photo of Blair's Mill that operated from 1748 to 1945 at the mill-dam site on the south side of Williamsville Road. This is the fourth mill to occupy the site. William Manlove built the first mill. His daughter, Mary, and son-in-law, Joseph Mason, purchased it in 1772. In 1809, the mill was sold to David Riggs and became known as Riggs' Upper Mill, to distinguish it from Riggs' Lower Mill at Griffith's Lake to the east. (Courtesy of Hazel Dickerson.)

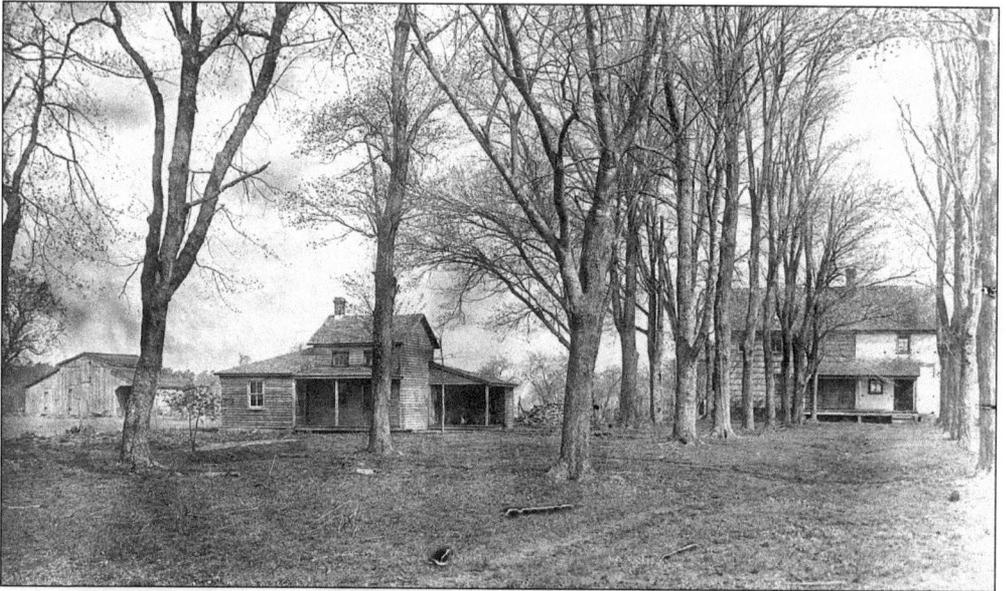

DAVID RIGGS HOME, 1809–1836. Ezekiel or David Riggs built this home between 1785 and 1809 when the Riggs family owned more than 600 acres at the headwaters of the Mispillion River. When David Riggs died in 1836 he had expanded the family holdings to 1,690 acres of land on both sides of the Mispillion. Virginia Simpson Kennedy, a great-granddaughter of David Riggs, restored this home. Today, her daughter Janet Johnson lives on the property known as "Golden Mine," on the north side of Williamsville Road at Blair's Pond State Park.

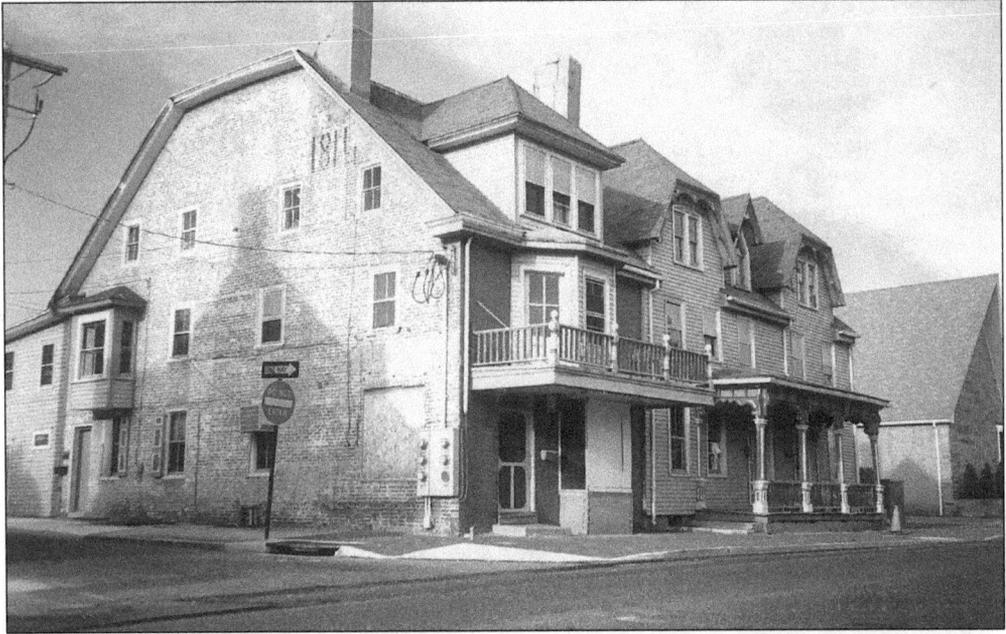

WILLIAMS-THARP-JEWELL HOME, 1814. This building sits at the northeast corner of Church Street and Northwest Front Street at the center of business activity in Milford from 1787 to 1840. The brick section (west side) was built to house a commercial store and the frame section (east side) was designed as a home for the family. John Williams constructed this building in 1814 as a wedding present for his son, Reynear Williams, and his new bride, Maria Potter. The frame section is scheduled for demolition in 2002 if a new owner cannot be found to move it and restore it to its former condition.

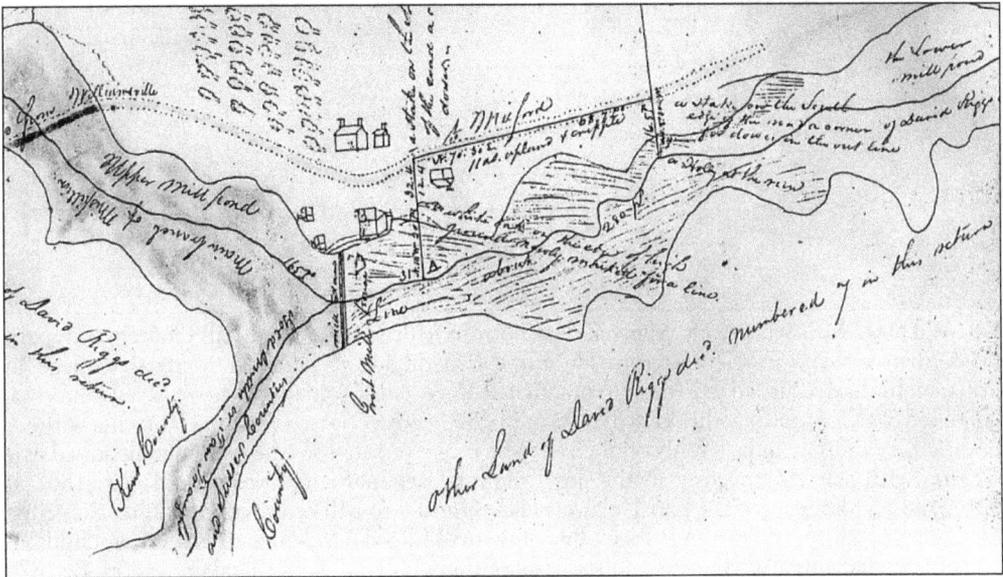

DAVID RIGGS'S SURVEY PLOT AT BLAIR'S POND. This survey plot was completed in 1836 following the death of David Riggs for the partition of his lands among his heirs. The sketch shows the location of the mill just northeast of the dam site and Riggs's home across the road to Milford where it still stands today. His total land was surveyed to be 1,690 acres.

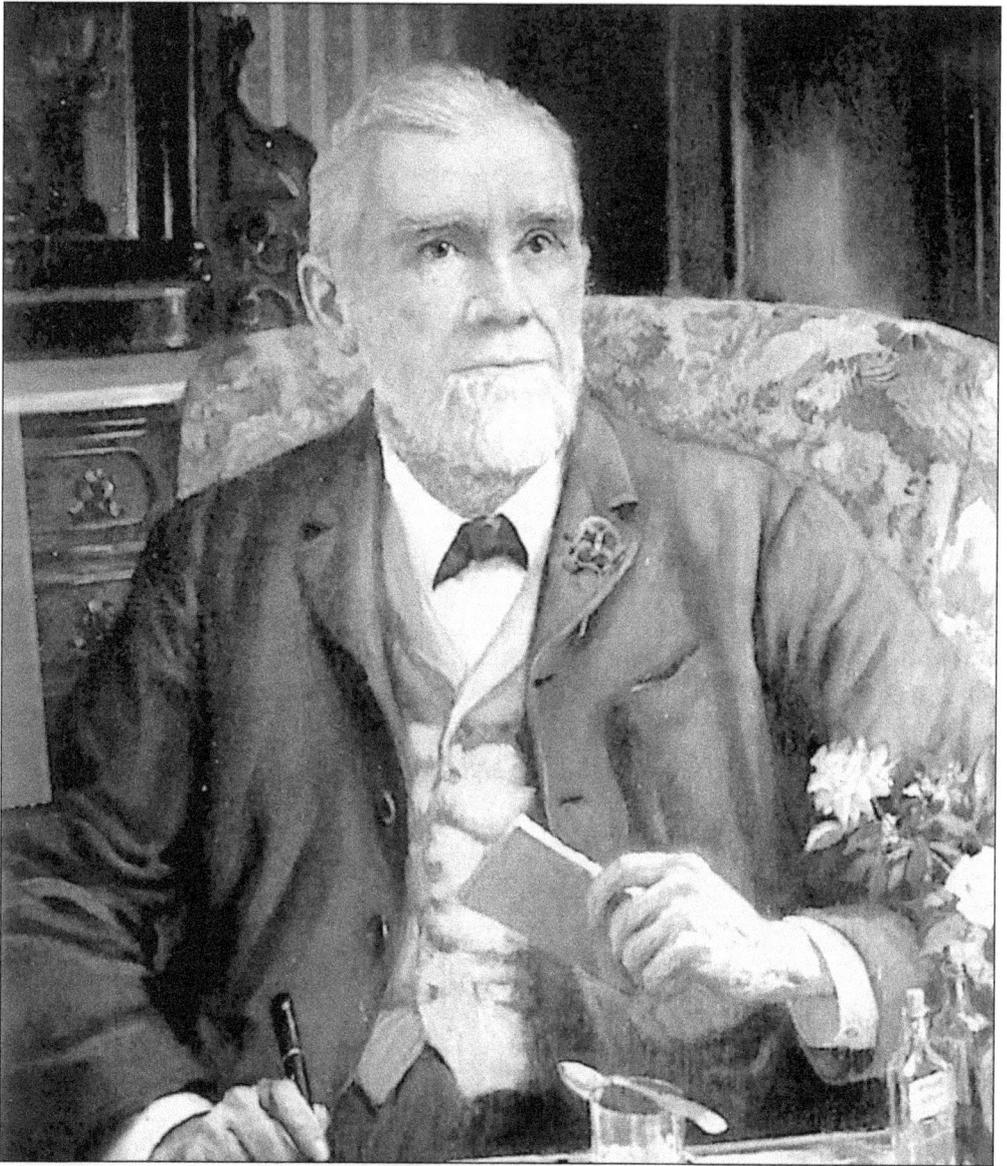

DR. WILLIAM MARSHALL. Dr. Marshall was born in Milton near Sand Hill Church and spent his formative years in Georgetown. He studied medicine at Jefferson Medical College in Philadelphia and returned to Milton to practice in 1847. After gold was discovered in California, he joined the Gordon Expedition as a surgeon in 1849 and spent two years in California without finding the "mother lode." When the Civil War broke out in 1861 he was commissioned as a surgeon with the Union army in the 3rd Delaware Regiment. He was wounded in 1862 at Antietam and later served at Fort Delaware. He returned to Milford to marry Hester Angelina McColley, daughter of Trusten P. McColley of South Milford. Dr. Marshall raised four children, one of whom, George W. Marshall, followed his father's path to the medical profession. By 1870 Dr. Marshall was involved as a partner in business with the shipbuilding firm of J.W. Abbott & Co. as financial manager. He purchased the Marshall Mill operation, expanded to a brick making business, and converted the water mill to steam power. He was active in all phases of Milford life until his death in 1900.

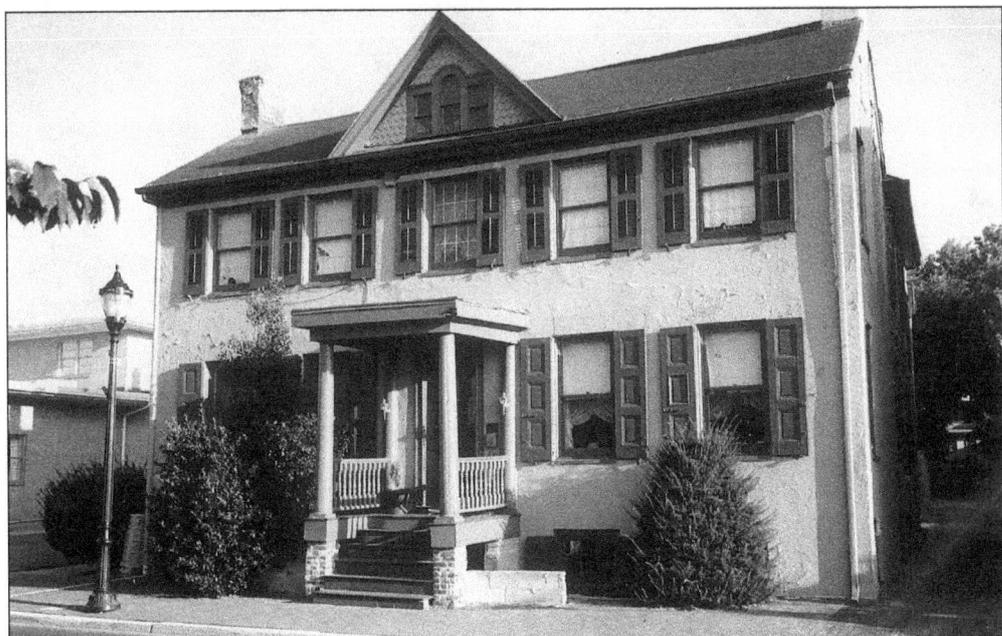

DR. JAMES P. LOFLAND HOME. This home built in 1810 is located at 115 Northwest Front Street and was built by Purnell Lofland for his son, Dr. James P. Lofland, a famous physician during the first half of the 19th century. Dr. Lofland was beloved by his patients and it was a great loss to the community at his early death in 1851. His son, James Rush Lofland, lived in the home until his death and later Sen. Sylvester Abbott. The home has been restored and modernized by Mr. and Mrs. Phillip R. Staley.

OLD ACADEMY, 1810–1930. The local Masonic Lodge constructed this brick building as a lodge meeting site and private school building in 1810. In 1904, all local public schools were consolidated and a high school was built on the corner of North Street and Northwest Second Street. The new school was attached to the old academy building and shielded it from view from 1905 until its demolition in 1980 to make way for the Academy Apartments.

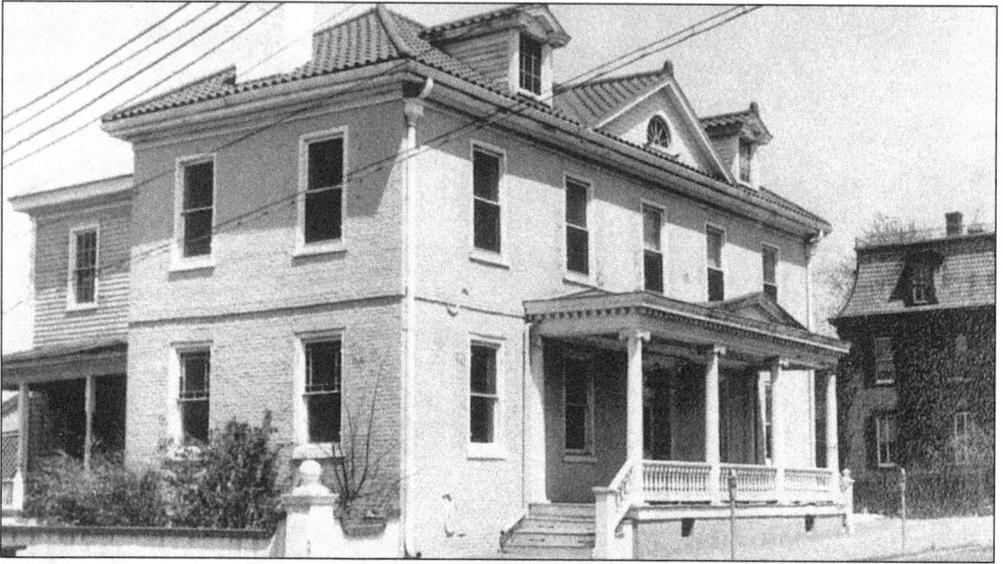

HENRY HUDSON HOME. This stately brick home was formerly located on the site of the Milford Public Library on Southeast Front Street. Henry Hudson built it in 1808 as the first new home in South Milford. He purchased most of the available land south of the Mispillion extending to McColley Street and plotted 10 large lots in 1810 from the heirs of Israel Brown. Hudson became overextended and lost most of his holdings by 1823 at public auction. After Hudson's death John Hazzard, son of David Hazzard of Milton, occupied this home. In 1890 Thomas B. Windsor, who moved from Gumboro to manage the Windsor Hotel in South Milford, purchased the home.

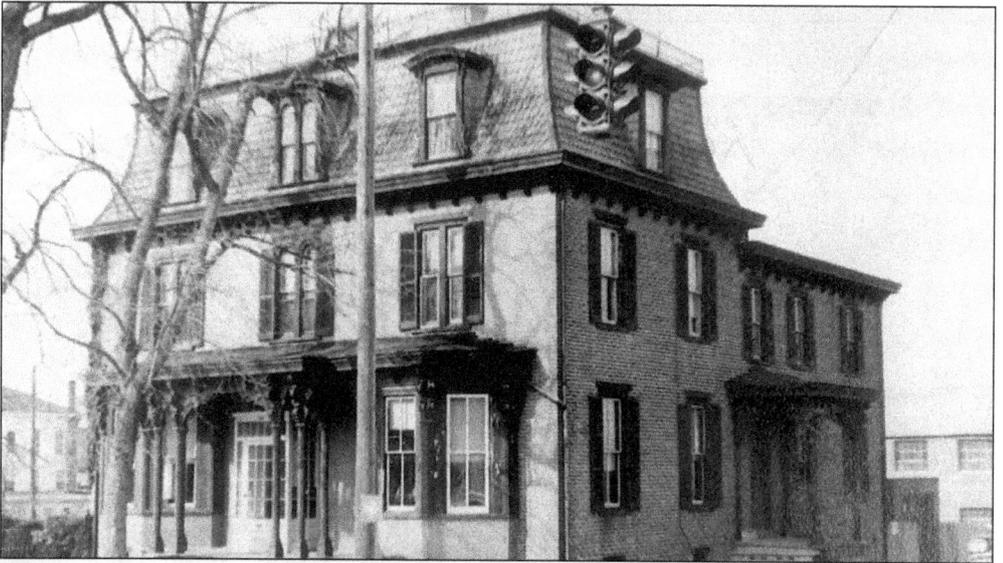

DAVIS HOME—"THREE SISTERS." This home formerly sat on the northwest corner of Southeast Front Street and South Washington Street from 1870 until 1965. It was built by the Davis family and became home to their three unmarried daughters, May, Jennie, and Burdella Davis. The home was built in a Victorian style common to the period following the Civil War. Its mansard roof, styling, and peculiar occupants made it appear haunted to Milfordians of the 20th century.

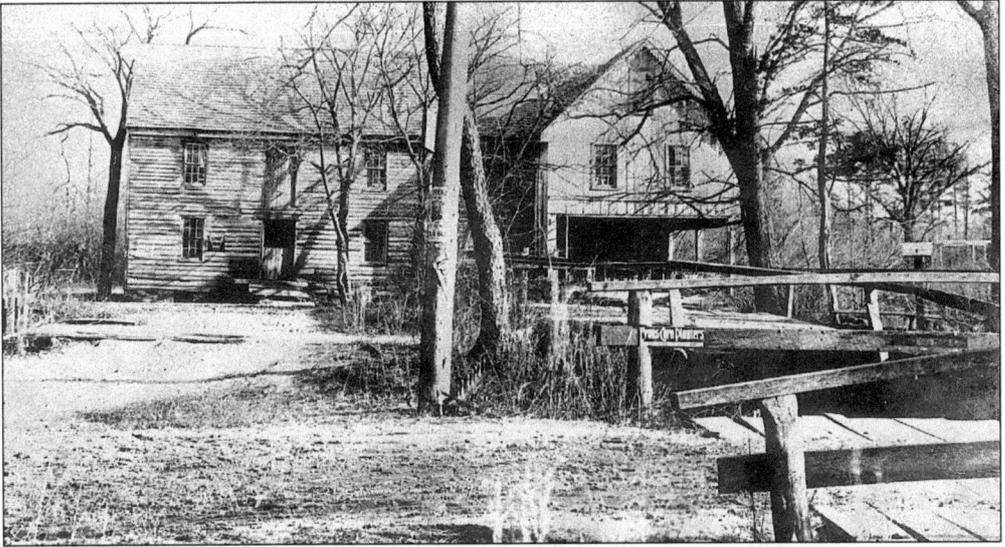

TUB MILL. This photo depicts the former gristmill located on Swan Creek and on the east side of Rt. 113 about a mile north of Milford. William Manlove built the original mill about 1760. It was left to his daughter, Mary, who became the wife of Joseph Mason. In 1786 it was known as Mason's mill and later was purchased by Dr. John Brinkloe who improved and operated the mill until his death in 1929. This mill was on the main road to Dover and became a landmark to many travelers during the 19th century. It was discontinued as a mill about 1900 and was destroyed about 1920.

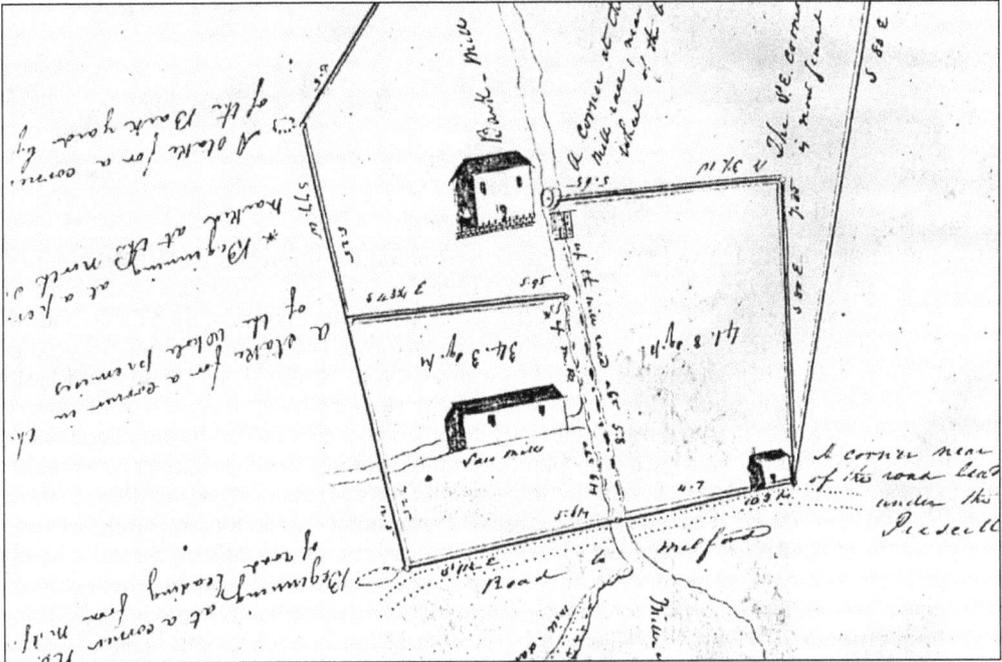

TUB MILL SITE. This plot was surveyed in 1829 following the death of Dr. John Brinkloe for the distribution of his land and holdings. The plot shows Tub Mill Pond at the bottom of the sketch with the road leading to Dover and Milford at the dam site. The sawmill is situated farther to the east and a bark-grinding mill still farther downstream.

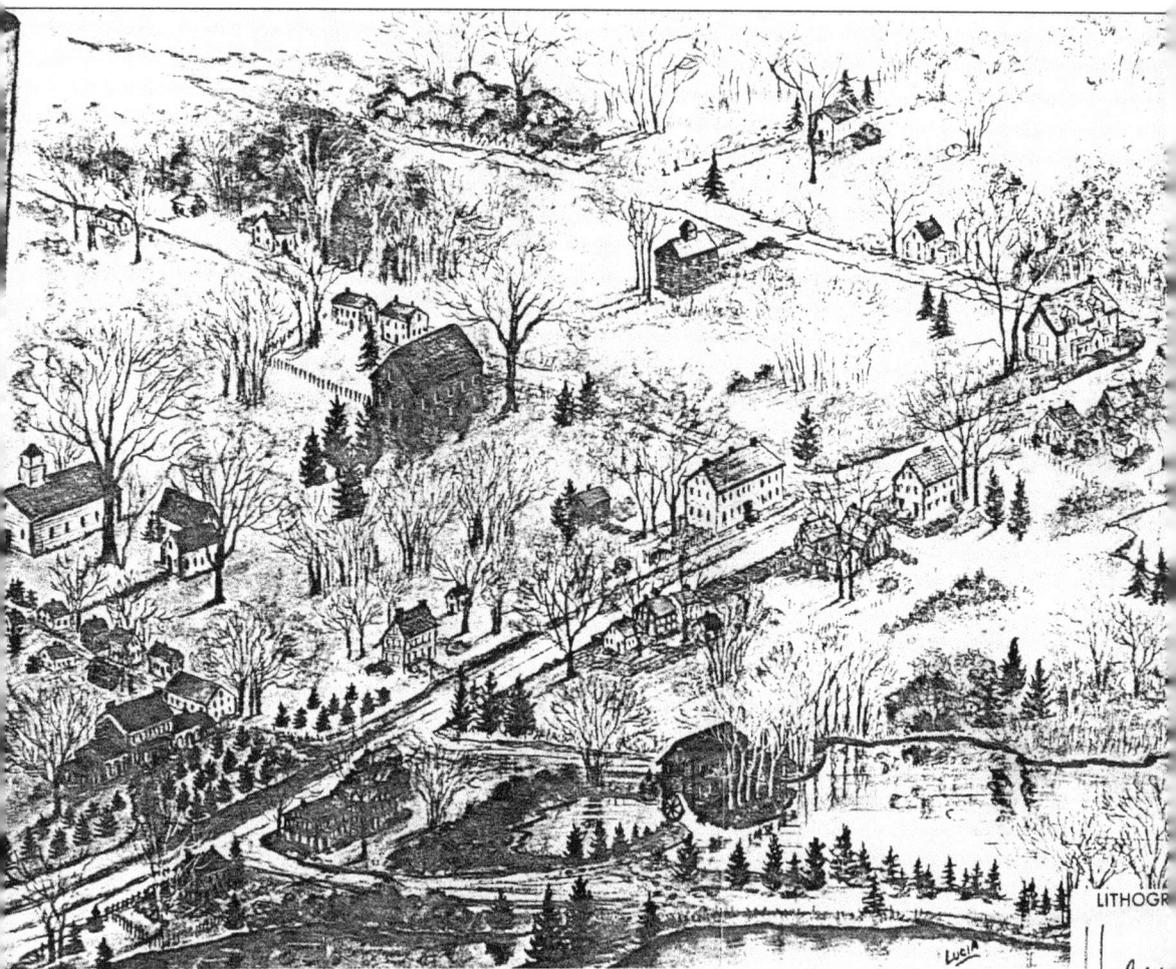

Milford About 1800

MILFORD ABOUT 1800, LUCIA LITHOGRAPH. Helen Lucia did this painting for the bicentennial celebration of Milford in 1987. It is a view of Milford as it would appear during the time of Parson Thorne and Joseph Oliver between 1787 and 1800. At the bottom of the plot are Parson Thorne's mill erected in 1787 and the buildings of Clayton & Blackiston's tannery located at the southeast corner of Maple Avenue and Northwest Front Street. The mill site and basin pond are located at the south end of Mill Street today along Milford's greenway trail. Across Northwest Front Street from the mill is Parson Thorne's home, later owned by James and Sarah Clayton, and their son, John M. Clayton (later Secretary of State) in 1808. In the center of this plot is the intersection of Northwest Front and Church Street where John Ralston lived (Sudler Apartments). On the southeast corner of Church is the home of Molton Rickards, an early merchant, later known as "Purity Row." Farther up Church Street is Christ Episcopal Church established by Parson Thorne in 1791. At the top of this plot is North Street where the old "Towers" home sat at the northwest corner. This home was a plain frame home in 1800, prior to its restoration in 1891 by Mrs. Roudebush. The old Milford Academy can be seen on the west side of North Street with its cupola and bell erected in 1810. Until about 1820, nearly all commercial activity in Milford centered along Northwest Front Street between North Walnut Street and Maple Avenue. Later, the business district expanded southward along North Walnut Street to the Mispillion River Bridge.

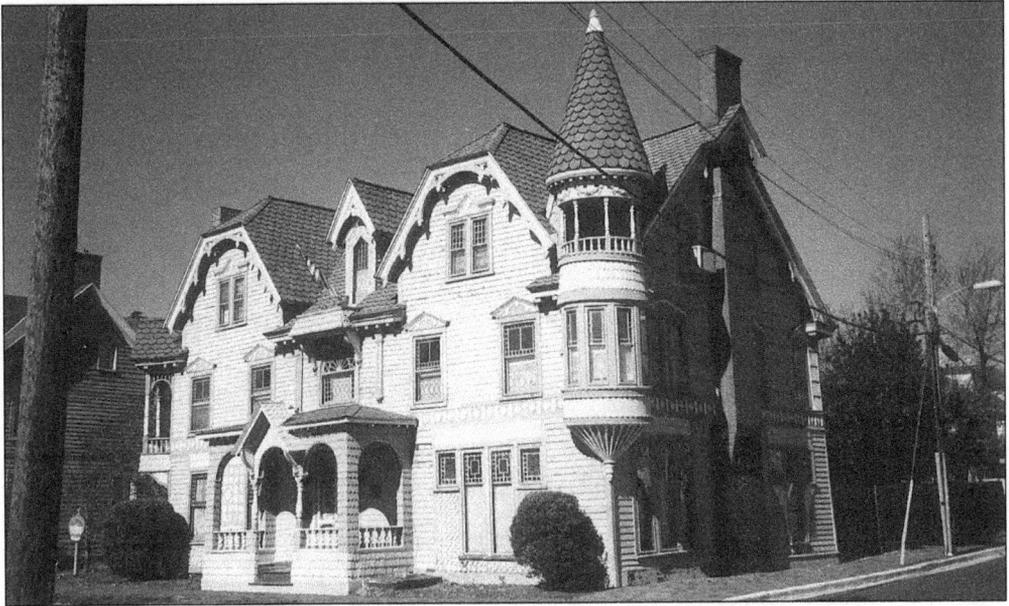

THE TOWERS. This landmark structure located at 101 Northwest Front Street was one of the first buildings constructed when Joseph Oliver surveyed his farm into lots in 1787. John and Cynthia Wallace built a home and store on this corner in 1783 and were succeeded by their son, Thomas. Later the home was purchased by Gov. William Burton and descended to his daughter, Rhoda, following his death in 1866. Rhoda Burton married a wealthy New York businessman, Clinton Roudebush, who sponsored her restoration of the old home in 1891.

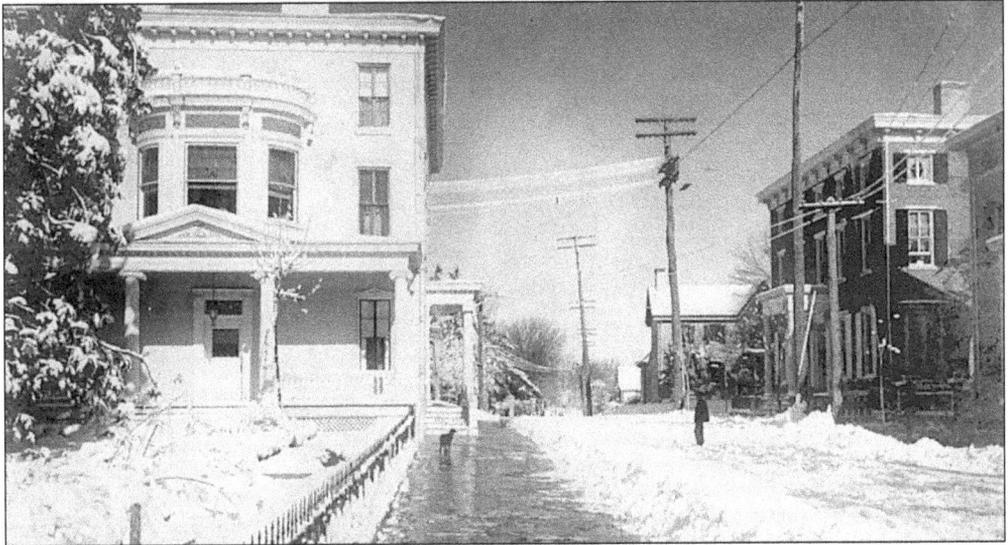

GENERAL TORBERT HOME, 1907. The three-story, Greek Revival home was at first a store built by Benjamin Wadhams and later used as a tavern for James Starr around 1810. Daniel Currey, merchant and father of Mary Currey Torbert, purchased this home from Governor Causey about 1854 and lived here until his death in 1864. His daughter married Gen. A.T.A. Torbert in January 1866, after which the newlyweds made this mansion their home. Alonzo Reynolds, a noted architect from Port Deposit, Maryland, upgraded this home to modern standards in 1850.

27

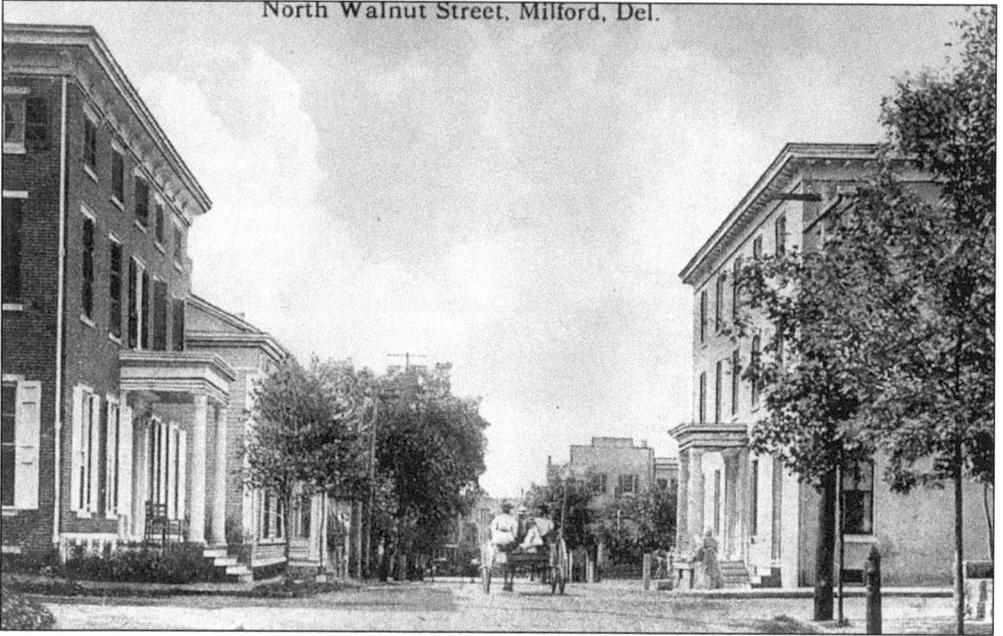

THE BANK HOUSE, 119 NORTH WALNUT STREET. This view of North Walnut Street is facing south at the corner of Northwest Second Street and Walnut. Construction for the brick home on the left was started in 1850, but not finished until 1857, after the bank failed in a financial scam that embarrassed some of Milford's prominent citizens. Dr. James R. Mitchell completed the building for his personal residence. Later the Thaw family lived here. Historian and author, E. Millis Hurley lived here until his death in 1986, when it became the home of Charles Parker.

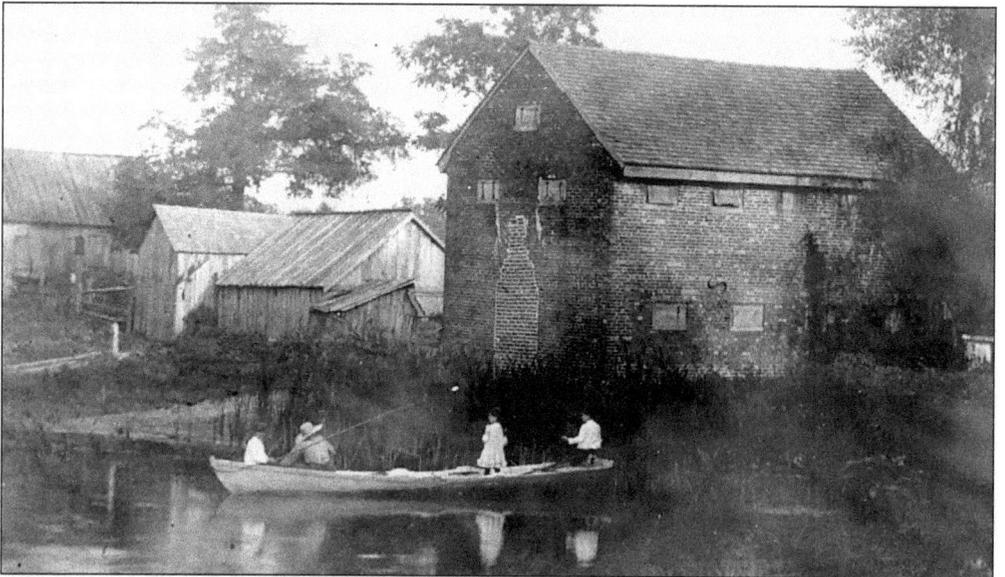

THE BRICK GRANARY, CEDAR CREEK. All travelers who passed along Kings Highway from Milford to Lewes between 1800 and 1920 knew this landmark. Gov. Daniel Rogers built the brick granary during his tenure on Cedar Creek between 1770 and 1800. He moved to Delaware to establish a trading operation along the banks of the Cedar Creek River near Argo's Corner. Ships sailed up Cedar Creek and traded goods for grain kept at this brick storehouse.

CHRIST EPISCOPAL CHURCH, CHURCH STREET. Originally organized as the "Savannah Church," it was located at Church Hill. When Rev. Sydenham Thorne arrived in Milford in 1774 he saw the advantage of moving the church to Joseph Oliver's new village on the Mispillion River. In 1791 a new building was begun a lot donated by Oliver at the corner of North and Northwest Second Street. Parson Thorne supervised the building of this church but fund-raising stalled in 1793 when he died. The church remained unfinished until Rev. Corry Chambers rallied the faithful in 1835 to enclose the building and rejuvenate the congregation. The structure was remodeled in 1863 and the bell tower added in 1895.

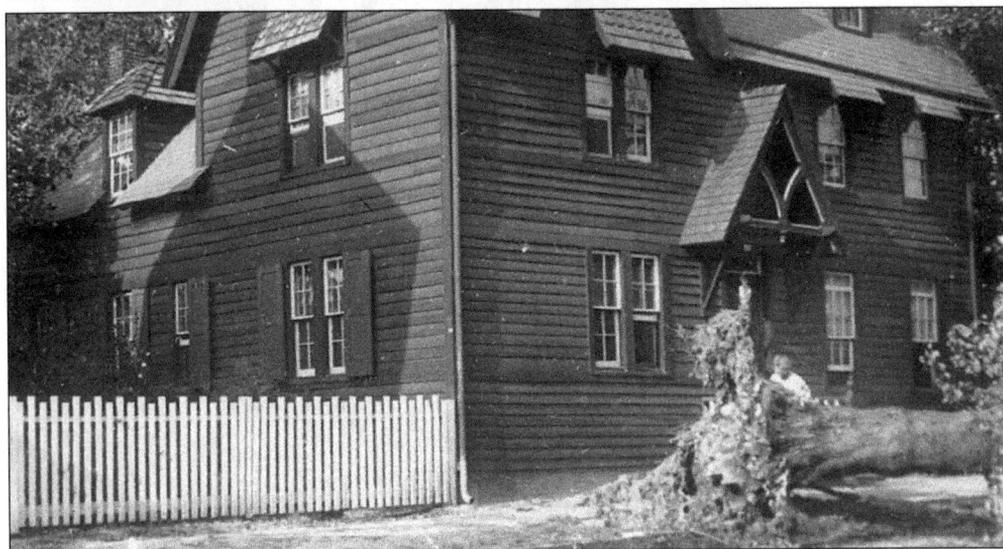

CHRIST CHURCH RECTORY, 1947. This home was built early in the 19th century for use as the rector's home for Christ Episcopal Church located on Church Street, between Northwest Second and Third. The home sat on the church property on the north side of Northwest Second Street. It was home to John Lynn McKim and later his son, John Leighton McKim, during their long periods of service to Christ Church between 1844 and 1908.

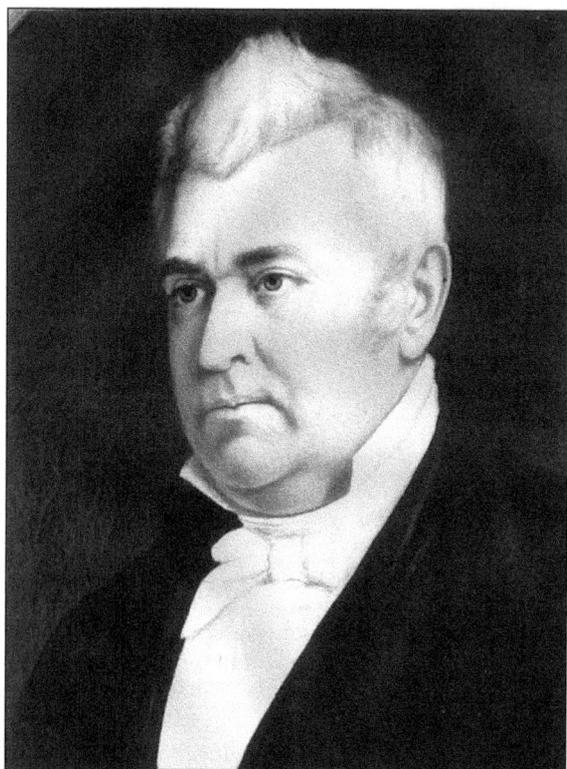

JOHN M. CLAYTON—STATESMAN, 1796–1856. Clayton was the son of James and Sarah Clayton, who moved to Milford in 1808 from Dagsboro. They purchased the Clayton-Blackiston tannery and mill operation at Silver Lake. John M. Clayton experienced his boyhood in Milford and attended the Milford Academy on Northwest Second Street and preparatory school in Connecticut before he was accepted at Yale College in New Haven. He later served three terms as a U.S. Senator and culminated his career in public service as Secretary of State under President Zachary Taylor in 1849–1850. He built his final home at "Buena Vista," south of New Castle, and died there in 1856.

SILVER HILL MANSION, 1930. This photo of the Thorne mansion was taken between 1916 and 1962 when the home was leased to tenants who farmed the land owned by the Draper family. Numerous Linden trees are evident on the front lawn that seems in need of proper care. John M. Clayton lived in this home from 1808 until 1823, when his father died, and the property was sold to Col. Benjamin Potter, who maintained a tannery and store across the street.

"ELLERSLIE," HOME OF GOV. CHARLES POLK, 1816–1857. This commodious home once sat on Governor Polk's farm located about one mile west of Delaware Bay near Big Stone Beach. Charles Polk was married to Mary Manlove, whose family were original patentee in Milford Neck. Governor Polk moved his family to Kent County in 1816 and built this home, called "Ellerslie," after his family's native home in Scotland. He served two terms as governor, from 1827 to 1830 and again from 1836 to 1837. Polk retired to this home following his public service and became a gentleman farmer on 1,000 acres of land overlooking Delaware Bay.

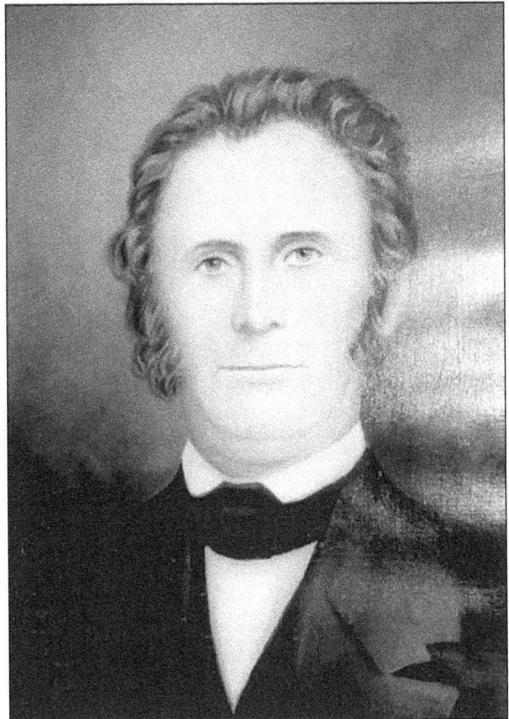

GOV. CHARLES POLK, 1788–1857. Charles Polk was the only governor to serve terms in the General Assembly from different counties. After two terms in the House from Sussex, Polk moved to Milford Neck to the land of his wife's family the Manloves. He built his home in 1816 near Big Stone Beach and called it "Ellerslie."

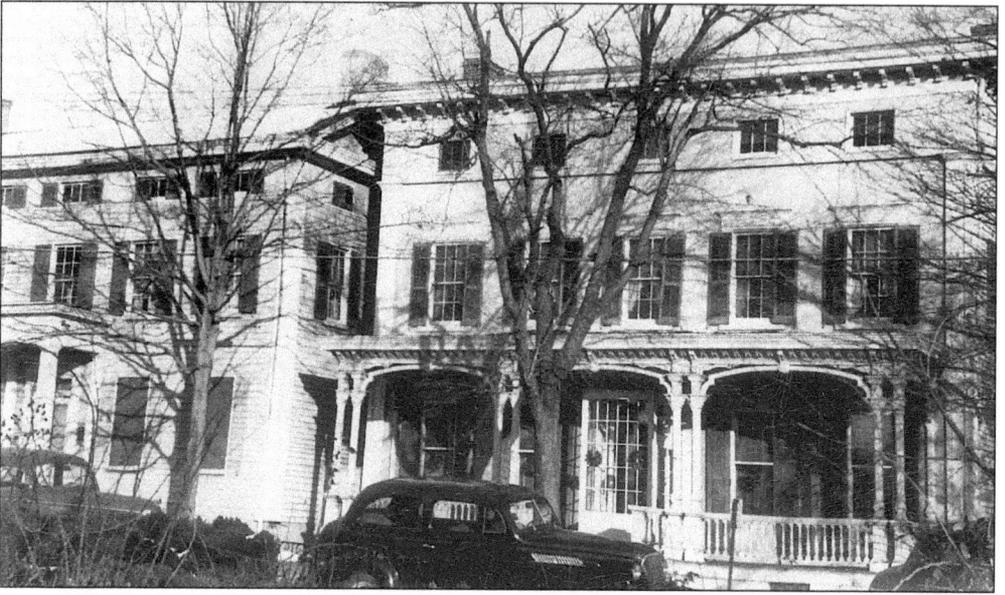

FRANK RICKARDS'S HOME. John McCurdy, father of Mrs. Nehemiah Davis, built this home located at 115 North Walnut Street in 1840, for his daughter and her husband. At the death of Mrs. Davis the home descended to her daughter, the wife of Frank Rickards (1856–1913). Frank Richards's daughter Helen married Dr. Willard Pierce and resided in the home during World War II. Dr. Robert Emory used this home as a dental office for about 20 years; today it is an apartment dwelling.

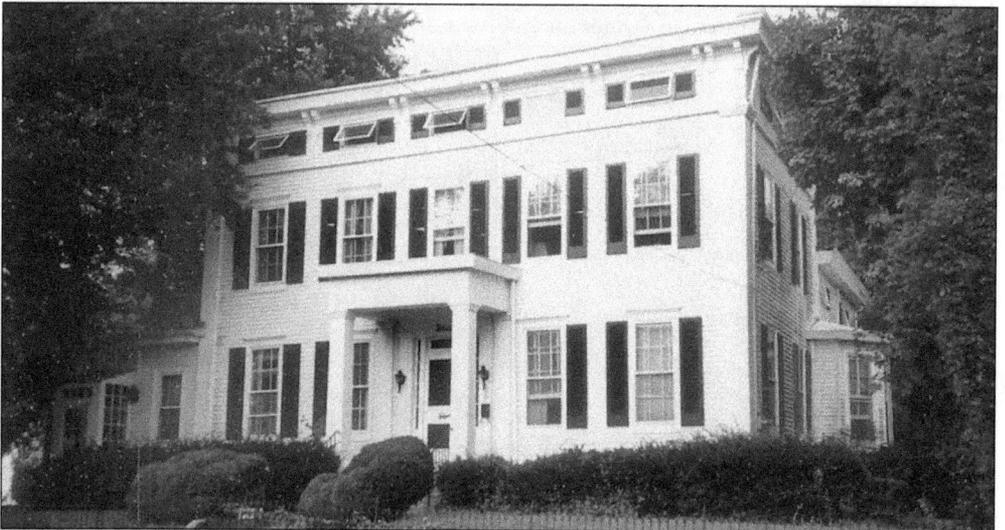

DANIEL C. GODWIN HOME, 206 NORTH WALNUT. Daniel Godwin was Milford's most prominent merchant during the early period of Milford history. He kept store in the Williams-Tharp-Jewell Building from 1820 to 1830. In 1830 he built the rear, brick portion of the Milford Hotel, later used as the Odd Fellows Hall and in 1843, he built the three-story masonic building at the corner of North Walnut and Northwest Front (Lou's Bootery). Godwin sold this home to Dr. Robert Frame who built a smaller home along Northwest Second Street (Col. Townsend's home) and sold the mansion to Dr. Robert Clark, paymaster in the U.S. Navy. The home is owned by John B. Baker Jr.

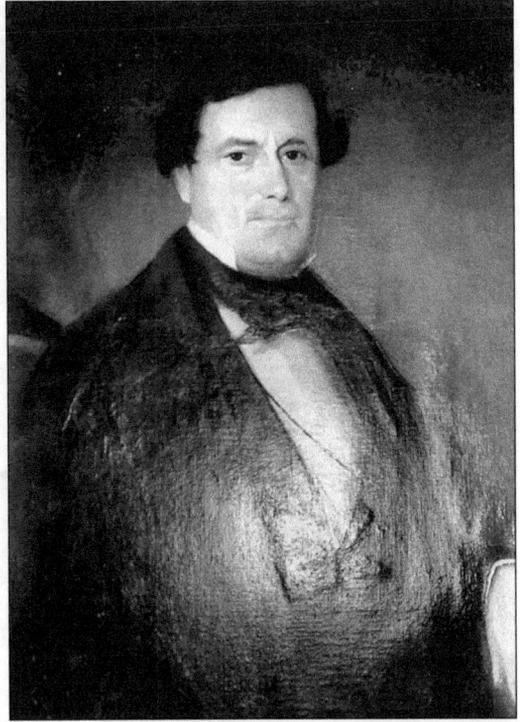

GOV. WILLIAM THARP. William Tharp was descended from one of the original families to settle in Kent County near Farmington before 1750. He allied himself in politics with Peter F. Causey and many of Milford's successful residents. He moved to Milford in 1847 during his campaign for governor with his wife and five daughters. They lived in the frame wing of the home formerly owned by Reynear Williams (died 1828) and his wife, Maria Causey.

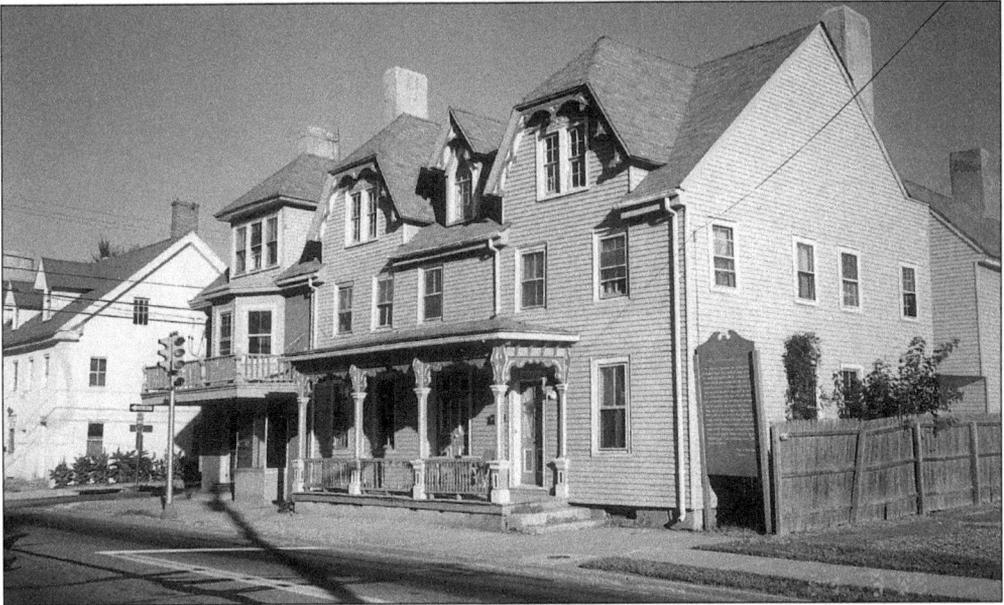

THARP HOME. Governor Tharp lived in the east wing of the Williams-Tharp-Jewell home from 1847 to 1865. The western section was built from brick and used as a grocery store from 1814 through 1988. Ann and Alonzo Reynolds maintained this home from 1865 until 1890 when Peter Houseman purchased the grocery store and home and lived here until John Jewell bought the building in 1925. After John's death, his sister, Thelma Jewell continued the grocery business until 1988. This building is scheduled for demolition in 2002 due to its age and deteriorated condition.

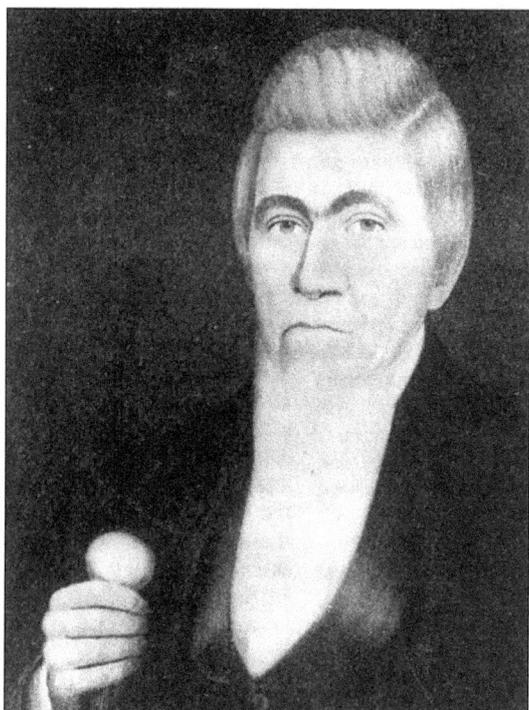

GOV. WILLIAM BURTON. Governor Burton was a physician who became involved in politics as a democrat following the failed political ideas of the Whigs under Governor Causey in 1855. Governor Causey supported the idea of liquor prohibition that was unpopular with local residents. Dr. Burton was a Southern sympathizer and ran for governor in 1859 on a platform of tolerance for the Southern cause. After the outbreak of the Civil War, Burton was forced to remain loyal to the Union by the General Assembly and supporters of Abraham Lincoln's candidacy. The Civil War took its toll on Governor Burton who was exhausted after his term expired in 1863. He returned to his home in Milford and died in 1866.

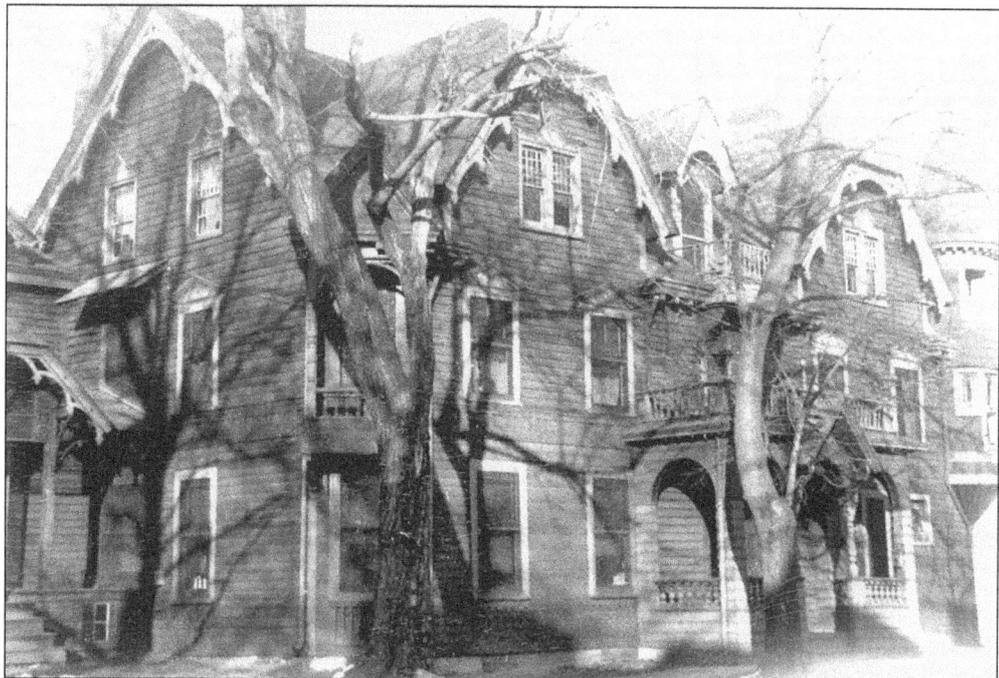

GOVERNOR BURTON'S HOME AT THE TOWERS. Although Governor Burton resided in the Parson Thorne mansion during his term as governor, he owned the old home known as "The Towers." This photo was taken in 1947 when the home was painted green with red trim. Early residents remember The Towers as the home of Mrs. Rhoda Roudebush, who was the daughter of Governor Burton and heir to the home.

ST. PAUL'S METHODIST CHURCH, 1842–2000. The three-story brick Methodist church formerly stood at the northwest corner of North Street and Northwest Third Street. It was demolished in June 2000 to make way for a new church. Early Methodist residents built this church after the original, wood-frame church was abandoned and moved from the center of the old Methodist cemetery just to the east on North Street. The Methodists used this church until 1873 when the congregation voted to build a new church on Railroad Avenue (now Church Street) near the center of town. The new church was delayed by fund-raising, but finally completed in 1876 and dedicated.

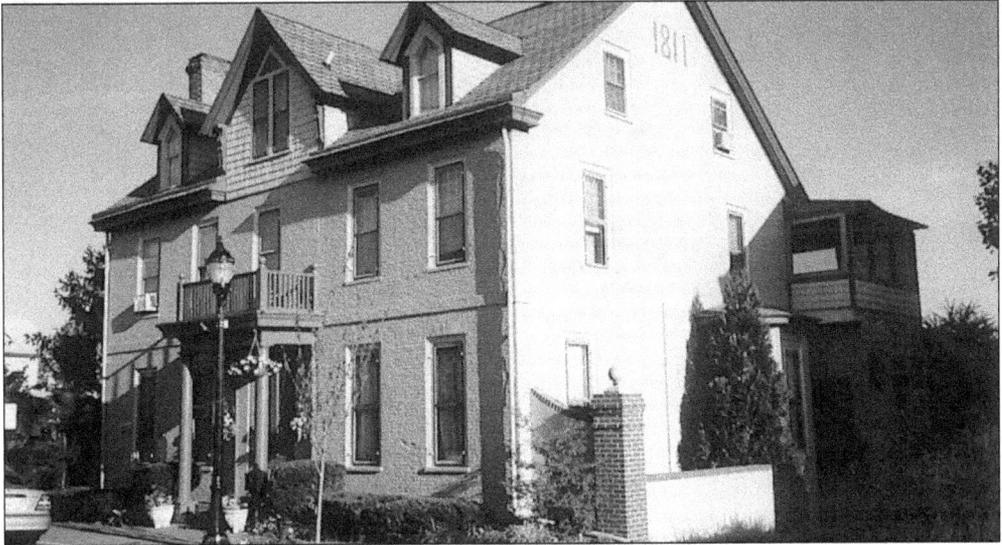

MARSHALL HOUSE-BANKING HOUSE. John Laws built the eastern section of this home in 1787 on land leased from Jos. Oliver. It was later owned by one of Milford's earliest merchants, Louder Layton Esq. Layton lived in this home until he moved to the Crapper mansion in South Milford in 1812, following the death of Gov. Daniel Rogers. In 1811 the western section of the home was built as the office of discount and deposit for the Bank of Smyrna. Dr. George W. Marshall purchased the former bank house and joined the two buildings for his residence in 1887. The home has been known as the Marshall house since 1887.

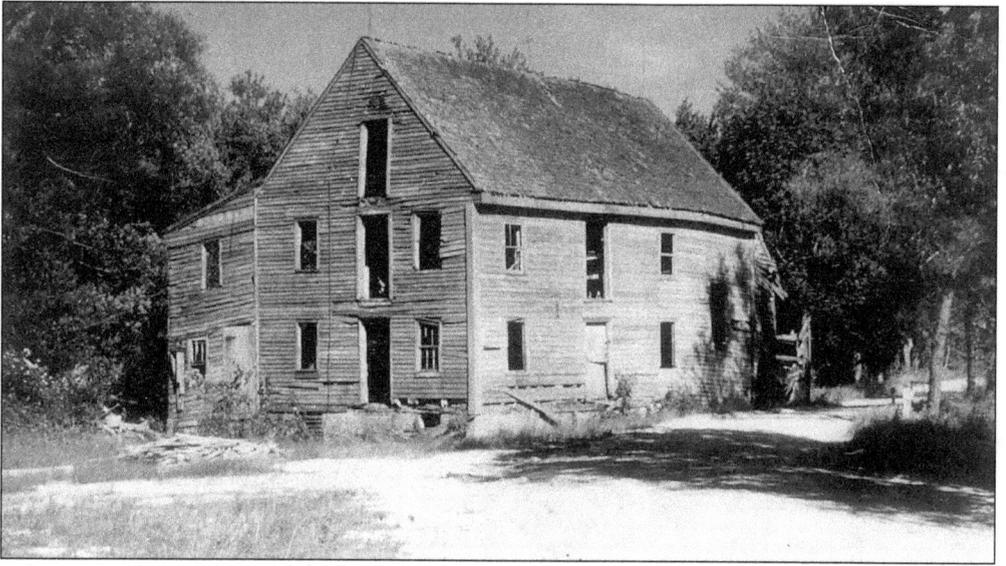

CUBBAGE POND MILL. The first mill on this site was built by John and William Draper about 1785 and rebuilt by Lemuel B. Shockley in 1819. It was sold to John C. Davis (1833–1863) and later to Hiram Barber (1863–1866), a Milford sawmill owner. From 1881 through 1892 Mark H. Davis owned it and the grist/sawmill was converted to a roller system of grinding. Frank Davis inherited the mill and operated it from 1892 to 1908. Samuel Cubbage (1908–1917) last operated the mill and had a small store attached along the roadway at the northeastern side of the dam. (Courtesy of Betty Cofer.)

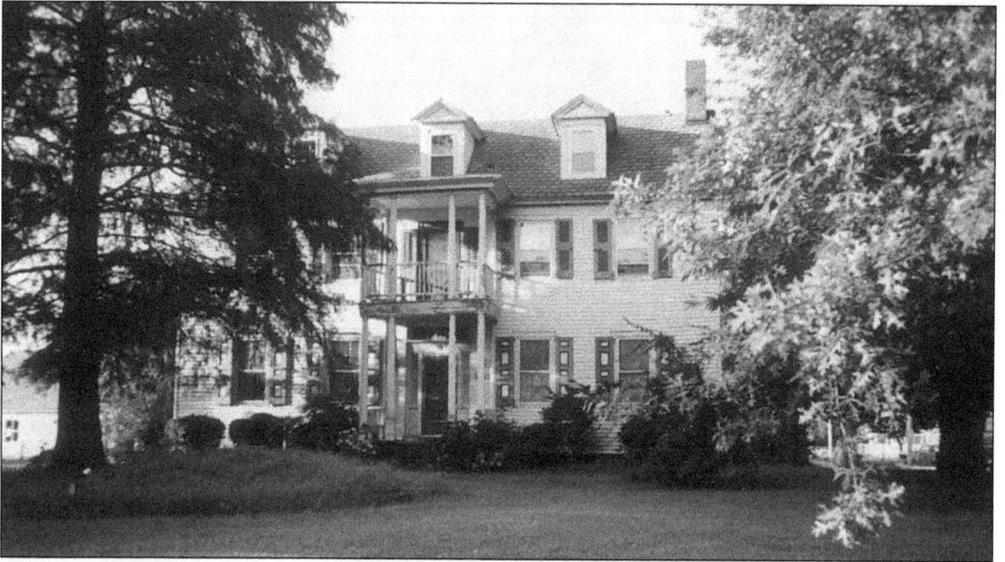

EGGLINTON HALL, 700 SOUTHEAST SECOND STREET. Thomas Egglinton built this home about 1795 and later George Black and his family occupied it during his ownership of the Marshall Mill property between 1785 and 1828. Trusten P. McColley purchased the old home in 1840 and added the two-story front section and planted cedar trees around the front lawn. McColley purchased all the unsold lots in South Milford during the decade between 1830 and 1840 and lived here until his death. He was a Methodist minister and performed many marriage ceremonies in this home.

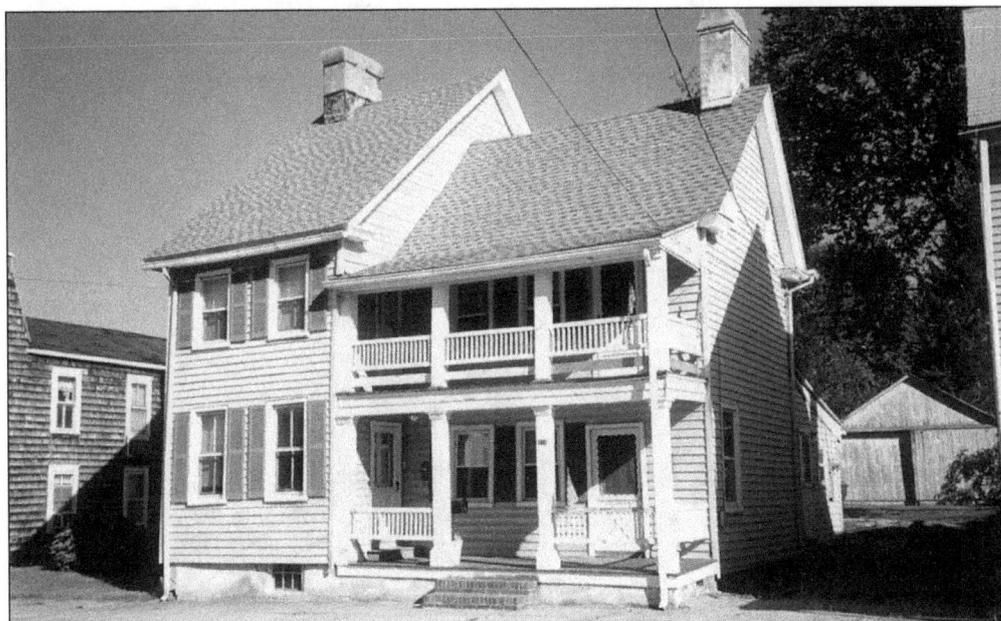

BENJAMIN YOE HOME, 1790–1811. This home located at 211 Northwest Front Street is representative of the earliest English homes built in Milford after founder Joseph Oliver began selling lots in 1787. Benjamin Yoe was a cabinetmaker and built the eastern section of this home in 1790 for his family. After his death in 1812 the home was sold to Samuel Talbot, a miller from Princess Ann, Maryland. Talbot built the western section to the home as an addition to increase the living area.

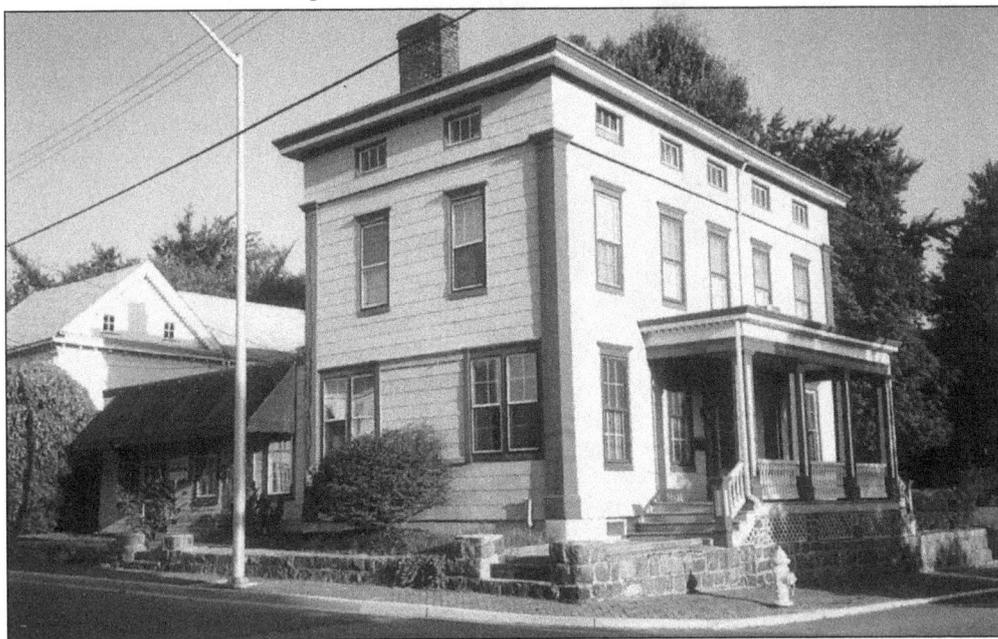

DR. MARK G. LOFLAND HOME, 200 NORTH WALNUT ST. The home was built about 1856 by Samuel Raughley who later sold the property to Dr. Mark G. Lofland, who lived here until his death in 1881. Dr. Lofland was the son of Dr. James P. Lofland and brother to James Rush Lofland and Peter L. Lofland, all prominent citizens from 1850 to 1900.

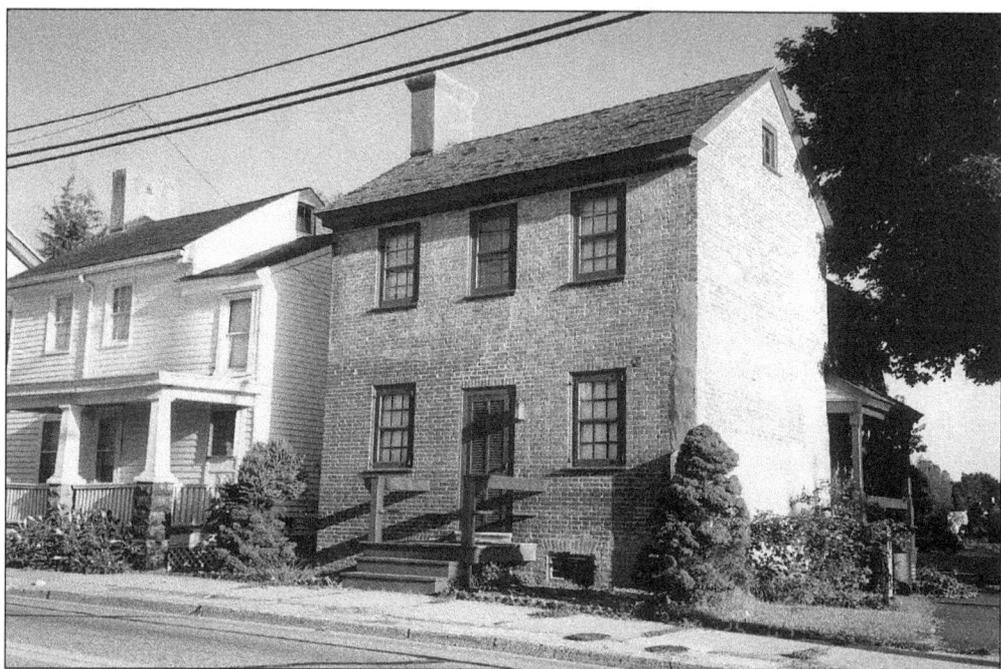

ISAIAH JAMES HOME. The original brick structure was built in 1787 on a lot leased from Joseph Oliver. After the death of Isaiah James his widow sold the tannery he owned behind this house to Benjamin Potter in 1798. Calvin Clendaniel, a local architect, separated the home from a frame section prior to its restoration to original condition in 1985.

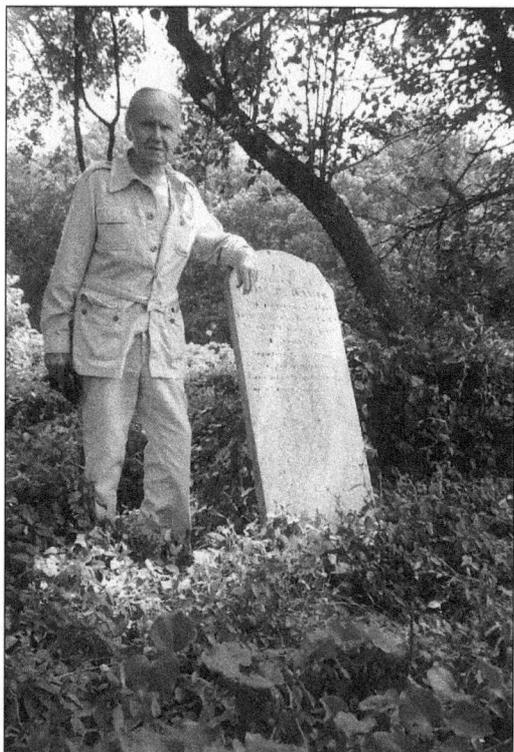

ROBERT BELL PIERCE (1902–1994). Bob Pierce was the son of Robert Hall Pierce and Mary Virden. He was one of Milford's earliest historians, following in the footsteps of his uncle, James H. Bell, author of the first historical account of Milford written in 1899. Bob is shown in 1987 leaning on the last tombstone standing in the remains of St. Matthew's cemetery, located on Route 30 at Cedar Creek Millpond. St. Matthews was an active Anglican and Episcopal Church from 1704 to1860. It once had more than 100 tombstones.

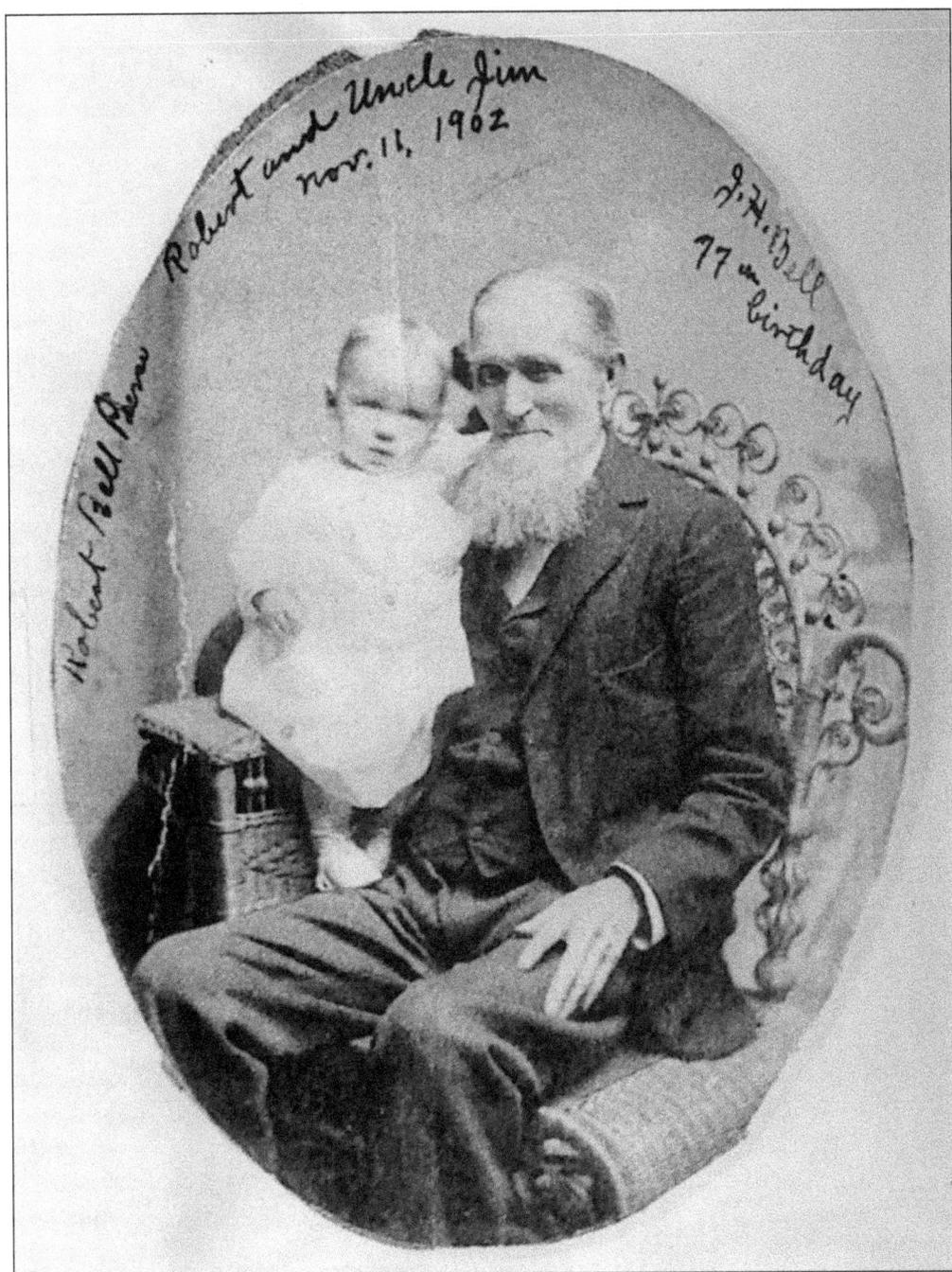

JAMES H. BELL AND ROBERT B. PIERCE, 1902. This photo was taken on the 75th birthday of James H. Bell. Bell was the author of Milford's first historical manuscript that was used in 1899 by George B. Hynson to write *Historical Etchings of Milford & Vicinity*. Mr. Bell was born in 1827, served in the Civil War and was wounded and captured by the rebels. He returned to Milford to serve as keeper of the Mispillion Lighthouse and postmaster. His mother was Mrs. Aaron Williams who knew Milford's founder, Joseph Oliver, and was acquainted with most of Milford's early citizens. Mr. Bell is shown with his nephew and namesake, Robert Bell Pierce.

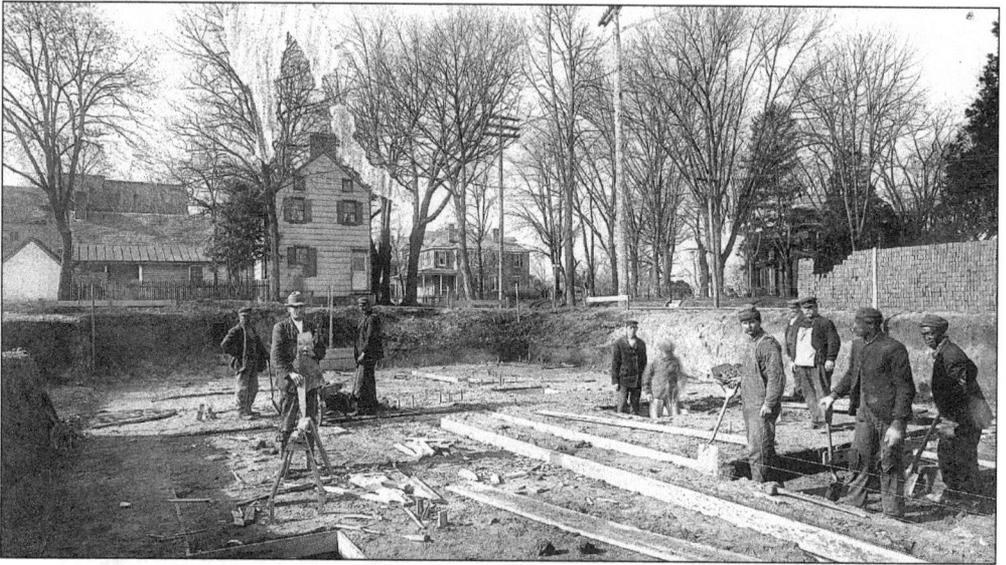

WALKER SIPPLE HOME. This March 31, 1909 photo shows the foundation of the Milford Post Office being constructed in 1909. The two-story frame home in the background formerly sat at the southeast corner of S. Walnut Street and Southeast Second Street, where City Hall stands today. The home was moved around the corner to South Washington Street in 1920 to make room for the home of Ruby and Elizabeth Vale on the corner property. It was owned by the Chas. Lacy family and later moved in 1990 to Ship Carpenter's Square in Lewes, Delaware.

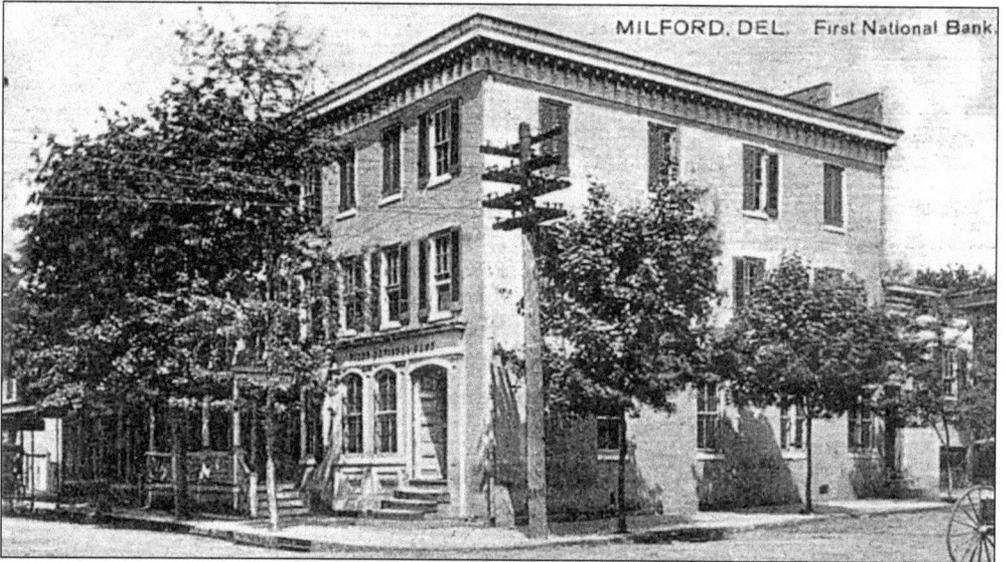

FIRST NATIONAL BANK, 1909. This building formerly stood on the site where Wilmington Trust Bank sits today. Abner Dill originally built it as a one-story tavern about 1790. After Abner Dill's death, Benjamin Wadhams, a merchant, turned the brick tavern/hotel into a two-story dwelling and store. When Wadhams died in 1833 the building became the business site of Peter F. Causey and Nehemiah Davis. When Causey was elected governor in 1855, he sold this building to Col. Henry Fiddeman who made his home in the western side and pursued his business in the eastern side. He added the third story about 1875 to incorporate First National Bank formed in 1876.

ANDERSON HOME, NORTH STREET, 1947. This home is located across the street from "The Towers" along the east side of North Street. It was home to the Anderson family and was the site of much social activity during the 1860 to 1890 period. Many local young people gathered at this home to sing, play cards, and prepare for thespian events. This home is described in the *Diary of Lizzie Dorsey* written in 1861 by Elizabeth Dorsey, who lived at 105 Northwest Front Street and was a close friend of the Anderson children.

THOMAS F. HAMMERSLY HOME. Thomas R. Hammersly purchased this home in 1840 for $900 from Daniel Godwin. Hammersly owned a drug store and served as cashier for the office of the Smyrna Bank. After his death, his son, Thomas F. Hammersly, inherited the home and lived here until his death. Later the home was owned by the Collins family and used as an insurance office. A physician, Dr. John Annand raised a family and practiced medicine from this home. Today it is the office of Moore & Rutt, attorneys and Sombar accounting.

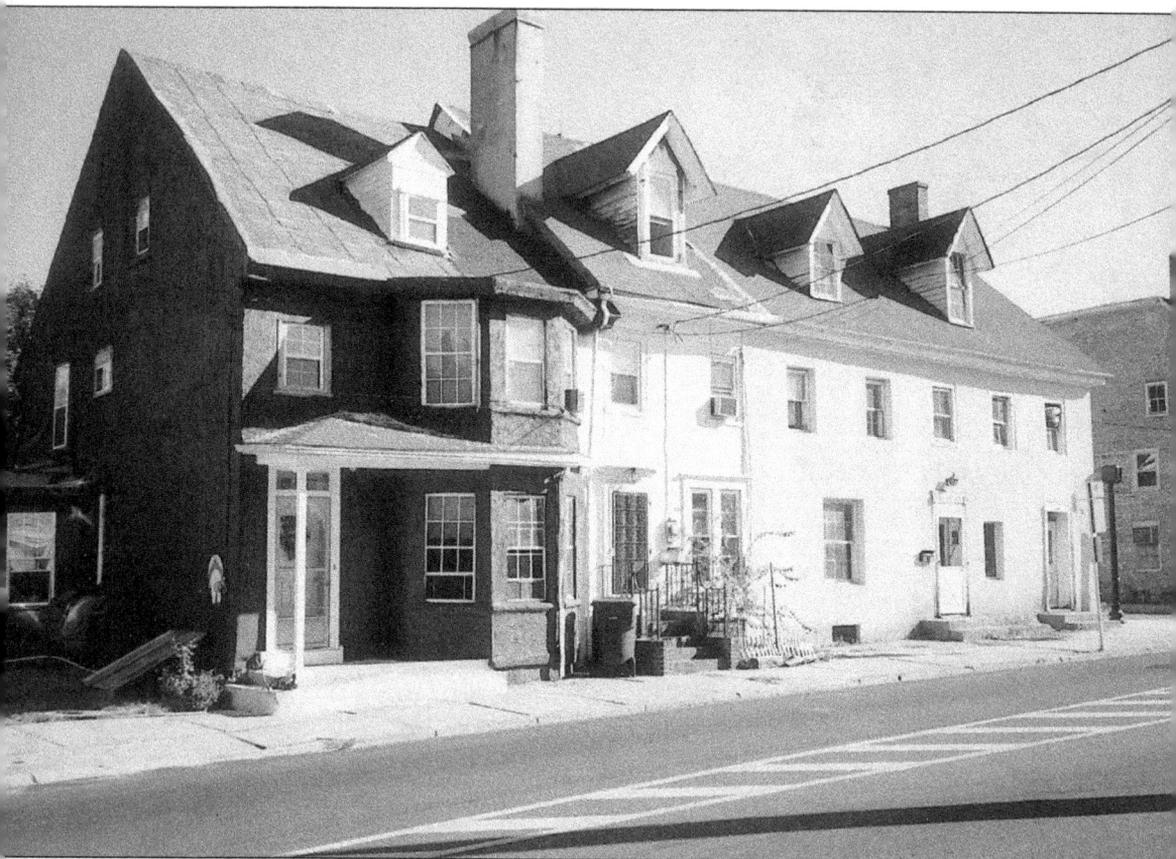

RALSTON/SUDLER HOME. John Ralston built this home in 1795 for his family. Upon his death, his son-in-law, Dr. Joseph Sudler, inherited the home and conducted his medical business from the corner office. Later in 1848 the building was used to launch Milford's first newspaper, the *Beacon*, published by John H. Emerson from Denton. Daniel Godwin used the building as a store prior to moving to the opposite corner to the Williams (Jewell's Store) building in 1830. This building was home to Milford Seafood Market from 1940 to 1955 when Dennard Conner owned the building. Today the property is owned by Frank Fioca and shows signs of old age. It is 206 years old.

Three

CIVIL WAR TO THE 20TH CENTURY
1860-1900

Milford reached its highest level of importance in comparison to other Delaware towns during the Civil War period beginning in 1860. Milford was the third largest town in the state with a population of 3,000. Politically, Milford was a very powerful center of activity with Governor Tharp serving as chief executive from 1847 to 1851 and Governor Causey controlling the state from 1855 to 1859. Governor William Burton assumed the top post in 1859 and served through 1863.

The period from 1860 to 1900 was a period of great strength and statewide influence in industry, banking, politics, and culture. Shipyards were buzzing, mills were grinding, farms were productive, and crops had markets in the cities. Changes after the turn of the century would outpace Milford and leave many of the "old guard" behind. But a new immigrant family named Grier would bring the dental supply business to Milford in 1900 and launch the next leap forward.

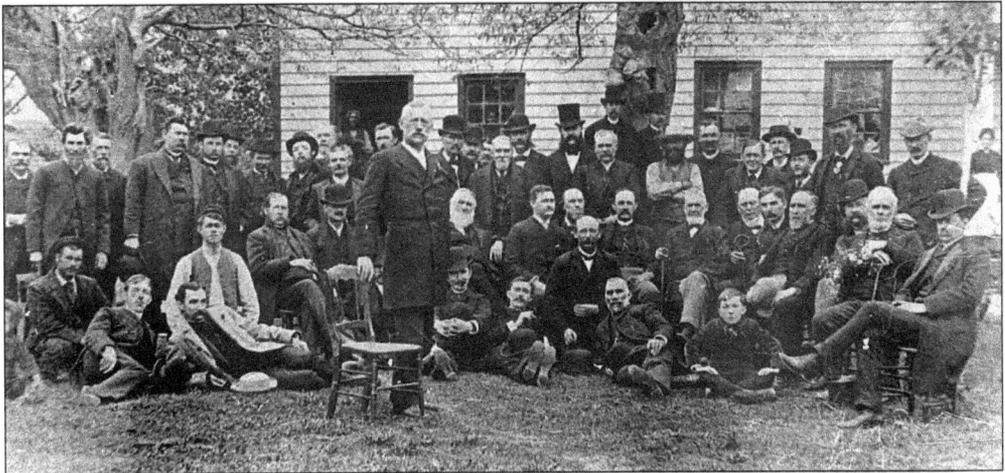

ANNUAL FRUITGROWERS AND CANNERS GATHERING. Rev. Johnathan Spencer Willis is shown hosting his annual picnic and gathering for his friends and business associates in 1880. Reverend Willis was a popular Methodist minister, politician, and fruit grower. In the front row reclining is Theodore Townsend, editor of the *Milford Chronicle* and investor in a fruit-drying machine. Rev. J.S. Willis is the host standing in the center. In the front row are Peter F. Causey Jr., John B. Smith; Congressman, John W. Causey; Attorney Fred Causey, Henry Hynson, Charles Barker, and Robert. H. Williams. In the rear of this photo are John J. Rosa, Frank Rickards, Dr. Dawson, Joe Holland, and Robert Grier, Dr. George W. Marshall, William V. Sipple, and Mark Davis.

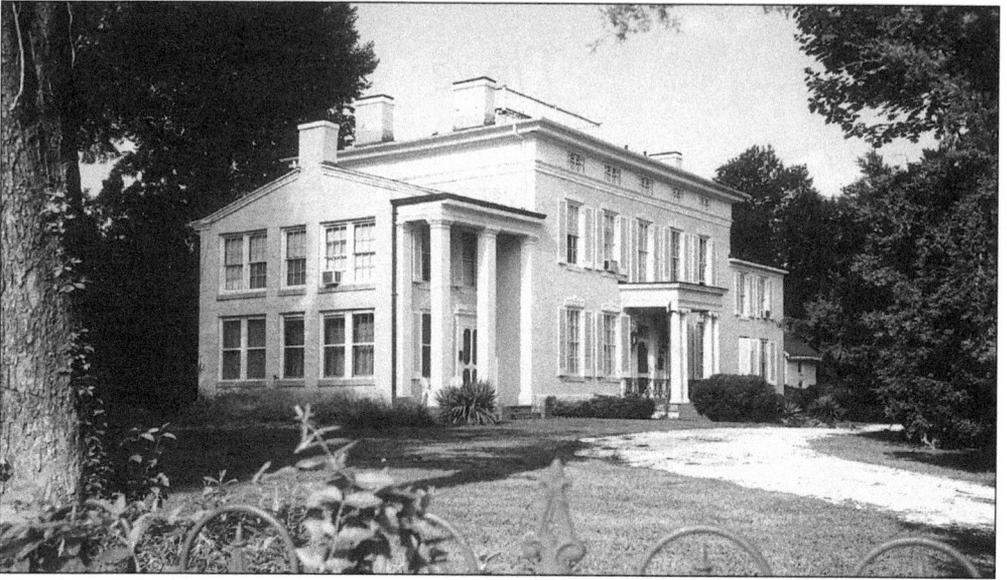

GOV. PETER F. CAUSEY MANSION. The center of this home was constructed in 1763 for Levin Crapper. After Crapper's death, Gov. Daniel Rogers married the widow of Moulton Crapper and lived here until his death in 1806. Louder Layton, a wealthy merchant from North Milford purchased the mansion in 1812 and died here in 1849. Peter F. Causey purchased the home in 1850 and began a major architectural change. He reversed the front entrance to face the town and Mispillion wharves. He added wings on the east and west ends of the house and modified the porticos and windows to reflect the latest Greek revival styling.

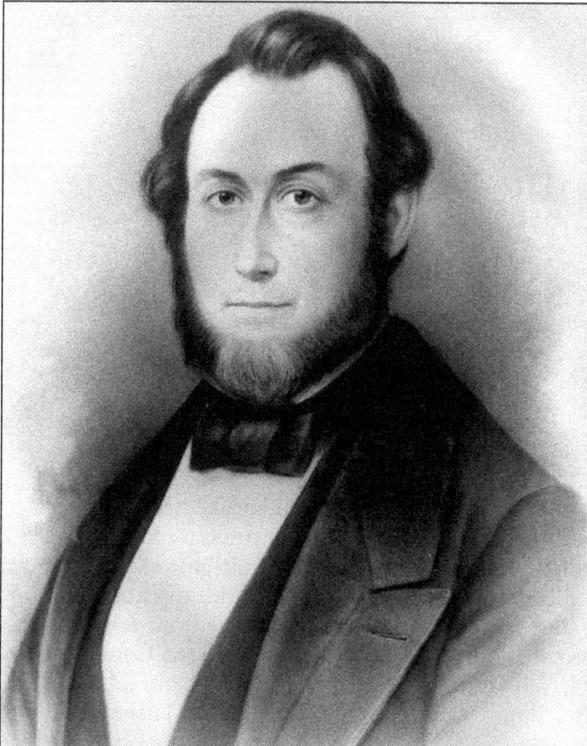

GOV. PETER F. CAUSEY, 1801–1871. Governor Causey is the best-known governor to make his home in Milford. His parents came to Milford from Easton in 1815 and started a mercantile business that was expanded by their son beginning in 1820. Governor Causey owned many of Milford's early businesses including Mill Creek Mills at Marshall Pond (1828–1850), Milford Mills at Silver Lake (1850–1870), and Haven Mills on that lake. He was a partner with his brothers-in-law, Justus Lowery and Reynear Williams, in many land ventures and served as governor from 1855 to 1859. He suffered a debilitating stroke in 1865 and spent the remainder of his life in the Causey Mansion.

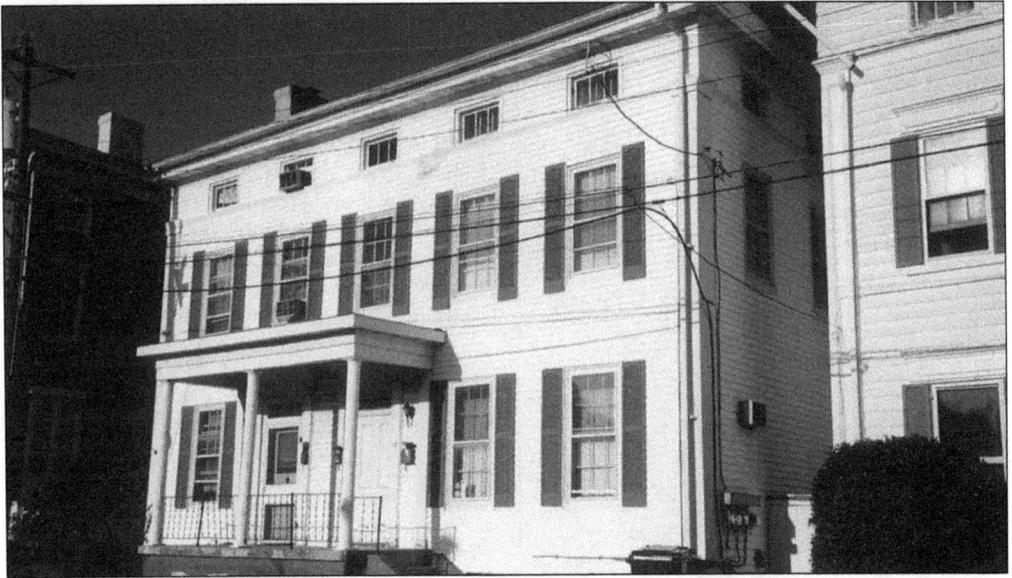

NEHEMIAH DAVIS HOME. Nehemiah Davis, who was a partner in the firm of Currey & Davis, built this home in 1840. Davis was heavily involved in fertilizer and farmland speculation. He shipped cordwood and barrel staves to Philadelphia and brought back farm supplies and traded goods. His partner, Daniel Currey, kept books in the office and lived across the street in the home that later became General Torbert's residence after he married Currey's daughter, Mary, in 1866. In the later portion of the century his son, Mark Davis, inherited the home.

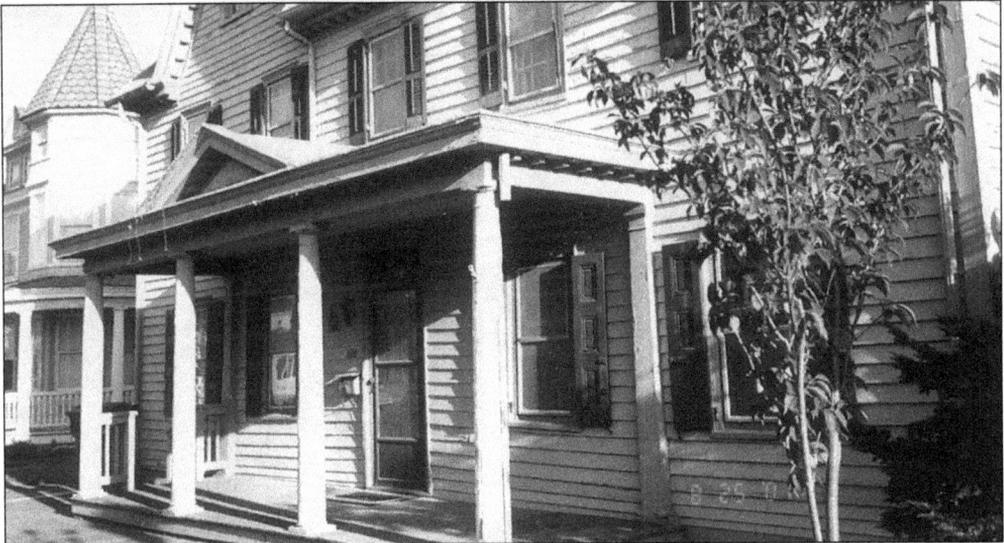

MOLLIE ATKINS BROWN HOME. Joseph Oliver sold the lot on which this home stands to William Sorden in 1787. After Sorden's death in 1806 this lot was purchased by Dr. William Burton for $3,300 and Sorden erected granaries on this property. Dr. Burton sold to Isaac Davis who sold the property in 1820 to Leonard Atkins, a banker. The home became known as the "Mollie Adkins Brown" home in 1920 when this descendant of Leonard Adkins bequeathed her extensive collection of books to the citizens of Milford, forming the first public library in Milford. She often invited school children to her home to read from her collection before the library room was completed in the Milford Community Hall in 1925.

45

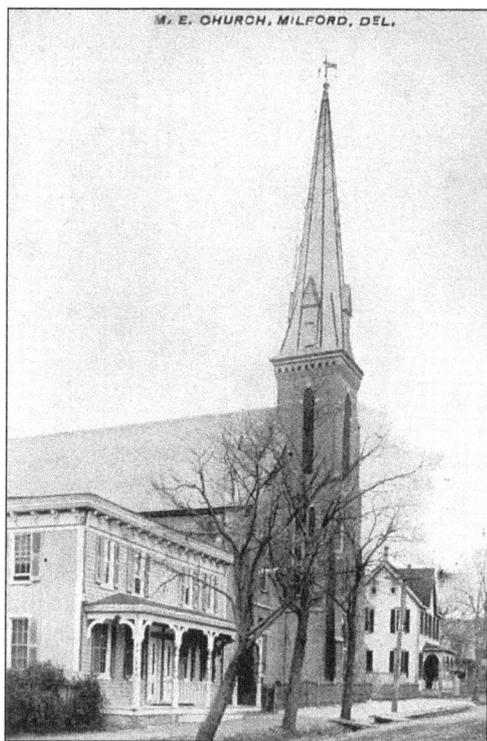

THIRD METHODIST EPISCOPAL CHURCH, 1875–1939. The old Methodist church shown in this postcard was a landmark from the time it was completed in 1875 until it was demolished for the new Gothic stone church built in 1939. Its belfry tower and steeple were visible for several miles. The Methodist parsonage is shown at the top of the photo. It was located on the southwest corner of Northwest Front and Church Streets.

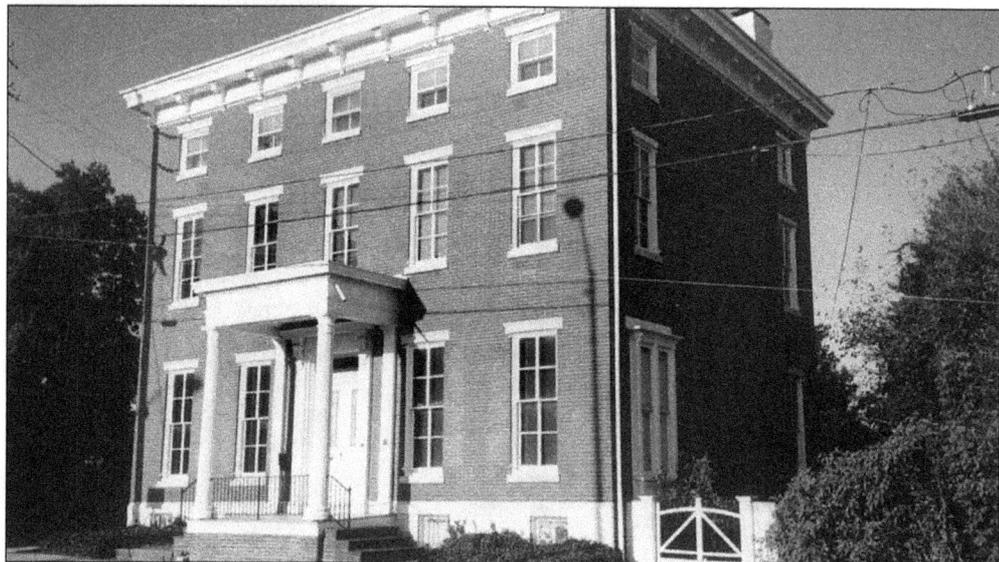

THE BANK HOUSE, 119 NORTH WALNUT STREET, 1855. This building is an outstanding example of Greek Revival architecture that was prevalent in Milford from 1840 to 1870. The corner was formerly occupied by the home of John Draper, a shipbuilder, whose home was moved in 1850 to Nine Northwest Second Street when plans were announced to construct the bank. Although many prominent businessmen owned stock in this bank, its principal owners were from New York. The stock manipulators embarrassed all local investors by absconding with the bank's funds and leaving the structure unfinished. It was sold at auction in 1855 to John R. Mitchell who completed the structure for his personal home.

46

E. MILLIS HURLEY—HISTORIAN, 1909–1986. Millis Hurley was the most prominent Milford historian after the death of George B. Hynson in 1926 until his death in 1986. Millis was born on North Walnut Street and grew up tending his father's store. From his early youth in 1920 until 1968 he was a grocer and merchant; however, his first love was Milford history. He was a founding trustee of the Milford Historical Society in 1961 and served as secretary for many years. His home at 119 North Walnut Street is a museum filled with antiques and artifacts collected over a lifetime. His rare books and documents were donated to the Milford Museum and are available in the E. Millis Hurley library today.

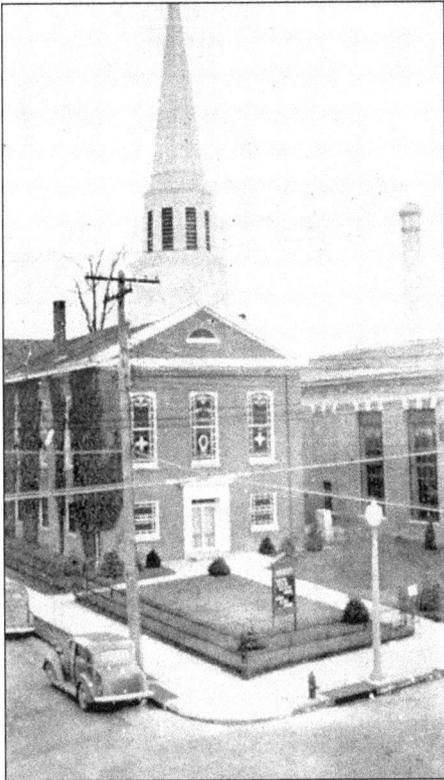

FIRST PRESBYTERIAN CHURCH. The church was built in 1850 by a congregation led by Hester McColley, who started a Sunday school for children, and other citizens who were unhappy to see the former "Three Runs" meetinghouse on Presbyterian branch at Kings Highway fall into disuse after 1820. This view of the church was taken prior to 1954 when a new brick front addition was added. The early church was covered in ivy and surrounded by a black iron fence. Today the church steps extend to the edge of Walnut Street.

MILFORD is surrounded by fertile well tilled farms reached by good roads in all directions
If you need a whiff of salt air REHOBOTH'S incomparable shores can be reached in forty minutes

Shipbuilding

Nearly four hundred sloops and schooners (coasting vessels) have been built in Milford. The most flourishing times were just before the Civil War, work dying with the advent of the railroad. Vessels were built as early as 1800 but the construction of pleasure craft and speed boats are the only class now constructing the water trade.

THE CAUSEY MANSION

MILFORD SHIPYARDS, 1780–1920. Sailing ships were being built along the Mispillion River as early as 1750 at Millstone Landing (New Wharf) and Wyncoop's shipyard near Marshall's Mill. Shipbuilding began in Milford about 1782 when John Draper established a two-acre shipyard site at the base of East Fourth Street where it meets the river (Domino's Pizza). His son, Alexander Draper, purchased the shipyard in 1801 and built several wooden sailing vessels at this site before moving to New Castle County. The Drapers built about 22 vessels between 1780 and 1809. The bulk of shipbuilding; however, was conducted along the south bank of the Mispillion between S. Washington Street and Fisher Avenue. This map was charted in 1938 by W.P. Richards, a civil engineer, and depicts the location of the main shipyards between Montgomery Street and Columbia. David West began building sloops in 1818 and built nine from the wharf behind his home at 205 S.E. Front Street (T.C. Collins) before his death in 1832. Sylvester Deputy and his son, James H. lived next to David West on the west side and at the N.E. corner of Front Street and Montgomery. The father-son team began shipbuilding in 1828 and continued until 1872 when James H. Deputy retired. William A. Scribner who lived in the Lank home at the southeast corner of Washington owned the entire riverfront block between South Washington Street and Montogmery Street and Front Street. Scribner began his shipbuilding career in 1846 and built 21 ships before his death in 1882.

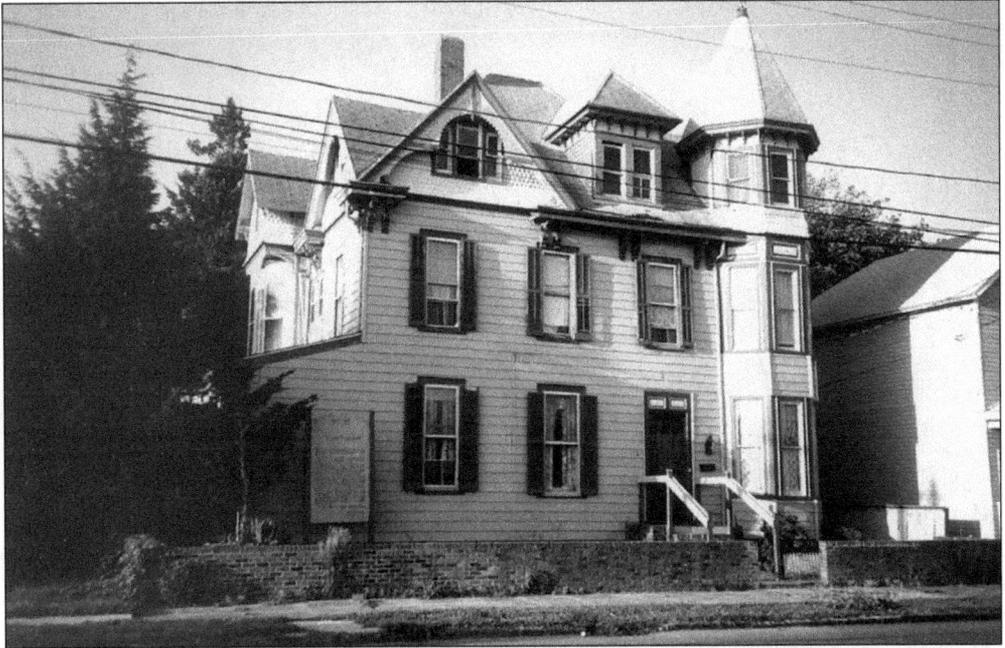

SCRIBNER APARTMENT HOUSE. The center section of this home was built by Samuel Radcliffe about 1823, but later purchased by William A. Scribner for his family in 1849. Scribner's ship carpenters remodeled this classic Victorian home in 1850 adding a dramatic three-story staircase and a garret tower. Woodwork in this home shows the skill of early Milford ship carpenters. George Russell, father of Milford's electrification project in 1885–1886, purchased the home for $7,000 in 1870. Later, Dr. O.A. James lived here from 1922 to 1956.

JOHN DRAPER HOME, 9 NORTHWEST SECOND STREET. This home, built in 1794, sat on the corner of North Walnut Street and Northeast Second (119 North Walnut) where Millis Hurley lived, but was moved to make way for the Bank House in 1850. John Draper purchased two acres for his shipyard in 1782 on the north bank of the Mispillion and lived in this home until his death.

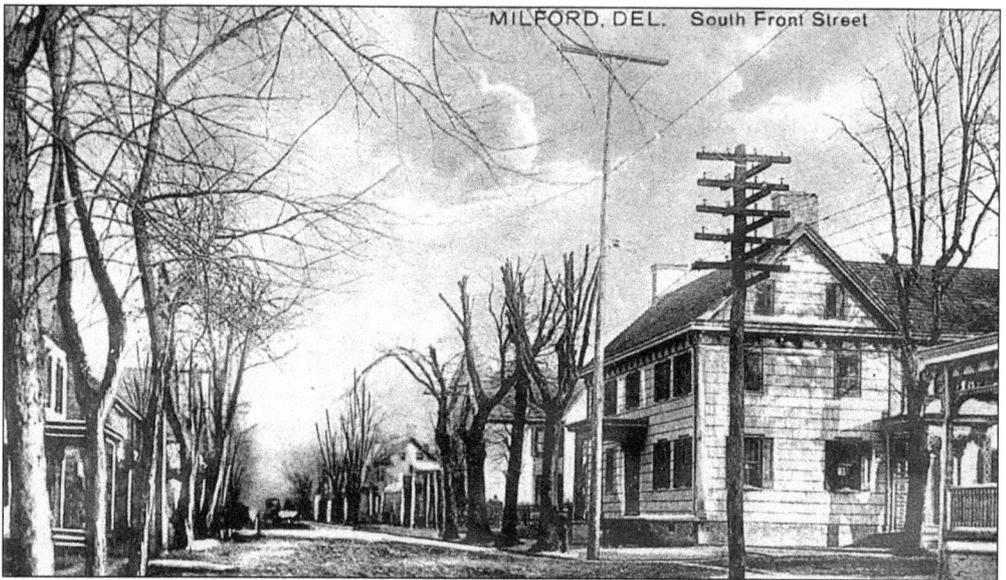

WILLIAM A. SCRIBNER HOME. John Scribner, carpenter and blacksmith, built this home about 1825 and bequeathed it to his son, William A. and Pricilla Scribner in 1836. Scribner owned the wharves and shipyards to the north, across Southeast Front Street. The home formerly sat at the southeast corner of South Washington Street and Southeast Front Street (site of King's Gas Station today). William Scribner died in 1882 and his widow lived in this home until her death in 1917. The home passed by inheritance to her son-in-law, William Edward Lank. Col. Lank lived in this home until his death in 1956.

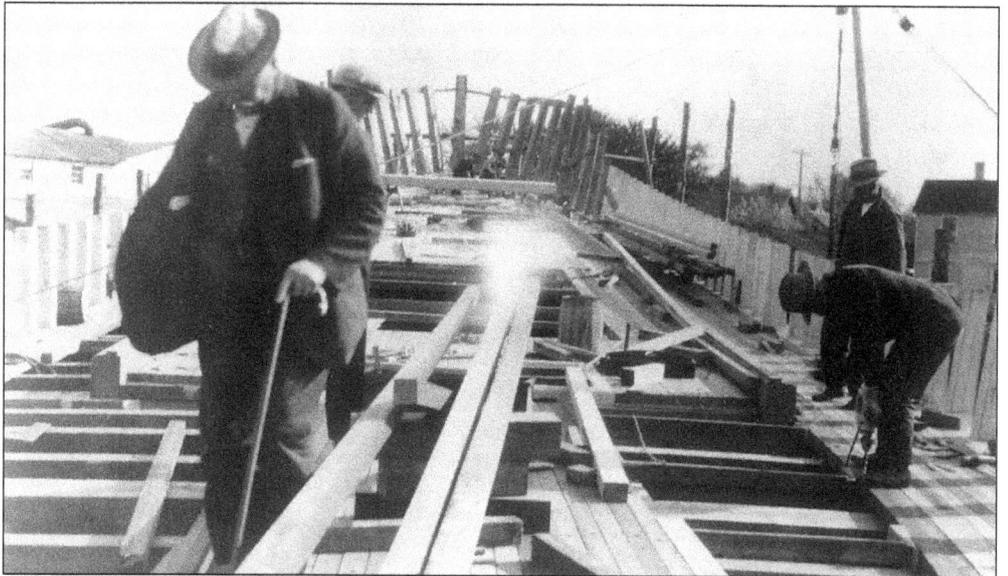

WILLIAM G. ABBOTT, 1864–1930. Mr. Abbott built the *Albert Paul* in 1917, the last sailing ship to be launched on the Mispillion River. He started shipbuilding with his father, James W. Abbott, before his 16th birthday and launched his first ship, *Governor Stockley*, in 1883, before he was 20. He built more than 20 ships from 1886 to 1920. After 1910 he built mostly motorized ships, but the 175-foot *Albert Paul* was his last big effort with wooden ships. This photo of William G. Abbott was taken about 1925 when he was 61.

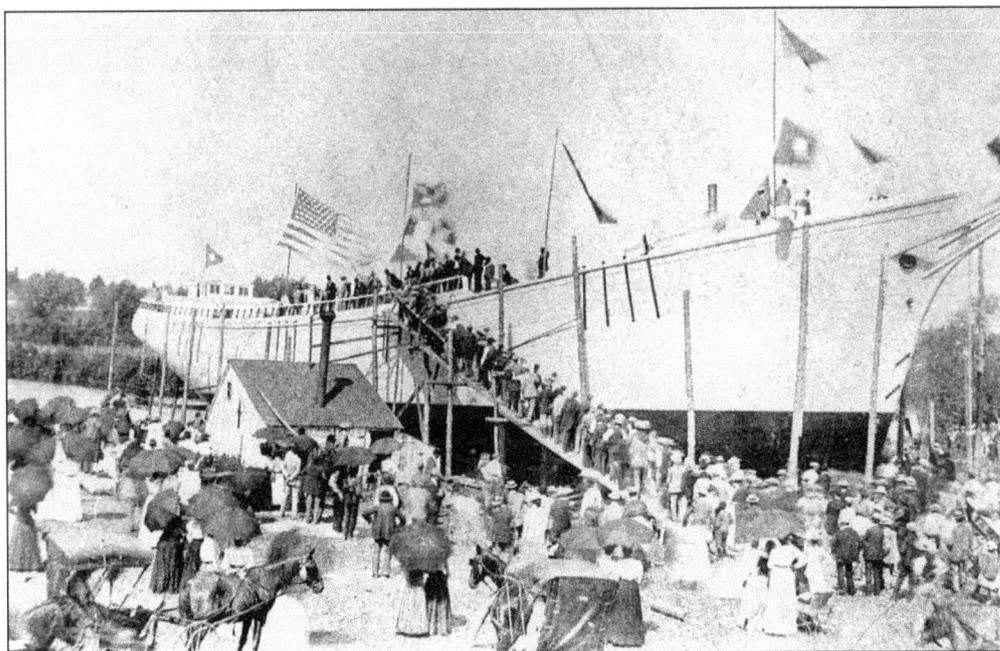

LAUNCHING OF GEORGE MAY, 1900. Capt. John C. Davis contracted the *George May* in 1899. It was the largest sailing vessel to launch on the Mispillion at that date. The ship was 162 feet long with two decks and four masts. The ship sailed in the coastal lumber trade between Florida and Philadelphia. Members of the Johnathan May family and other Philadelphia investors owned her. The ship's worth was estimated at $40,000 when new. She sank in the Bahamas during a storm on October 25, 1911, while carrying iron pipe. It is suspected the iron cargo caused a compass deviation error that may have contributed to her loss in the storm.

MANLOVE R. CARLISLE, 1809–1881. Manlove Carlisle was one of the greatest shipbuilders to live in Milford. He began building ships with William F. Reville at the age of 24. The partners built 29 ships until Reville retired in 1853. Carlisle continued on with a new partnership with his younger brother, Thomas H. Carlisle from 1855 to 1877. The two brothers built 19 ships during their partnership. Carlisle was worth more than $40,000 when he retired in 1877. He lived 12 more years and died in 1881, at the age of 72. He was married to Elizabeth Watson, sister to Bethuel and Curtis Watson, prominent fertilizer and grain dealers in Milford. When Bethuel and his sister died of typhoid fever in 1857, Manlove Carlisle, remarried Ruth Tharp Watson, the widow of Bethuel. He moved to 12 Northwest Front Street and died in the Watson home in 1881. (Courtesy of Catherine Marshall Lamieu.)

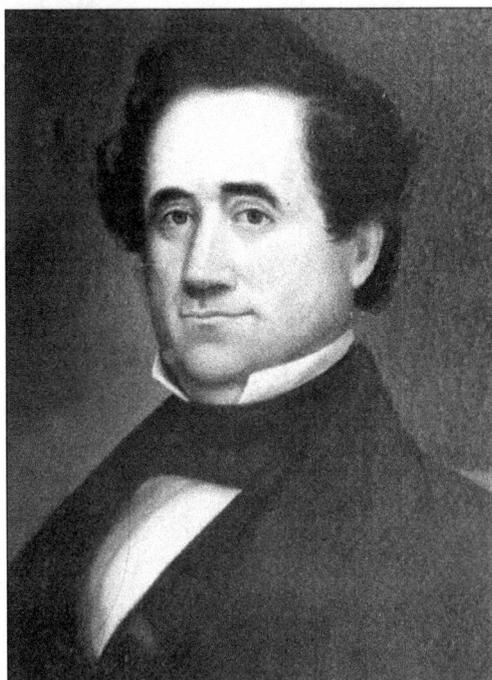

51

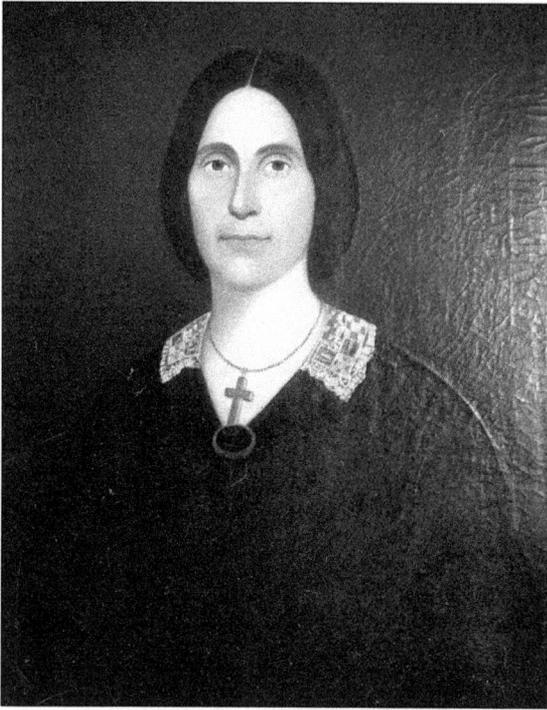

RUTH THARP WATSON CARLISLE, 1828–1907. Ruth Tharp was the eldest daughter of Gov. William Tharp who moved to Milford in 1847 to run for governor. Ruth and her four sisters were raised in the Williams-Tharp-Jewell home at 127–131 Northwest Front Street. She married Bethuel Watson and had a son, William Tharp Watson, who would later become acting governor in 1897. In 1857, after the death of her husband, Bethuel, from typhoid fever, Ruth married the wealthy shipbuilder, Manlove R. Carlisle, who was widowed following December 1857 death of his wife, Elizabeth Watson Carlisle. Ruth lived 26 years after the death of Manlove Carlisle in 1881. She maintained her residence in the Watson/Carlisle home at 12 Northwest Front Street until her death in 1907.

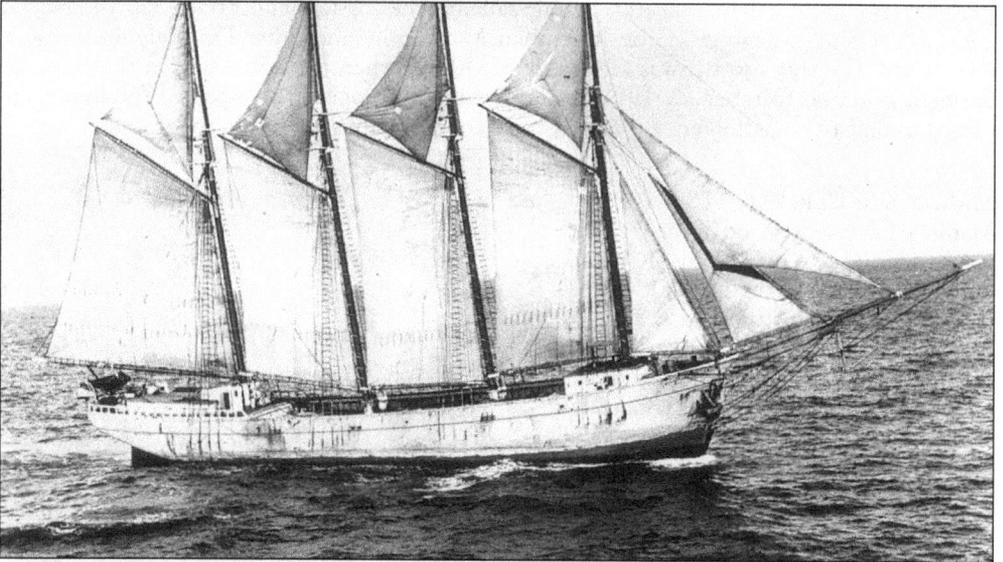

ALBERT F. PAUL. The largest sailing vessel built on the Mispillion, the *Albert Paul*, was launched with great fanfare on August 2, 1917, at Abbott's Shipyard. The four-masted schooner measured 175 feet in length and required 30 days to float down the river during high tides to Delaware Bay. The ship was put to work sailing along the eastern seaboard in the "coal, salt, logwood, and lumber trade." She sailed as far as Brazil, Bermuda, Maine, and the Calicos Islands. She made a total of 99 voyages before the Paul family sold the ship in 1942 for $40,000. On the first trip on March 4, 1942, with new owners the *Albert Paul* was struck by a German torpedo near Turk's Island in the Bahamas. All hands were lost. This photo shows the ship at sea about 1930. (Courtesy of Mariners Museum-Newport News, Virginia.)

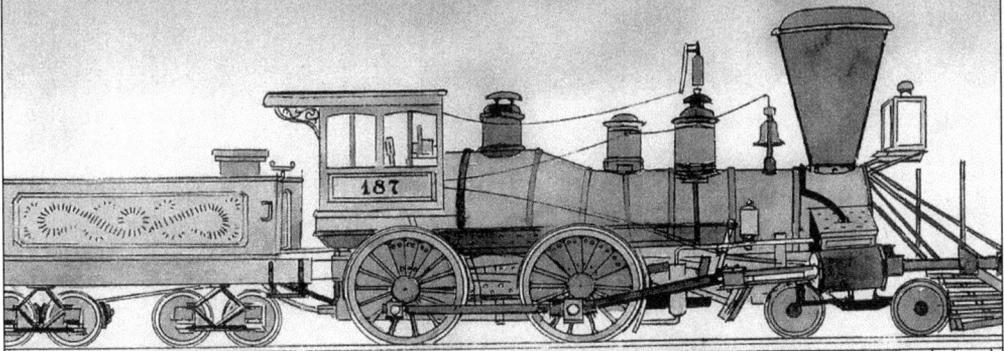

"Tiger" - First Locomotive -1859

"The Tiger" First Locomotive to Milford

"THE TIGER." Milford businessmen fought the first railroad that made its way down the peninsula beginning in 1855. The railroad was forced to locate its tracks west of Rt. 13 and nearly 10 miles west of all river towns including Smyrna, Dover, Frederica, Milford, and Milton. Small towns sprang up around the railroad just as fast as tracks were laid. The towns of Clayton, Cheswold, Viola, Farmington, Harrington, and Greenwood were all built when the railroad came downstate in 1856. After resisting the railroad for two years and enduring a treacherous eight-mile trip to Harrington, Milford businessmen formed the Junction & Breakwater Railroad in 1857 to extend tracks to Milford, Georgetown, Lewes, and Rehoboth. The line opened to Milford on September 7, 1859, with the arrival of "The Tiger." This locomotive served the line until the turn of the century.

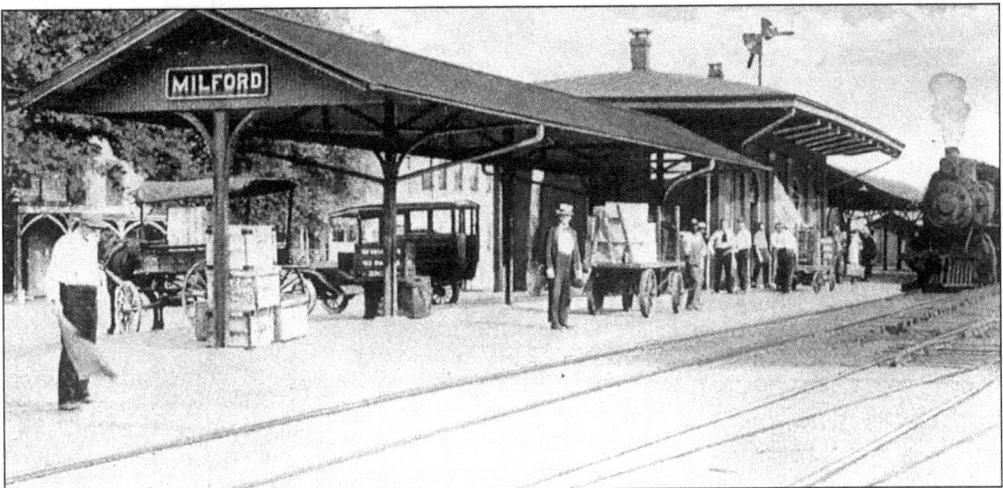

THE RAILROAD DEPOT, C. 1915. The railroad depot was the center of activity for businessmen from 1859 until 1940, when trucking began to carry the bulk of farm produce, coal, and freight to the cities. This scene shows a northbound train in 1915 with hotel hacks lined up to carry passengers to local hotels. From 1890 to 1920 as many as seven trains passed Milford daily.

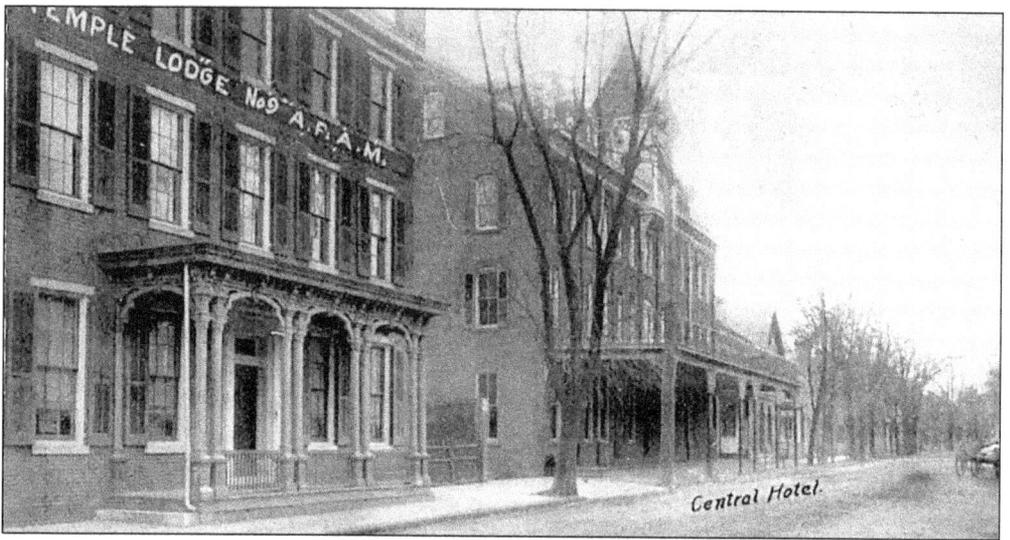

WATSON/CARLISLE HOME AND MASONIC HALL, 1909. Curtis and Bethuel Watson built the homes at 10 and 12 Northwest Front Street in 1855 as their personal residences. After Bethuel's death in 1857, Manlove R. Carlisle and Ruth Tharp Watson Carlisle occupied the home at number 12. In 1907, Ruth Carlisle died and the home was used as the meeting hall for Temple Lodge No. 9, Tall Cedars of Lebanon. The elaborate front porch is gone, but the building still stands today.

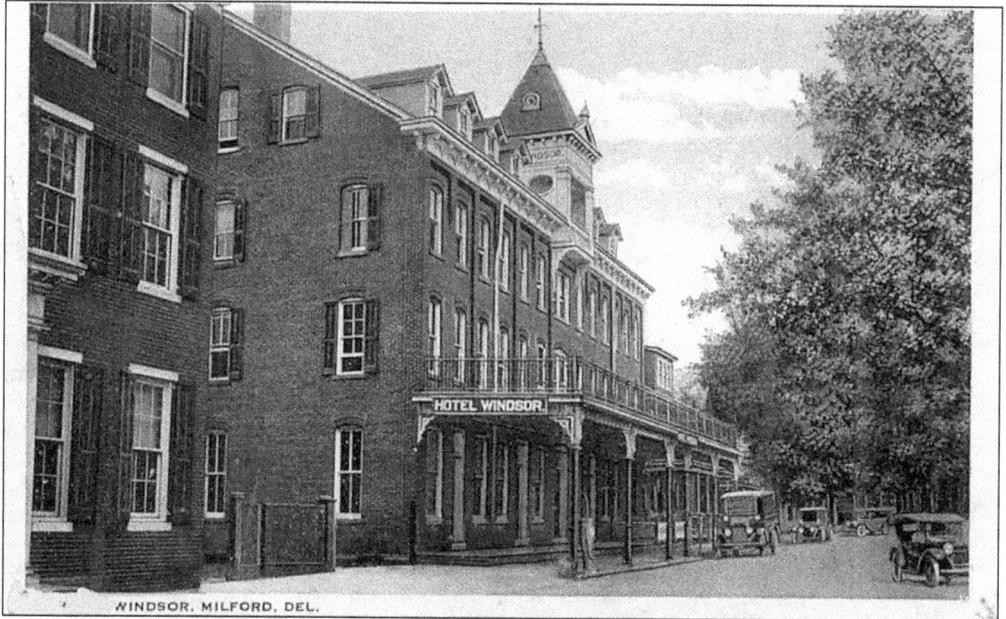

THE HOTEL WINDSOR. The Hotel Windsor was opened in 1912 when Thad Windsor purchased the former Central Hotel after Frank Kramlich sold out in 1908. The original hotel on this site was built in 1811 by Martinus deWaele and later remodeled in 1885 by Kramlich. The "Great Milford Fire" of 1891 started in a stable behind the residence of Ruth Carlisle (home to left) and burned much of the hotel in January 1891. Following the fire, Frank Kramlich rebuilt the hotel using brick and reopened in December 1892 with the most modern hotel downstate.

THE HUMPHREYS HOME–FORK LANDING. The old Humphreys home at Fork Landing is shown in this painting as it appeared in the early part of the 20th century. The home was built around 1828 when Gov. Peter F. Causey purchased the mill at Marshall's Pond and the 100-acre "Fork Farm" located at the confluence of the Mispillion River and Herring Branch (Dike Bridge on Cedar Beach Road). After Governor Causey sold "Mill Creek Mills" in 1850, Thomas J. Humphreys, a native of Reading, Pennsylvania, purchased the home in 1866. Humphreys maintained the wharf and landing behind this home until his death in 1903. His seven children sold the property and it became home to Dubal and Alice deWitt from 1919 to 1941. Dennard Conner, a seafood dealer, purchased the home in 1941 and his family lived here until 1965. Dennard Conner's grandson, John, painted the home as he remembered it.

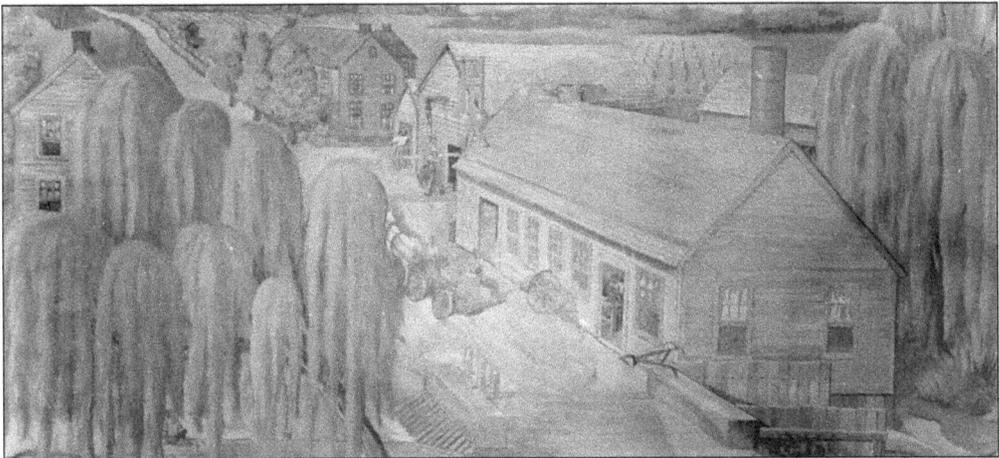

GRIER FOUNDRY–HAVEN LAKE. George Smith Grier immigrated to the States in 1843, and joined a construction crew building railroads in Cuba. He returned to Milford in 1849 to set up a blacksmith shop and iron works foundry on Mill Street at Mullet Run. A fire nearly ruined his fledgling business, but he rebuilt in 1851 at Haven Mills along the original dirt road that crossed the dam site. This painting shows the iron foundry and water wheel on the north side of the dam.

55

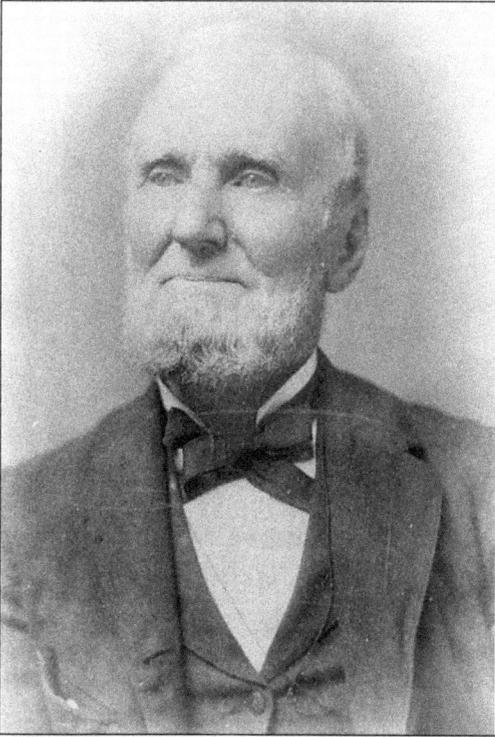

GEORGE S. GRIER (1820–1906), INVENTOR AND FOUNDRYMAN. George Grier epitomized the immigrant spirit in the 19th century as one of millions to land in America with nothing but initiative and perseverance. He saved money to sponsor his wife and family to America in 1851. His skill with machinery enabled him to hold 12 patents for mechanical reapers and fruit drying machines. He raised 10 children with two wives and lived to see two sons found the L.D. Caulk Company in Milford and become famous for their own achievements in dentistry. He was owner of one of the first canneries in Milford in 1870, brought the first steam engine down-state and installed the first ice-making machine in Milford after learning the process during the 1876 Centennial Exhibition. He lived long enough to see the Wright Brothers fly the first motorized airplane in 1903, which was the crowning achievement of the industrial age he helped to launch.

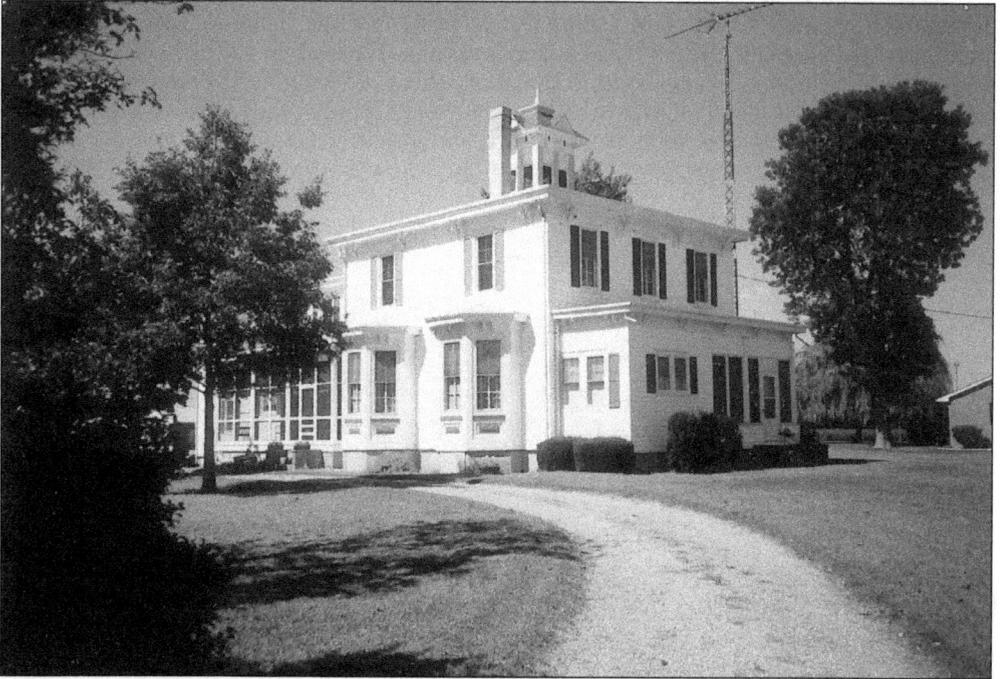

JOHN J. ROOSA FARM, ROOSA ROAD, 2001. John Roosa moved to Milford in 1870 from upstate New York to take advantage of cheap farmland being sold in Delaware. He bought this home, planted a large orchard, and opened a cannery and fruit drying operation on this farm that is still owned by his descendant, Mrs. Jacob Roosa.

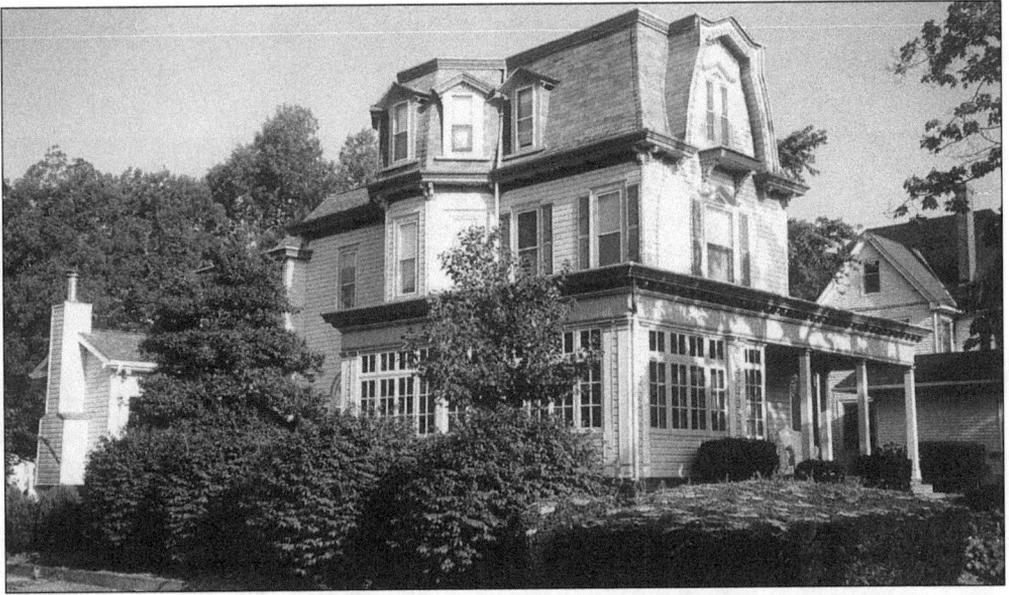

WILLIAM A. HUMES HOME. William Humes built the home at 206 South Walnut Street in 1880 after he moved in 1878 to Milford from Indiana to sell farm implements and hardware. The home is an example of the second empire style of the Victorian era. After the death of William A. Hume, his daughter and her husband, Harry Grier, resided in this home and later, their daughter, Mr. and Mrs. Milton Dill (Sarah Grier). Zelma and Robert Nicklas, who have restored the home to its original appearance, own the home today.

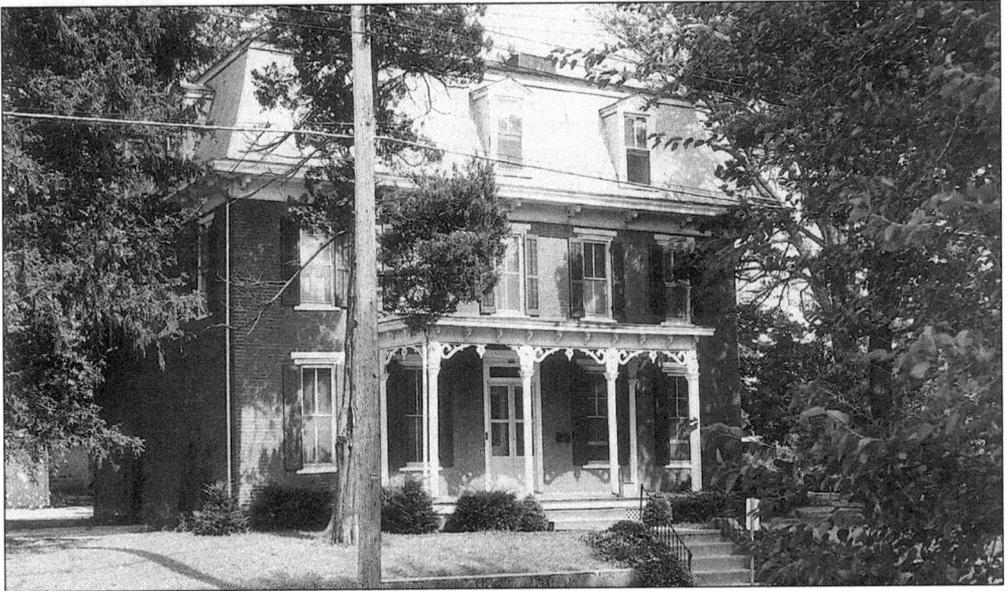

PETER LOFLAND HOME. Peter Lofland was one of four prominent sons of Milford physician Dr. James P. Lofland. His brother, James Rush Lofland, became a noted attorney and served with the Union Army during the Civil War. Mark G. Lofland studied medicine and followed in his father's footsteps after his death in 1851. Peter Lofland became the family entrepreneur. He owned farms, ships, businesses, and all the ground-rent lots in Milford. He built this stately home on North Walnut Street in 1880.

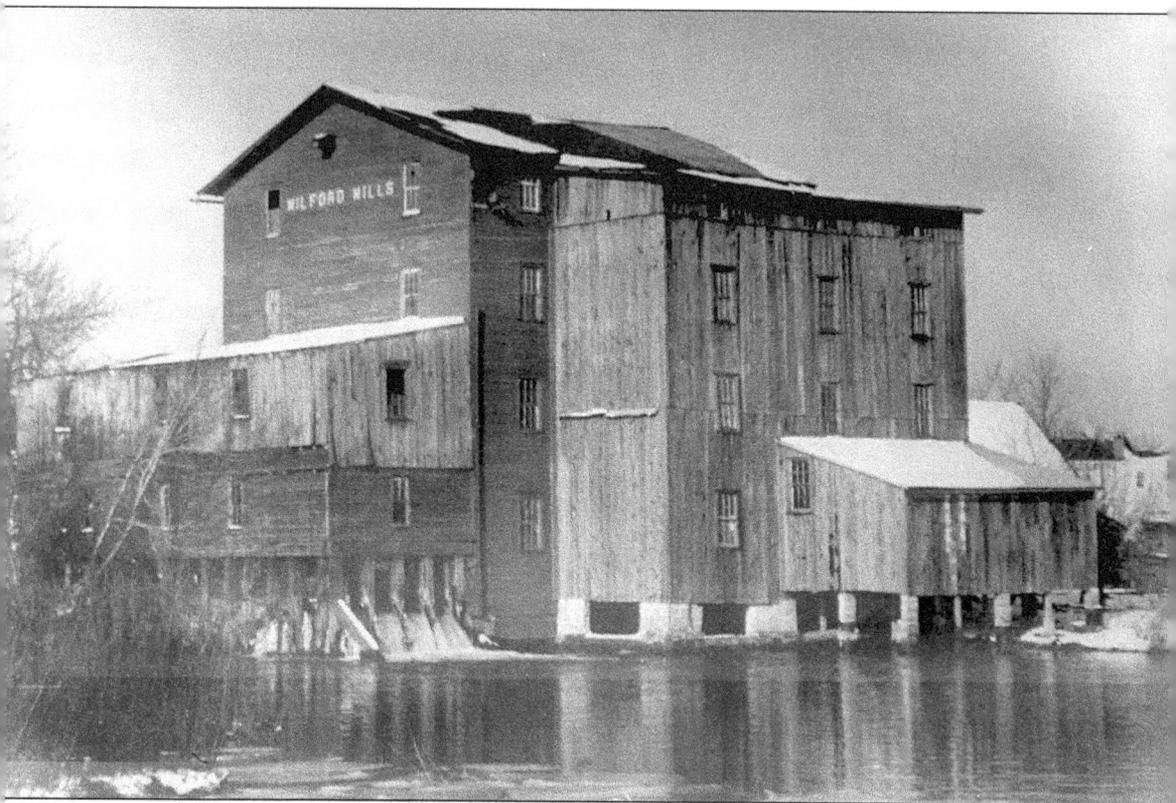

OLD RED MILL, 1875–1945. The old Red Mill was the most prominent landmark in Milford from its construction by Peter F. Causey Jr. in 1875 to its demolition by Hallett Vinyard in 1945. The four-story mill towered over every other building in Milford. It was situated on the site of the original mill built by Parson Sydenham Thorne in 1787. When James Clayton and his partner, Blackiston purchased the mill property in 1808 from Thorne's nephew, Peter Caverly, they built a new mill that functioned until 1845 when the property was sold to John Darby. Darby built another mill on the site, but went broke and sold the property to his brother-in-law, Gov. Peter F. Causey. After Causey's death in 1871, his son, Peter, owned the mill until it was destroyed by fire in 1875. Peter F. Causey Jr. rebuilt the mill as shown in this photograph. Wm. R. Hitchens last operated it from 1921 until 1942 when the mill ceased to operate. Hallett Vinyard dismantled the huge mill in the summer of 1945 to make way for his fuel oil business that required tanks on the site. Mr. Vinyard disposed of many of the large timbers in the foundation to stabilize the ground around the mill foundation. Today the site is part of Milford's greenway trail along the Mispillion River where visitors and hikers can walk from Joseph Oliver's landing at the Walnut Street Bridge (along the wooden bridge-path) behind the oldest section of homes in Milford and continue to the site of Parson Thorne's mill built in 1787.

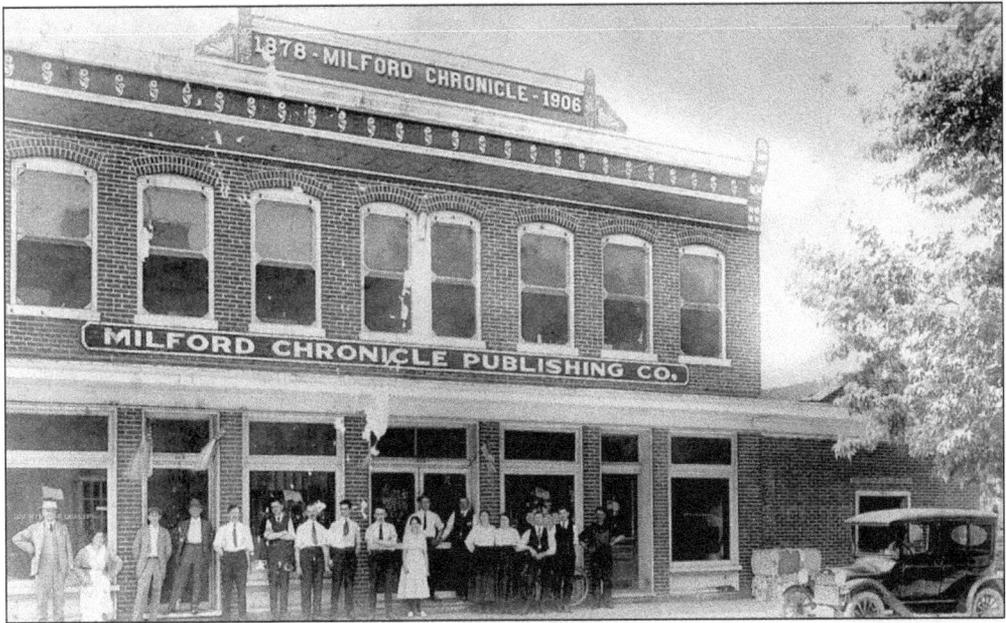

MILFORD CHRONICLE OFFICE. Theodore Townsend and Julius C. Scott founded *The Chronicle* in October 1878. The first office was on the ground floor of the Dorsey Hotel building in South Milford. *The Chronicle* was the first newspaper to rival the *Peninsula News & Advertiser,* the oldest paper in town. This photo shows the new office when it was moved to Southwest Front Street in 1906. In 1880, Julius Scott sold his interest to William P. Corsa. In 1885, R.H. Gilman bought out Mr. Corsa and was a partner until Colonel Townsend purchased his interest in 1886.

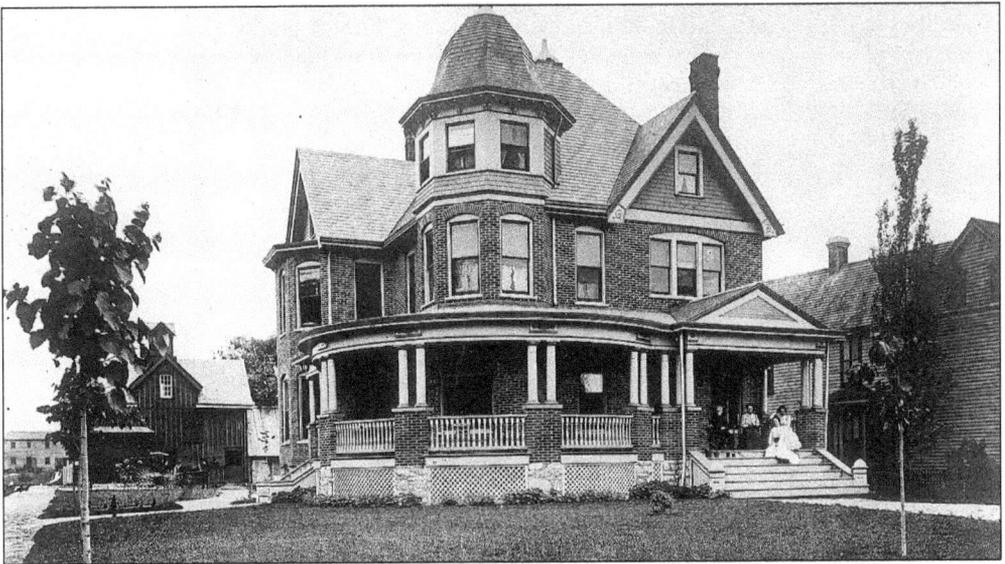

GEORGE H. DRAPER HOME, 100 CAUSEY AVENUE, 1885. George H. Draper moved from Slaughter Neck to Milford in 1885 to start Draper Canning Company in partnership with David Reis, a Baltimore businessman. The brick Victorian mansion built by Mr. Draper has a stone-slate roof and elaborate woodwork throughout the home. After his death in 1935 the home passed to his daughter and her husband, John Truitt and later to a nephew, Tom Draper.

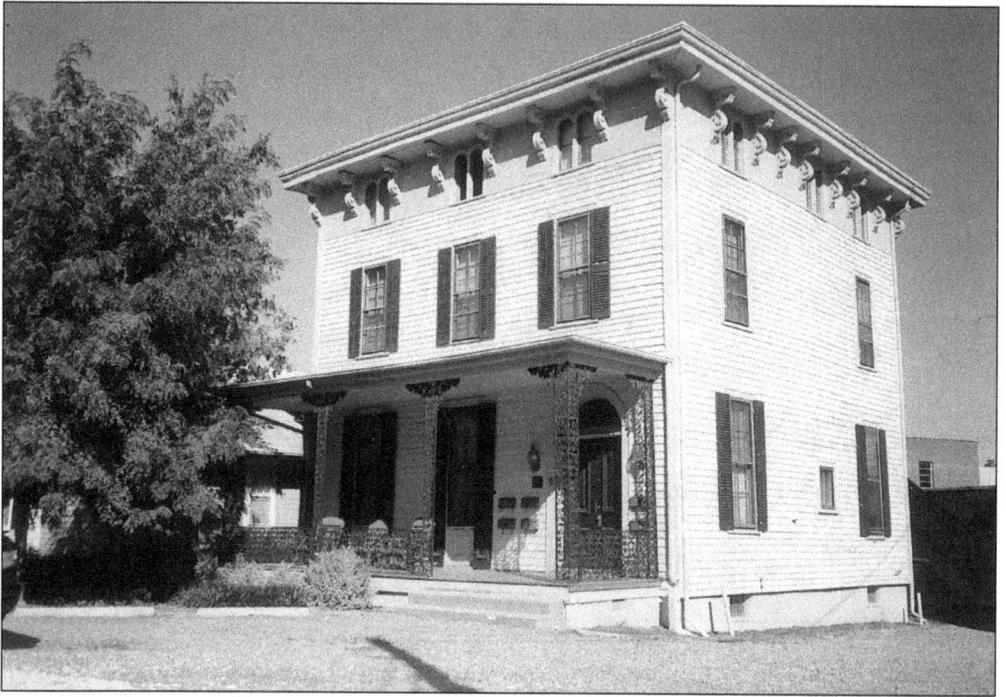

PETER F. CAUSEY JR. HOME. Governor Causey raised three sons and two daughters in Milford prior to his death in 1871. William Frederick Causey made his home in the family mansion while his brother Peter F. Causey Jr. built his Italianate home at the corner of S. Walnut and Causey Avenue, the site of the Palace & Shine theaters from 1922 until the present. When the Palace Theater was constructed in 1922, Peter Causey's home was moved westward, around the corner to its present location on Causey Avenue. His younger brother, John Causey, built a home next door to the west in 1907 and died there. The Peter Causey home later became the Plaza Apartments and it serves in that capacity today.

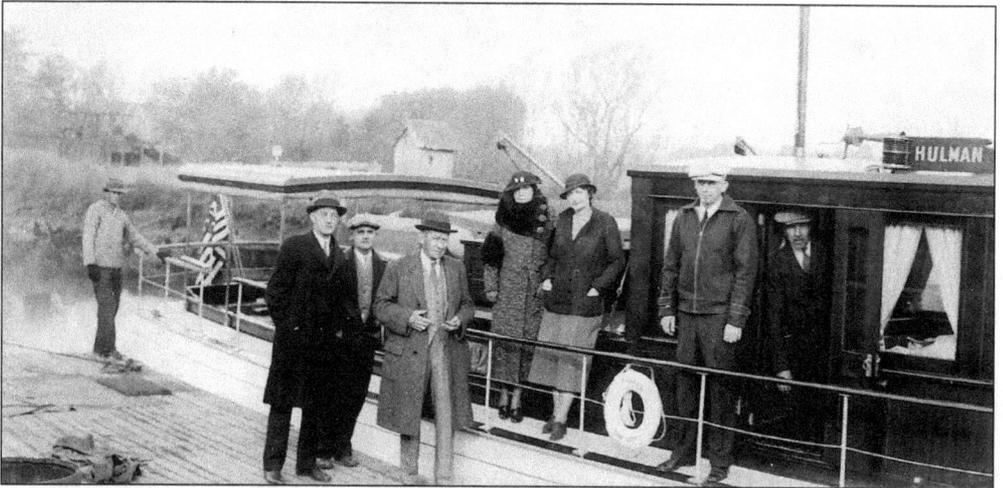

CAPTAIN WILSON M. VINYARD, OCTOBER 30, 1934. Captain Vinyard and his son Wilson S. Vinyard (center) greet Indianapolis industrialist Tony Hulman on his way south to Miami in a Vinyard-built yacht. Hershel Deputy, shown standing along the railing, served as foreman for Vinyard for 30 years. (Courtesy of Hershel Deputy.)

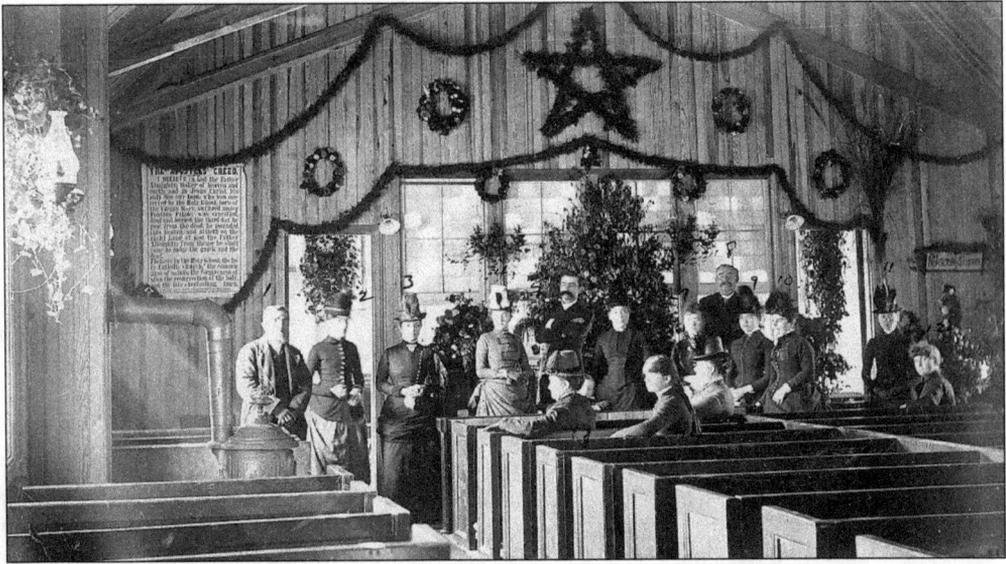

METHODIST CHAPEL, SOUTH MILFORD, 1885. The small wooden chapel located on the southwest corner of South Washington Street and Southeast Second Street was torn down in 1998 after more than a century of use. Contrsucted by Peter F. Causey Jr., who felt the citizens of south Milford needed a place of worship, funded the chapel. Many workers from the shipyards did not feel comfortable attending the elegant Methodist Episcopal church built in 1875 in North Milford. This photo depicts a gathering in 1885, very soon after it was constructed. Standing in the rear from to right are Mr. Easter, Mame Bell Pierce, Ella Warren Dillahay, Anna Aldred, Reverend Willey, Bessie Davis Roosa, Sallie Bell, Peter Causey Jr., Lal Davis, Kitty Bennett, Annie Bell, Maggie Marvel, Mrs. David H. Holland, Mamie Hudson, and Mrs. Peter Causey.

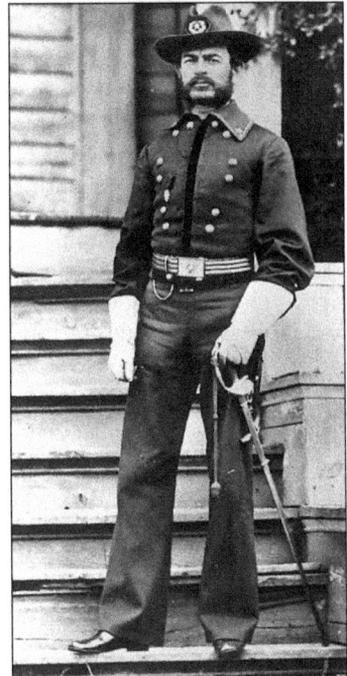

MAJ. GEN. ALFRED TORBERT, FALL 1863. Major General Torbert was the highest-ranking military officer to live in Milford. He served with distinction during the Civil War, leading the New Jersey brigade at the Battle of South Mountain in 1862, again at Fredricksburg, Gettysburg, and eventually serving as general of the Calvary for the Army of the Potomac under Phillip Sheridan, General Grant's handpicked leader. After the War, General Torbert returned to Milford in January 1866 to marry Mary Currey, daughter of Daniel and Mary Currey. He used his friendship with President U.S. Grant to gain an appointment as Consul to El Salvador, Havana, and eventually Paris. In August of 1880 he sailed to Mexico on the *City of Vera Cruz*, a passenger steamer. The ship steamed headlong into a hurricane that tossed the ship for five days along the Atlantic seaboard before sinking off Cape Canaveral. Torbert washed up on shore on August 31, 1880, and died the same day. His funeral was the grandest spectacle ever witnessed by Milfordians. Mary Currey never remarried and remained inconsolable as a widow until her death in 1895.

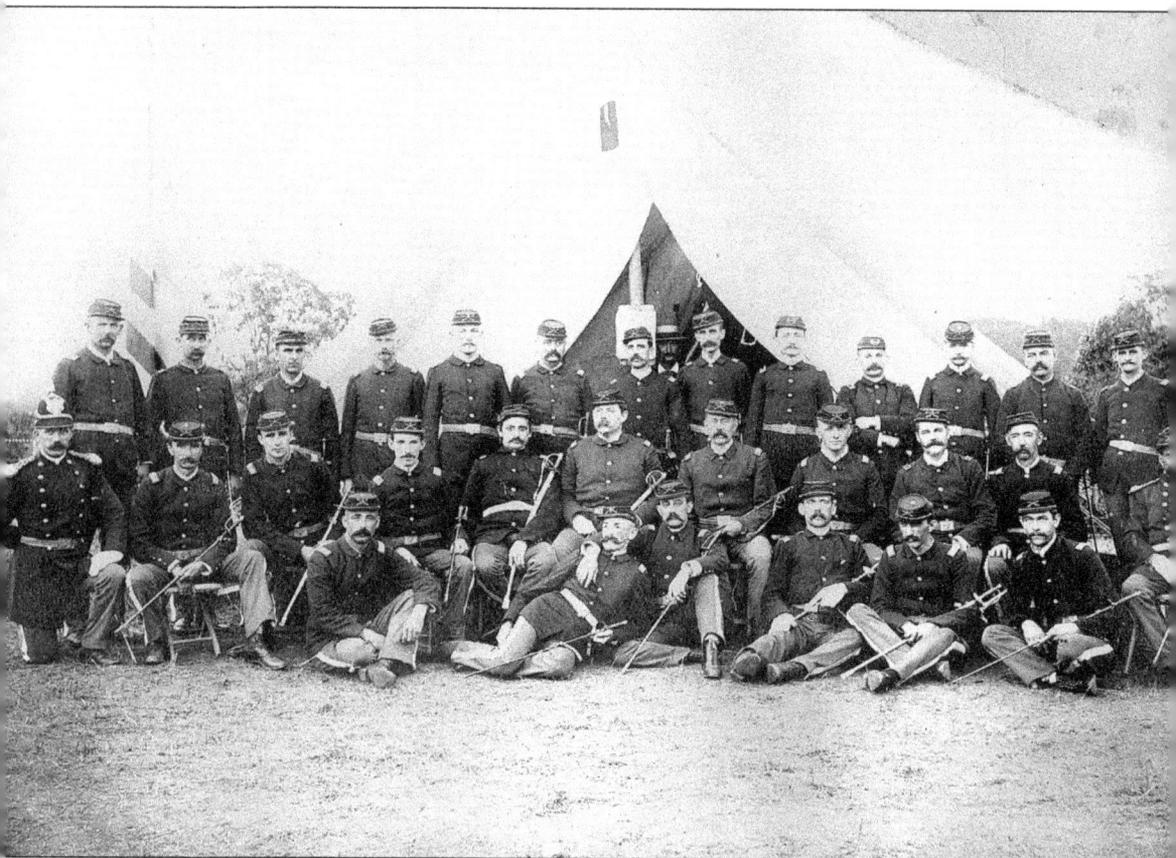

THE TORBERT GUARDS, 1880. Dr. George W. Marshall organized Milford's first militia in August 1880, to serve in the funeral procession for Gen. Alfred Torbert. This group later became the nucleus for Company "B" of the Delaware Volunteers (National Guard) that served in the Spanish American War in 1898, in Deming, New Mexico chasing Poncho Villa in 1916, and later in France when the unit was federalized in 1918 during World War I. Company B finally was integrated into the 261st Coast Artillery Regiment and activated again in January 1941, for service at Fort Saulsbury during World War II.

In this photo, Major George W. Marshall is shown in the center of the second row. He was elected by his men to serve as their commander. His successor was Col. Theodore Townsend shown seated in the second row, second from left (sword in lap). Other prominent Milford boys in this photo are George B. Hynson (author of "Our Delaware"), Peter L. Lofland, John, Alex, and Jacob Roosa (fruit dryers), Dr. James S. Stanton, Wilbur, and Arthur and Herb Jump.

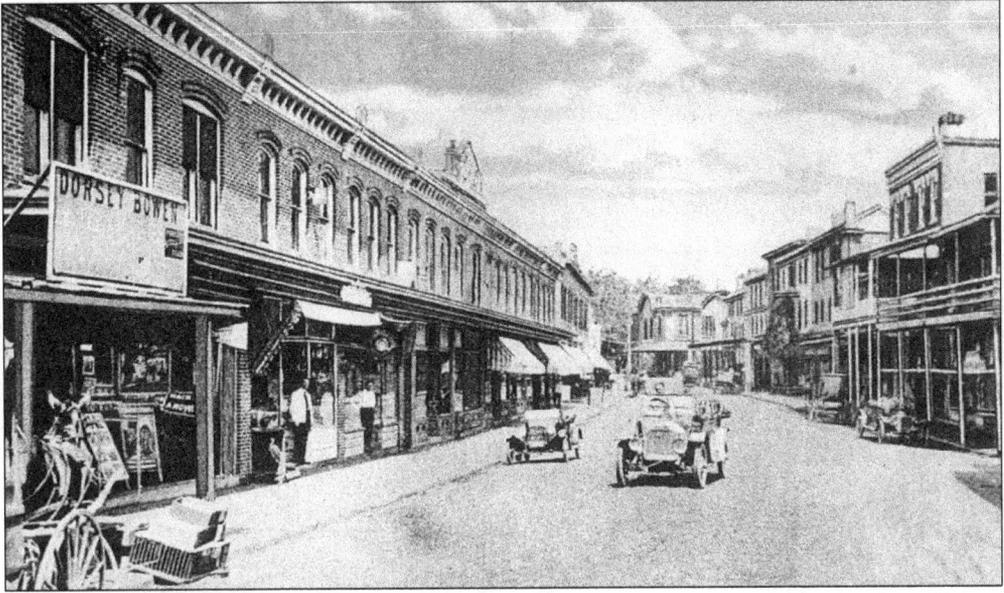

THE JUMP BLOCK, 1910. John W. Jump purchased the majority of the west side of N. Walnut Street in October 1865, and began improving the early wood-framed stores that were built between 1800 and the Civil War. He was born in 1831 near Williamsville and moved to Milford in 1841 to begin his mercantile career. This line of stores included Dorsey Bowen's grocery, Will Warren's movie theater, The American Store and Miss Stidham's hat shop. The block was finally razed in 1995. John W. Jump died in July 1904. His widow, Lydia Chase Jump, continued managing his business interests until her death on April 30, 1927.

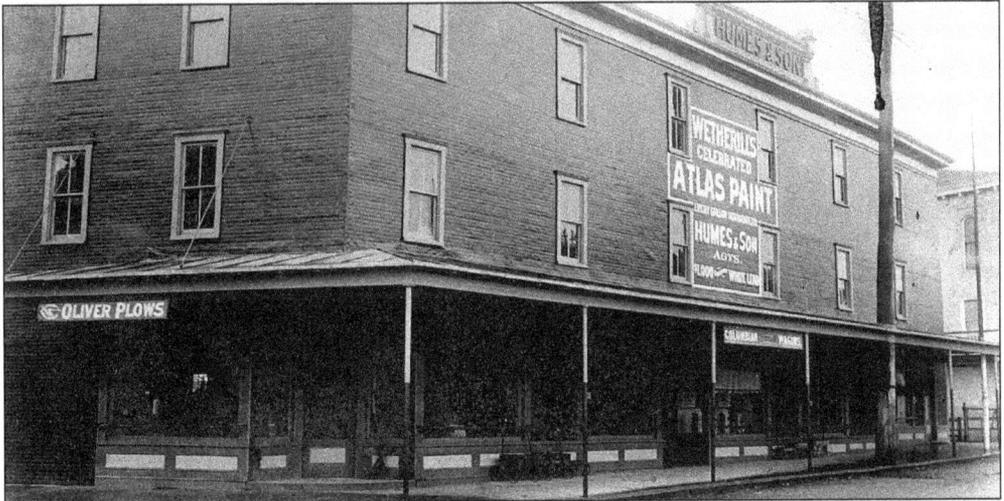

HUMES HARDWARE STORE. The corner of North Walnut Street and Water Street has been the home of Humes Hardware since William A. Humes moved to Milford to open a farm implement and hardware store in 1878. The three-story frame building has been a fixture in Milford for more than 120 years. This photo was taken in 1910. Three generations of the Humes family owned and managed this business. Harry Humes assumed control about 1920 and his sons, Al and James Humes, carried on the tradition into the 1960s. Paul Cosden modernized the building during his 20-year ownership from 1965 to 1985. The building burned in the mid-1930s and was replaced by the structure that still stands today

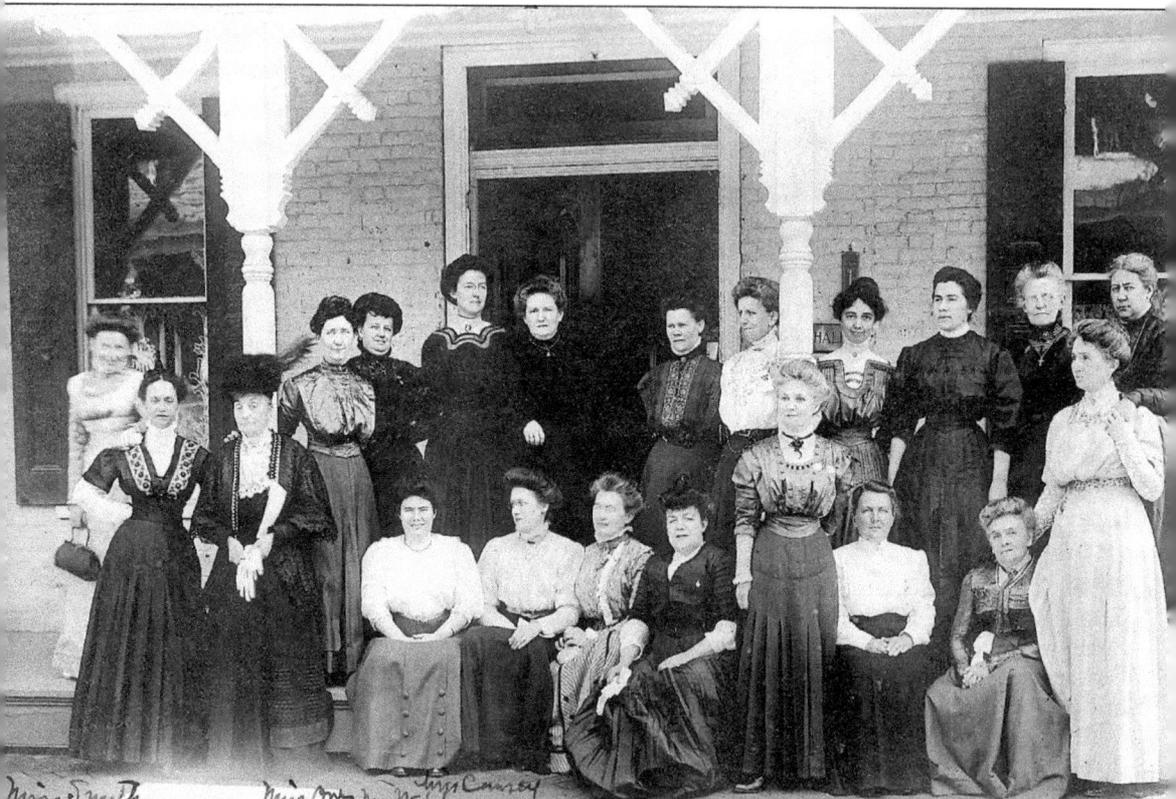

Miss Smith. Miss Ort. Mrs Walsh Miss Causey Mrs Chas Wagher Mrs W. B. Megaw Miss Ida Draper Mrs Paul Short
Mrs Sheldrake Miss Hall Miss Theo. Dale Mrs Ann Owens Mrs Leiflin Mrs Chas Sorlle Mrs Rin
Mrs Fooks Mrs Zula Roe Mrs C. C. Fulton Mrs Watson Mrs M. L. M
Mrs Robinson

112 N.W. Front St. Milford, Del. 1904–1905

MARSHALL HOUSE GATHERING. This photo provides a rare look at the women who directed Milford's stratified society at the turn of the 20th century. Mrs. Mary Louise Marshall (front row, far right) was the wife of Dr. George W. Marshall and inspiration behind the founding of the Milford Emergency Hospital in 1907. This gathering was held at Mrs. Marshall's home at 112 Northwest Front Street in 1904. Her sons, Dr. William Marshall II and Dr. S.M.D Marshall made her dream for a Milford Hospital a reality with the opening of the Emergency Hospital in 1913 after years of planning and effort.

64

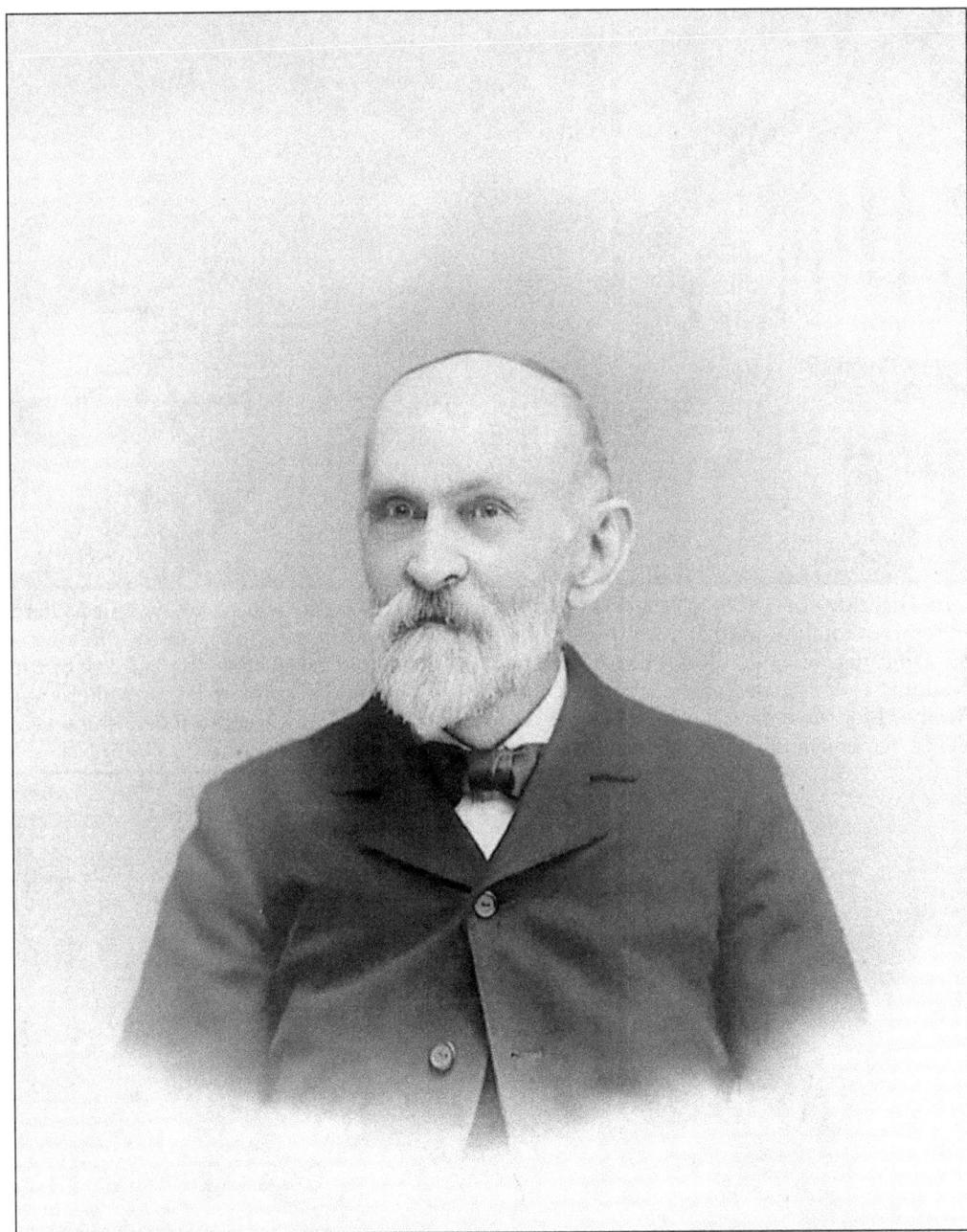

SOLOMON MATTHEWS 1890. Matthews was one of the early rugged individualists born during the Industrial Revolution. He was born in 1826 near New Bedford, Massachusetts, and struck out for the gold fields in 1850. He returned to New Bedford in 1853 and met Isabela, daughter of James and Emeline Brown, a tinsmith who had recently moved to Milford, Delaware. By 1858, Solomon had married 18 year-old Isabela and moved to Milford with the Brown family to work in the tin-can manufacturing business at 33 N. Walnut Street. He started in the foundry business in 1870, but the original building burned and he rebuilt with the help of Cornelius J. Hall in 1873. He raised five sons to become machinists and ironworkers before his death in 1899. He took his own life in the foundry he built at the age of 72.

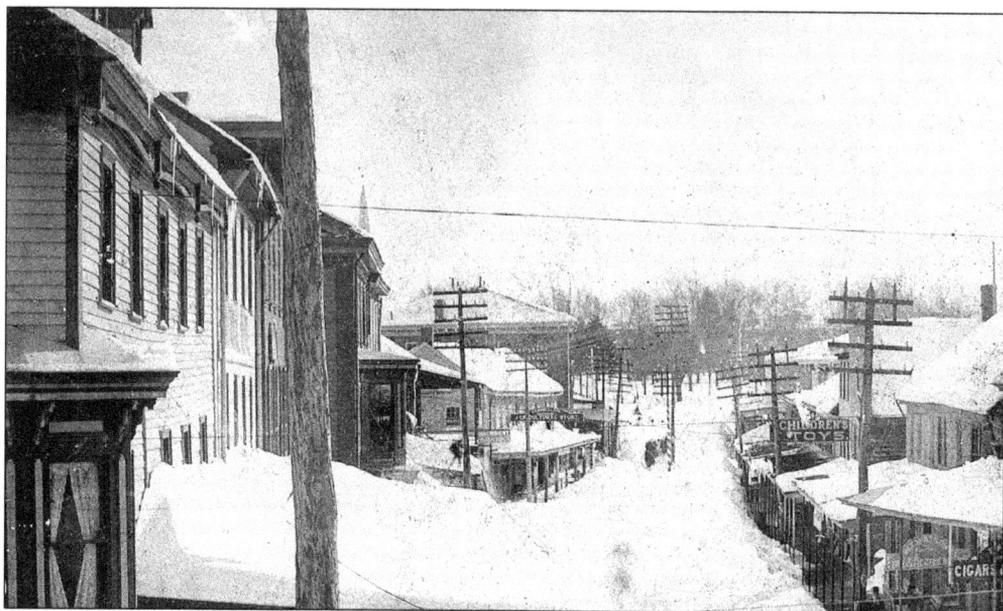

THE BLIZZARD OF 1888 NORTH WALNUT STREET. The worst snowstorm to ever hit Milford in terms of total snowfall and wind-swept drifts occurred in February 1888, the year following electrification of Milford's downtown streets. This photo was taken from the balcony of the National Hotel located at the southeast corner of Walnut and Northwest Front. Milford was paralyzed for three days, digging out from 24 inches of snow. Trains were stranded, ships were blown aground, and rural residents were unable to travel for over a week.

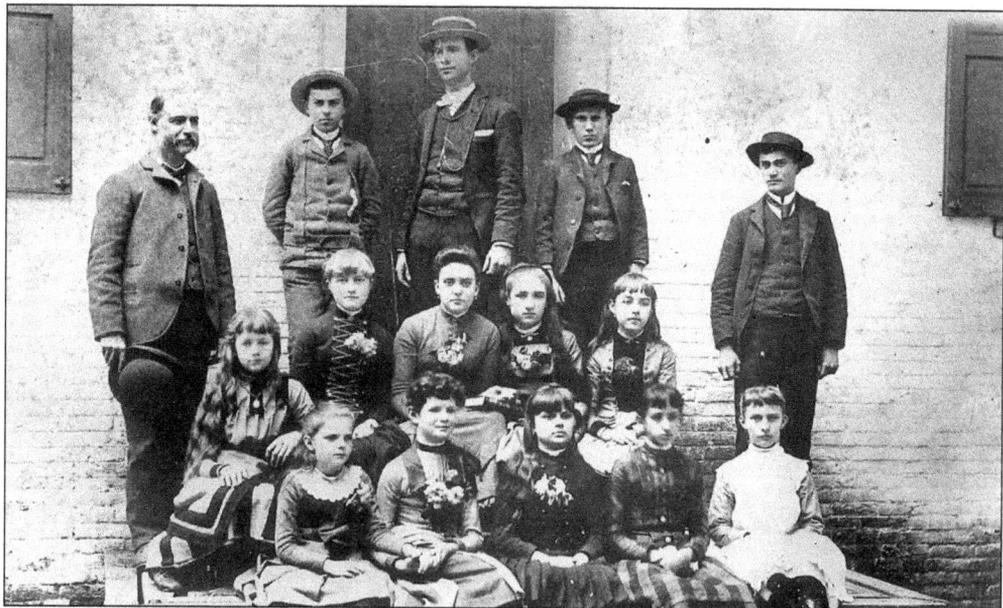

CLASS OF STUDENTS AT OLD ACADEMY, C. 1880. Prior to school consolidation in 1904, many students attended group classes with various grades in the same room. The Old Academy was a brick structure that served North Milford scholars from 1800 until 1930, when the new high school was built on Lakeview Avenue. The brick structure shown in this photo was located behind the larger school built in 1904.

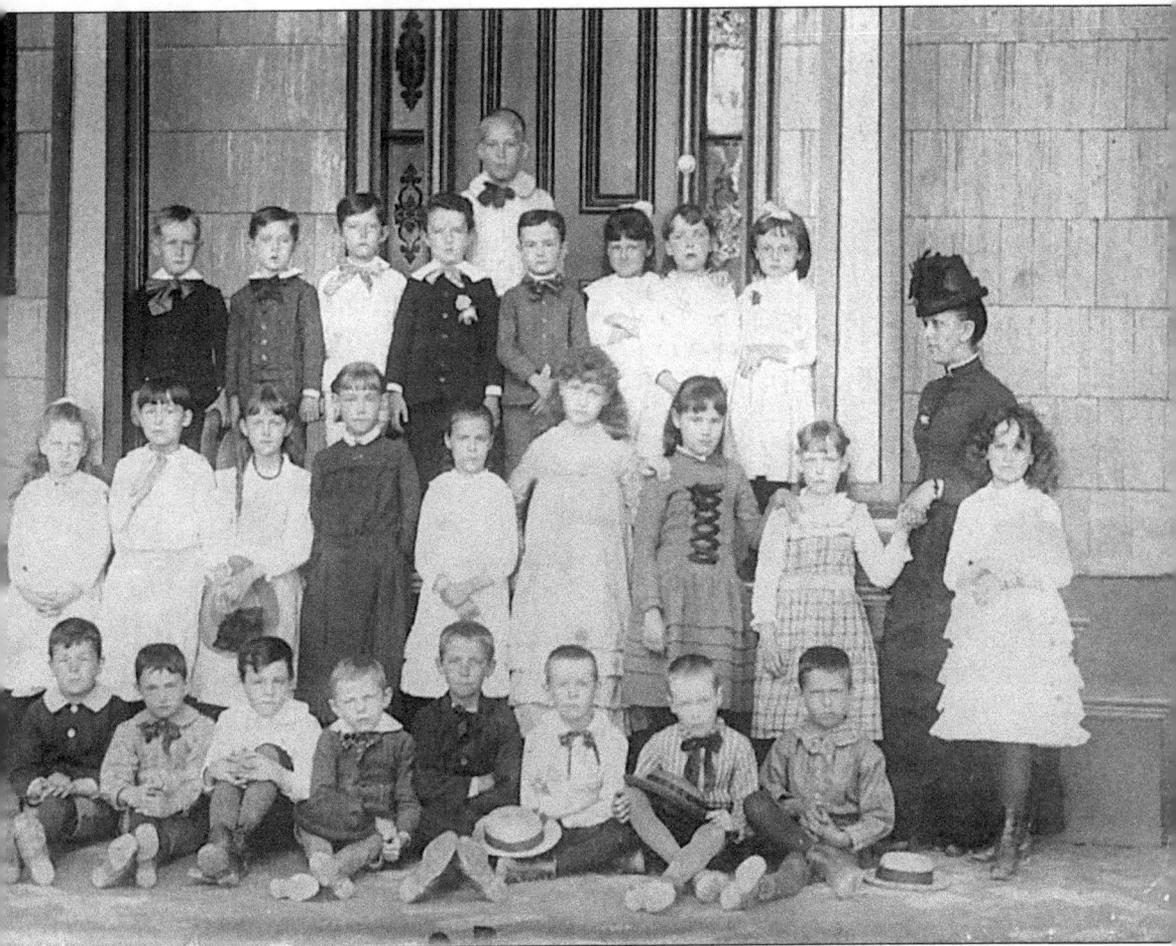

SOUTH MILFORD SCHOOL, 1885. The South Milford school was located on Southeast Front Street at the northeast corner of South Washington Street in the old Joseph Oliver home, which was moved to the site in 1855 when Curtis and Bethuel Watson built brick homes at No. 10 and No. 12 Northwest Front Street. This is a mixed class photo taken in front of the Scribener home directly across the street from the school. Mrs. Ella Titus, teacher, is shown at the far right. In the front row seated, from left to right, are William Pullen, Donnell Marshall, William Sipple, Joseph Watson, and Chas. Cuykendahl, Edward Casuey, and Arthur Titus. Standing in second row are Virginia Yardley, Elizabeth Gilmore, Mildred Causey, Katie Cuykendahl, Mabel Thompson, Todd Vaules, Bess Draper, Elizabeth Williams, and May Vaules. Standing in rear are Will Foulk, Harry Latchum, Hall Anderson, John Holland, Harry Kern, Mabel Brown, WinnieBelle Goslin, and Elizabeth Rickards.

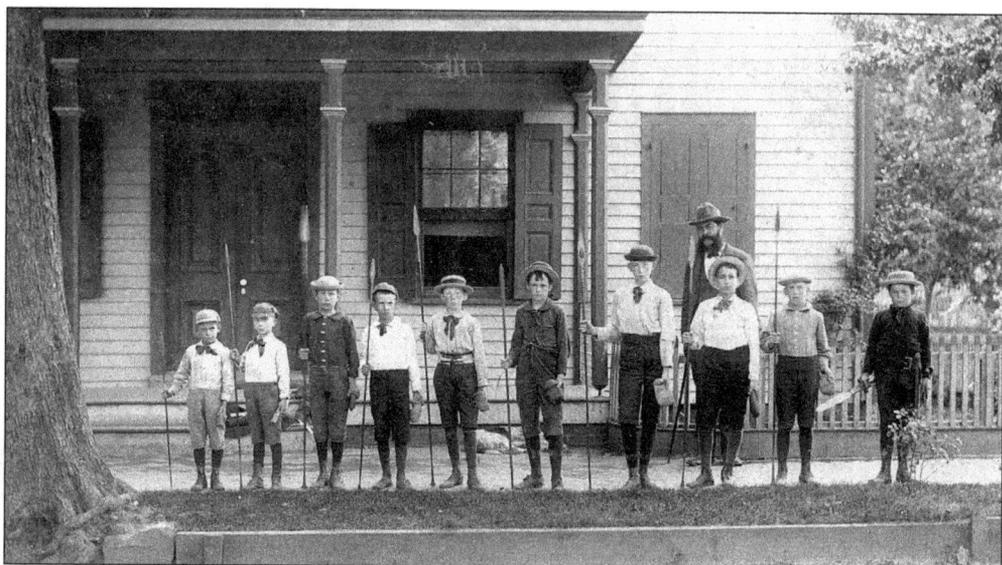

ARCHAEOLOGICAL SOCIETY, 1889. Dr. John G. Dawson, instructor, leads his young charges from his home at 200 Southeast Front Street on the corner of Montgomery Street. From left to right are Harry Thaw, Hiram Truitt, Oscar Wilson, Rogers Thaw, George Truitt, Will Sherwood, John Truitt, Causey Williams, Lewis Pratt, and Will Pullen. The house was razed in 1997.

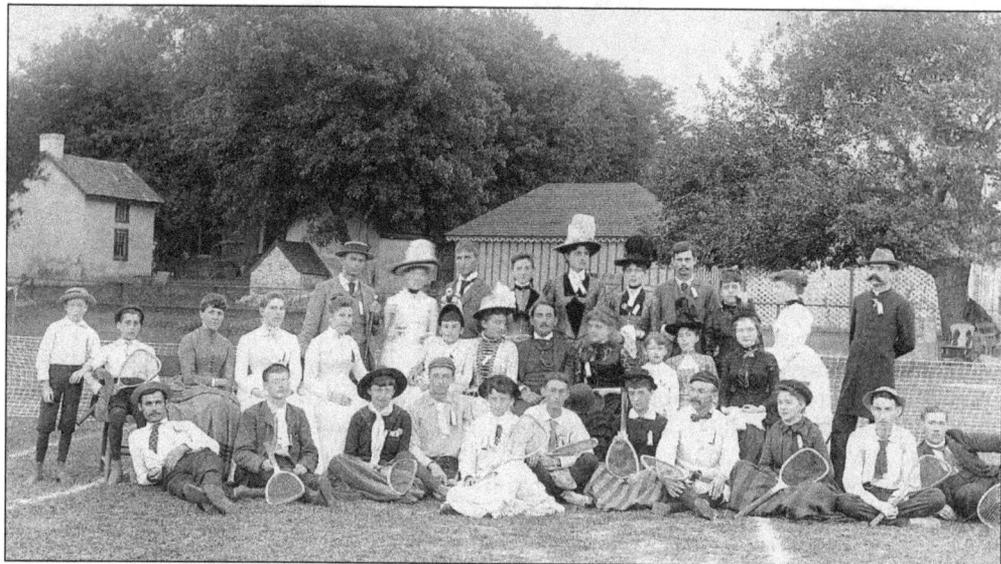

CAUSEY LAWN TENNIS PARTY, 1885. Before the invention of telephones, moving pictures, and automobiles, young people gathered at homes to socialize. The home of William F. Causey, son of the governor, was graced with a side lawn suitable for tennis matches. In this photo many of Milford's prominent youth are shown at a tennis court located west of the Causey Mansion slave quarter, visible in the background. This lot was later given to Dr. Newell Washburn and his wife (Vinyard) who made their home at Six Causey Avenue. From left to right are (front row) Than Davis, Virgina Gilman, Foster Causey, John Adkins, and Trusten Causey; (second row) Mary Hall, Irma Hall, Leene Shay, and Lizzie Williams; (back row) Robert Davis, Lillie Causey, May Davis, Sallie Marlatt, Grace Rickards, Verdi Causey, and Reverend Willey.

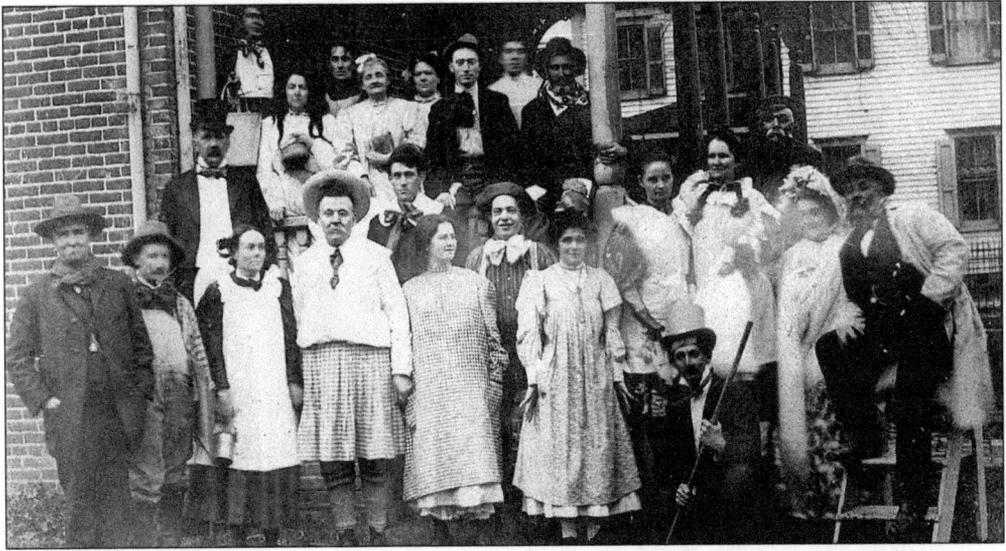

PRESBYTERIAN THESPIANS 1880. Mr. Charles Barker moved to Milford in 1870 to engage in canning and fruit drying. He was a native of upstate New York, where many enterprising Milford businessmen originated after the Civil War. He bought the brick house at 219 South Walnut (People's Place office) and became involved in theatrical events with the Presbyterian Church. The play was entitled *District School.* Adults dressed as children for this event. From right to left are (top row) Ray Shockley, Nan Evans, Mrs. Carmean, Mrs. Daniels, Tom Reed, and ? Holcombe; (bottom row) Colonel Townsend, Chas. Holzmueller, Cora Pivans, Tom Pierce, Jacob Roosa, Irma Reed, C.D. Abbott, Clara Humes, Jay Foulk, Mrs. Fisher Pierce, Mrs. Pitcher, Mrs. Stanley Short, and Fisher Pierce.

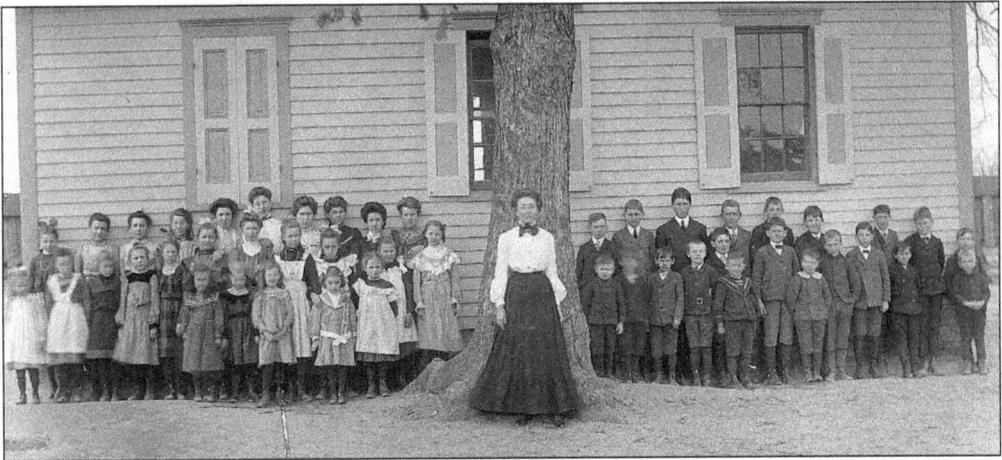

SHAWNEE SCHOOL, 1897. The wood-frame, one-room schoolhouse was the standard for children raised outside town limits. The legislature appropriated funds in 1880 to build these schools in rural neighborhoods. The Shawnee School was located on the west side of Route 36 (Greenwood Road), just east of the junction with Abbott's Mill Road (CR-620). Grace Griffith was the teacher; girls were separated from boys for most activities. This schoolhouse was moved to the rear of Milford High School in 1930 and served as the band activity room until 1960. Shown in the photo are children born between 1888 and 1893. Most lived within walking distance of the school in the area known as "Shawnee." Pearl Griffith (Watson), Clarence Calhoun, Ida Calhoun (Warren), and Zena Johnson (Vibbert) are seen in this photo.

69

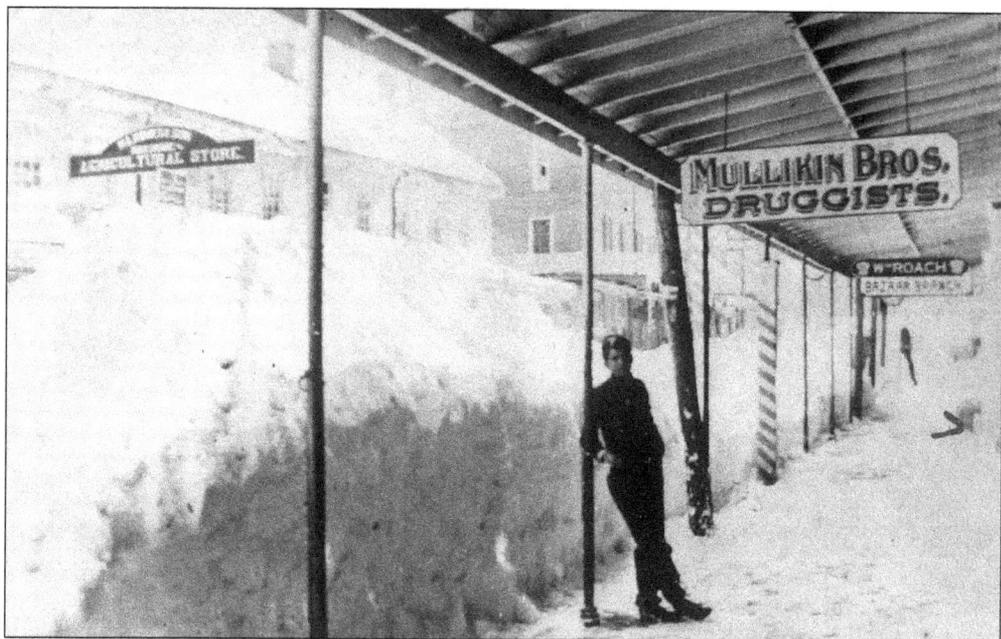

BLIZZARD OF 1888 NORTH WALNUT STREET. The blizzard dropped about 24 inches of snow on Milford over the course of 18 hours. Merchants shoveled snow onto Main Street to permit customers to shop at their stores under canopy. Main Street was impassable for over a week and tunnels were dug to allow towns people to cross Main Street.

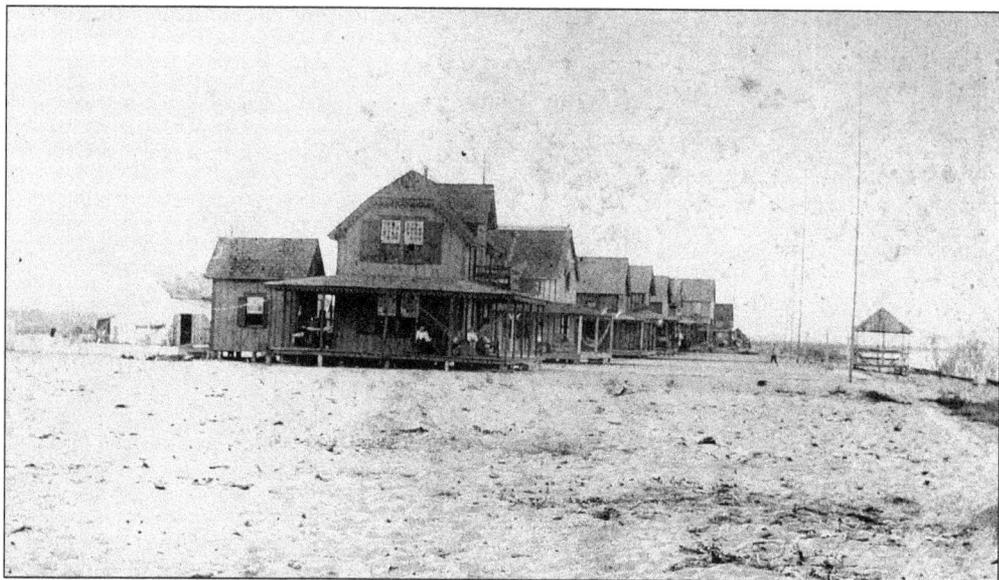

ORIGINAL SEVEN COTTAGES—SLAUGHTER BEACH. Slaughter Beach was founded as a residential community on August 17, 1885, when Frank Rickards and S.N. Gray leased a lot for 99 years from George Male, owner of the hotel, and built the first frame cottage just north of the present fire hall. Dr. George W. Marshall leased the second lot three days later and built his cottage on the site of the firehouse truck bay. Charles Barker and David H. Holland followed with cottages in 1886 and 1887. By 1890 the first seven homes were completed and prominent Milford families began spending summers on Delaware Bay at Slaughter Beach.

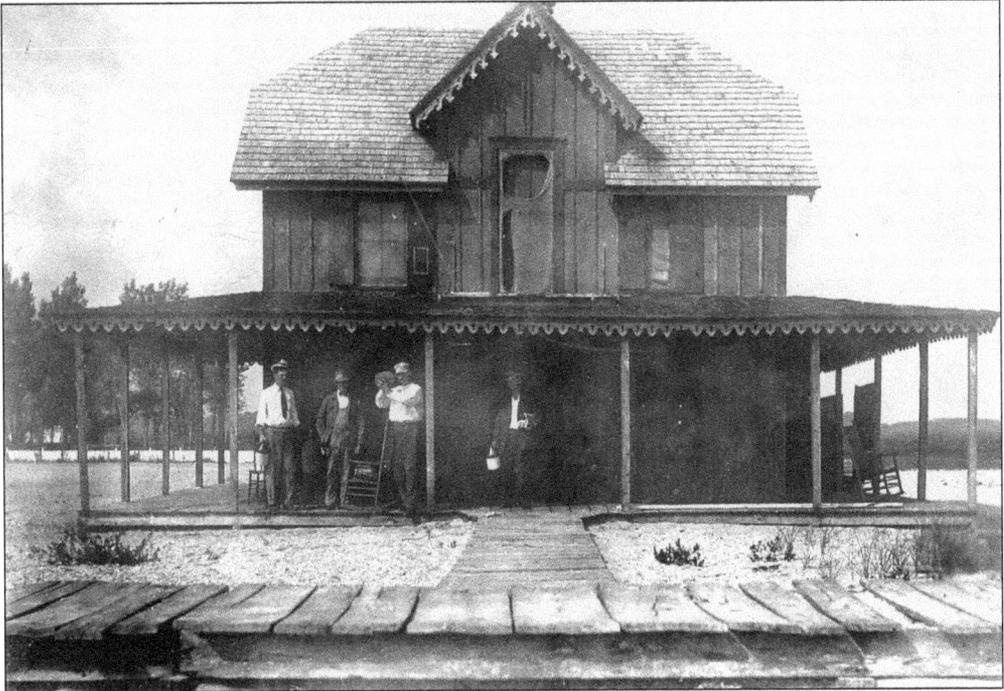

Dr. George W. Marshall Cottage. The second cottage built at Slaughter Beach was situated in front of the old hotel and on the bay front. Dr. Marshall died in 1915 and this cottage was sold to Dr. Joshua Ellegood who vacationed here until his death. This cottage was torn down in 1972 to allow for an expansion of the firehall to accommodate a new truck bay.

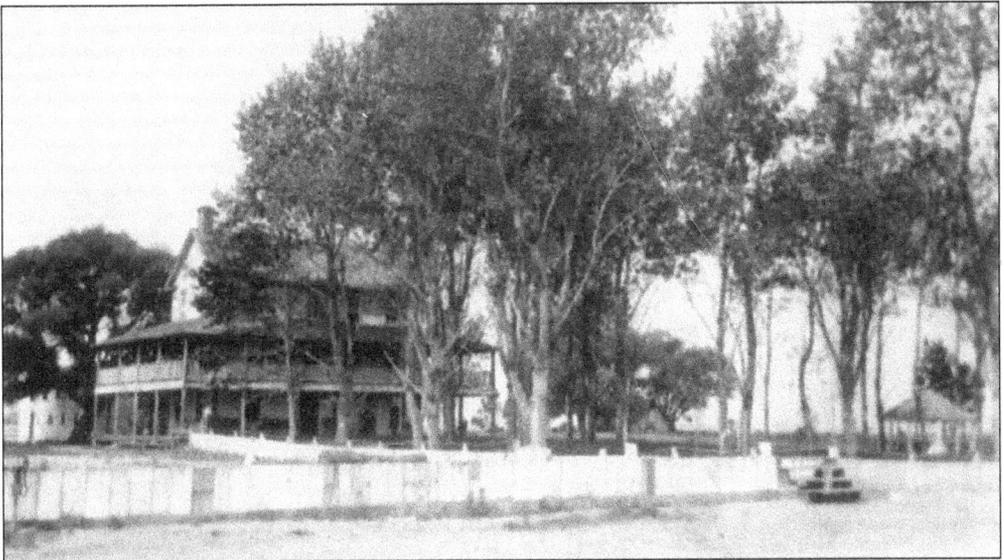

Slaughter Beach Hotel. Joseph Morgan, the farmer who owned the land on which Slaughter Beach was built, constructed the old hotel in 1868. Morgan died in 1871 and sold the hotel property to Charles Todd who sold it to George Male in 1876. Male owned the property when the first 99-year leases were granted in August 1885. The hotel was a gathering place for waterfowl hunters in winter and fishermen in summer.

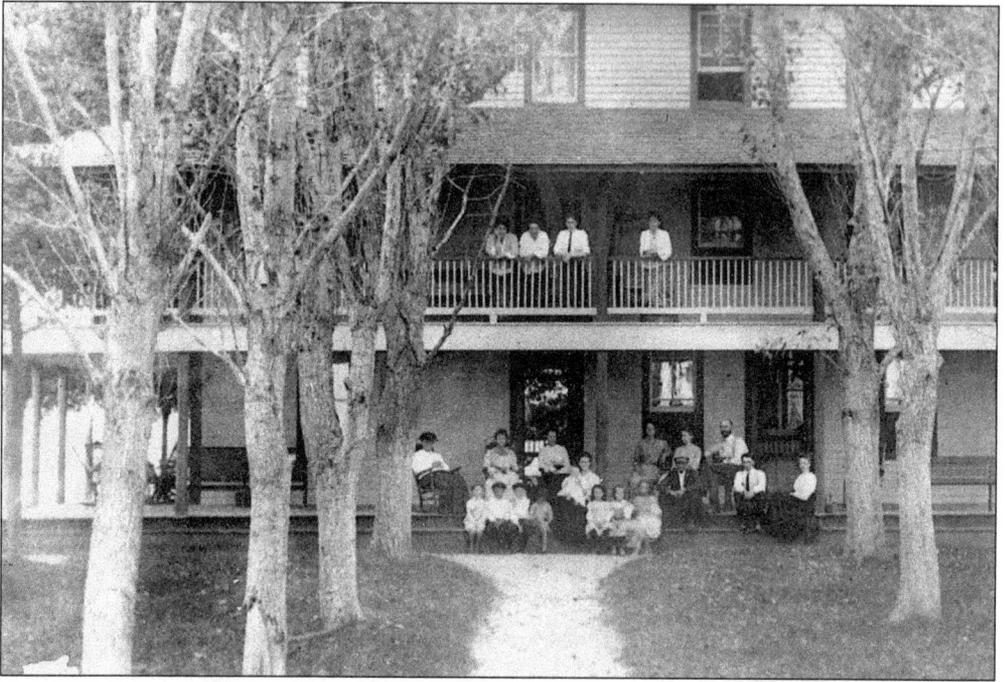

SLAUGHTER BEACH HOTEL. This 1905 photo provides a close-up view of patrons on the ground floor and second floor of the hotel. The front walkway was lined with "Silver Maple" trees common to Slaughter Beach. These trees had leaves that turned backward during windstorms that made storms at the beach appear more fearsome.

THE OLD STAND PIPE TOWER. Milford developed its public water system following a devastating fire in January 1891 that nearly burned the entire town. The fire started in the stable-loft behind Ruth Tharp Watson Carlisle's home at No. 12 Northwest Front Street. It burned the Central Hotel (later called The Windsor) and all buildings along both sides of North Walnut Street. The fire company was forced to fight the fire with a bucket brigade from the Mispillion River. After this scare, town council voted to install a public water system with its main water well located between Pearl Alley and South Washington Street. This photo taken in 1910 shows the early "stand pipe" that provided pressure for a public water supply. The modern city water tower occupies this site today.

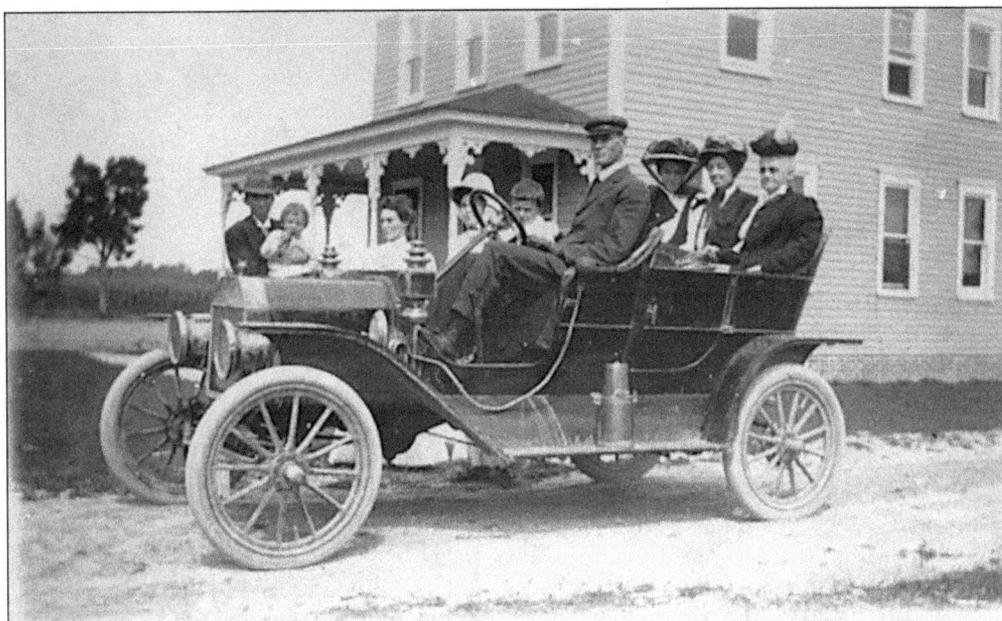

AUTOMOBILES ARRIVE IN MILFORD, 1910. It is recorded that Dr. James Stanton brought the first automobile to Milford, but Dr. George W. Marshall was the first, while the Draper and Townsend families were not far behind. This photo shows Mrs. George H. Draper riding in the rear of an early car. Her daughter, Linda Draper, is sitting in the middle. Thomas R. Draper is seated beside the chauffer.

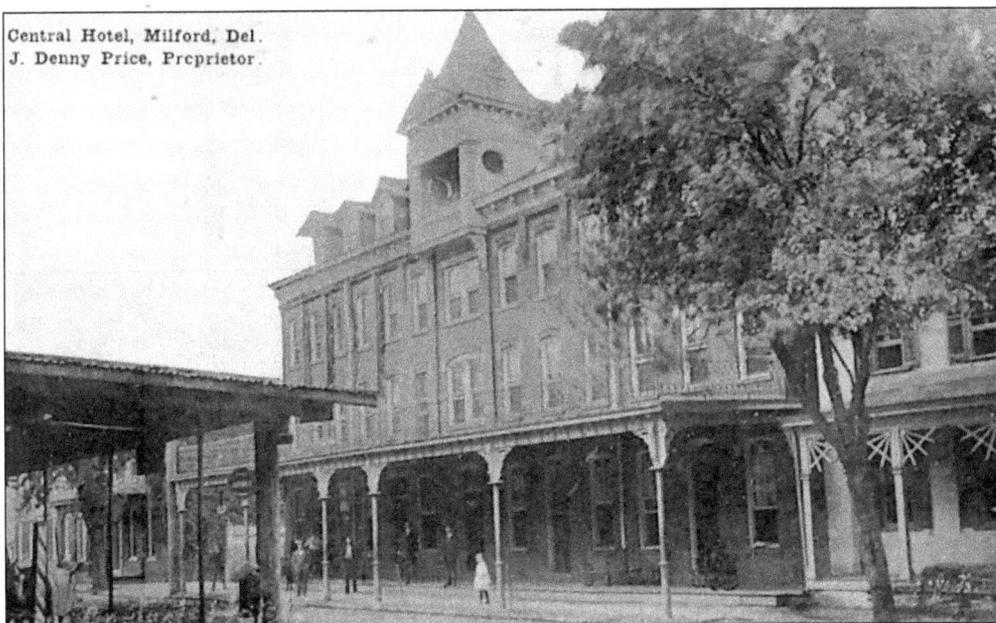

CENTRAL HOTEL, 1908. Frank Kramlich built the Central Hotel in 1892 following the fire in 1891 that nearly destroyed downtown. He sold the hotel after retiring in 1904. Denny Price operated the hotel until 1912, when Thad Windsor purchased it and changed the name to New Windsor Hotel. Purnell Lofland built his home (located to the west, right side) in 1790. It was razed in 1969 to make way for the driveway of the Kent-Sussex Inn.

73

TOWNSEND FAMILY AUTO. Virginia Salevan Townsend and her husband G. Marshall Townsend took a Sunday drive in the family motorcar as seen in this 1910 photo. Col. Theodore Townsend and his son G. Marshall owned and managed the *Milford Chronicle* newspaper that expanded in 1906.

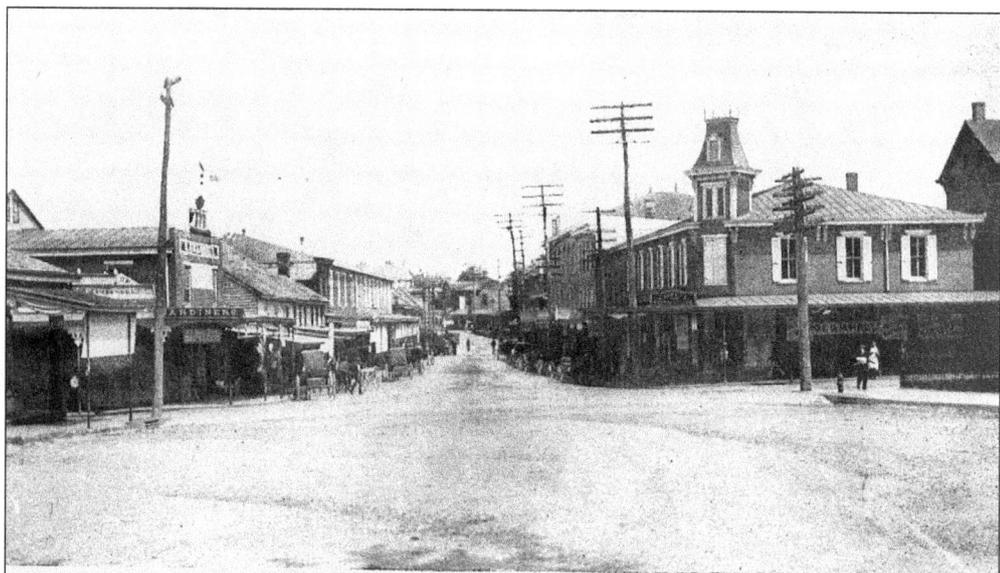

Walnut Street, Milford, Del.

PUB. BY W. W. DAUGHERTY, MILFORD, DEL. Copyrighted 1906 W. W. D. Germany

DOWNTOWN MILFORD, 1895. This postcard is marked 1906, but was taken prior to 1900 when Walnut Street was paved with bricks. Only horses and buggies are parked along Walnut Street with no autos in sight. This view of Milford was how the town looked just prior to the turn of the 20th century. The department store on the corner was called "the Busy Bee" and was managed by Col. George H. Hall. It was sold to Arthur Derrickson about 1920 and today is owned by Bill Graves.

74

Four

EARLY 20TH CENTURY
1900–1920

Milford, like many towns in Delaware, underwent a significant change in 1900. The turn of the century was the demarcation event that separated the old days from the new. The internal combustion engine was perfected in 1895 that allowed small, portable engines to develop power that was formerly unavailable. Bulky steam engines were not practical for farm use, motorized carriages, or airplanes that would soon be developed. Electricity developed by Thomas Edison in 1875 was finally installed in Milford in 1887 and appliances that resulted from electricity became readily available about 1900. Town Council paved Walnut Street in 1900 with brick cobblestones that replaced the oyster-shell surface used in the 19th century. Railroads became reliable and offered more frequent schedules to Milford. Manufacturing took a positive turn in 1900 when Dr. G. Layton Grier and his brother, Dr. Frank Grier, moved the young L.D. Caulk Company to Milford after the death of Dr. Levin Caulk in 1896. The following pictures attempt to show Milford's progress between 1900 through the end of World War I.

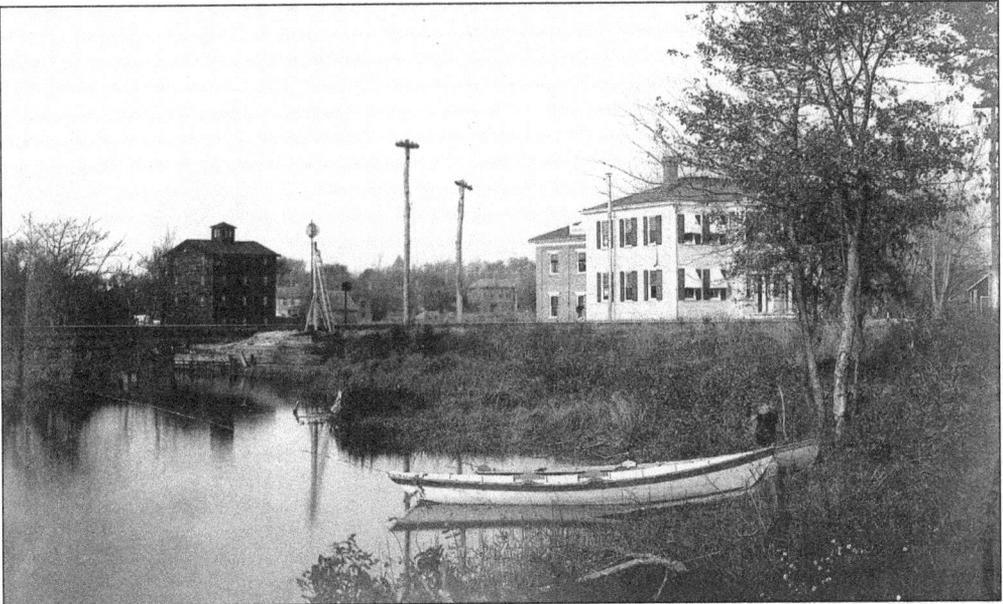

OLD RED MILL & NEW CAULK CO. The old, four-story Red Mill is visible from Silver Lake as it stood just as the new L.D. Caulk Co. was gaining its foothold in Milford. The mill stood at the foot of Mill Street where the "Greenway" path passes today. The Mill continued to function until 1943, when it was closed because of its age and outdated processes. Dr. G. Layton Grier built the frame Caulk Co. administration building in 1900 and the manufacturing brick structure behind it in 1908.

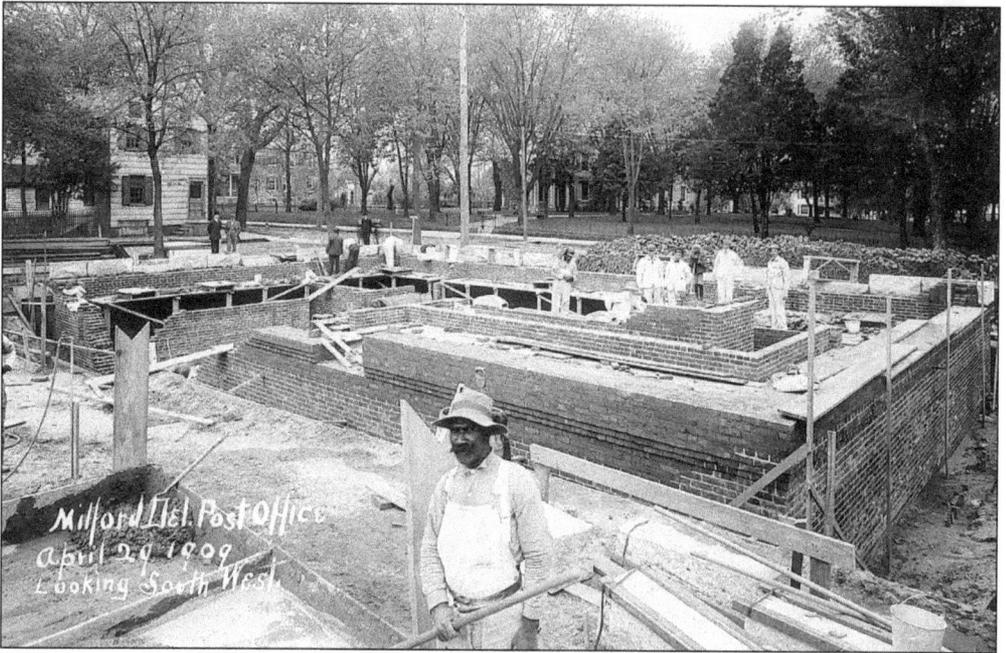

MILFORD POST OFFICE. A town had "arrived" when it was scheduled to receive a federal post office. Milford's postal duties had been handled prior to 1910 in stores where the postmaster was often a local merchant and political appointee. This photo was taken looking from Pearl Alley westward toward the Causey Mansion yard.

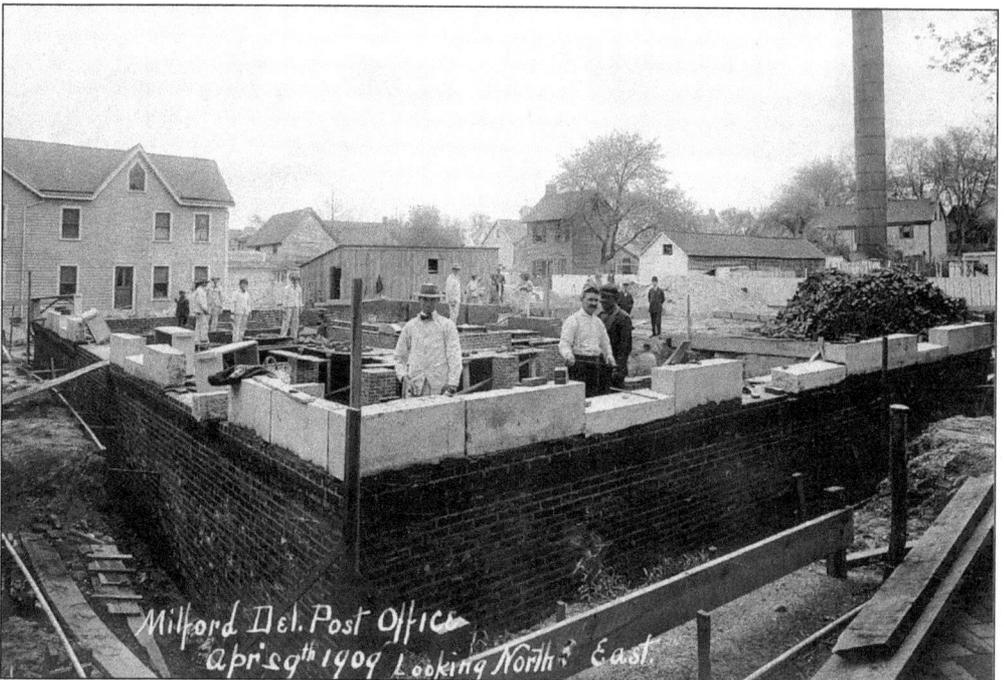

MILFORD POST OFFICE. This 1909 view of the new post office is seen looking eastward, toward Pearl Alley. The standpipe is visible where the city water tower is located today. Houses along South Washington Street are visible in the background of this photo.

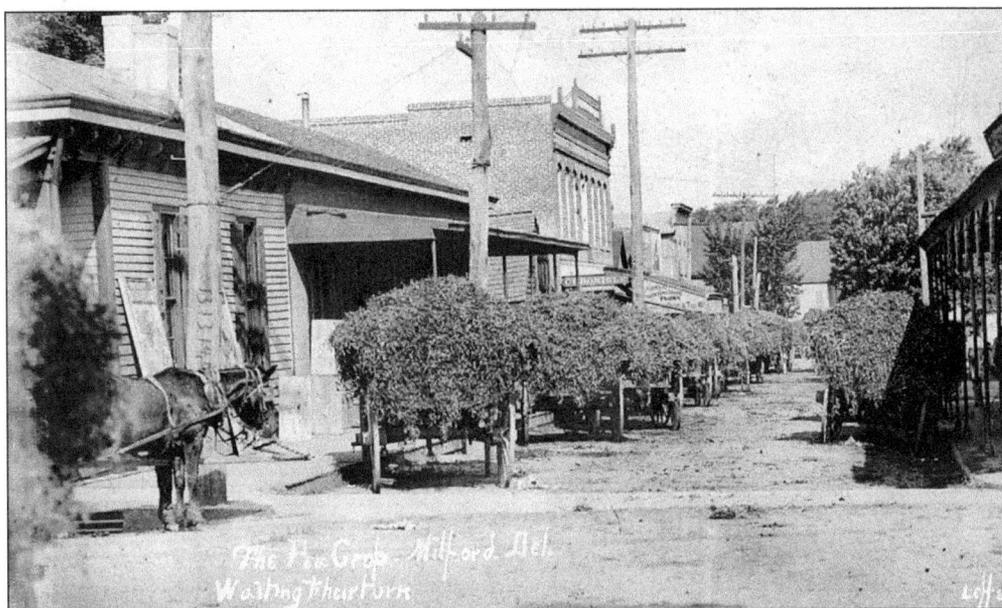

THE PEA CROP WAGON. Milford was a farm town in 1906 and the Draper cannery was located at the west end of Southwest Front Street. During the harvest season in June, wagons could be seen lining up along Southwest Front Street waiting their turn to unload vines for the cannery. Tatman's store is visible on the left side. Warren & Gibson replaced it in 1928. Warren Furniture occupies the site today. Merchant Joseph Holland, owned the right side store. Today the building has been modified to house the bookstore owned by Ken and Fran Novak.

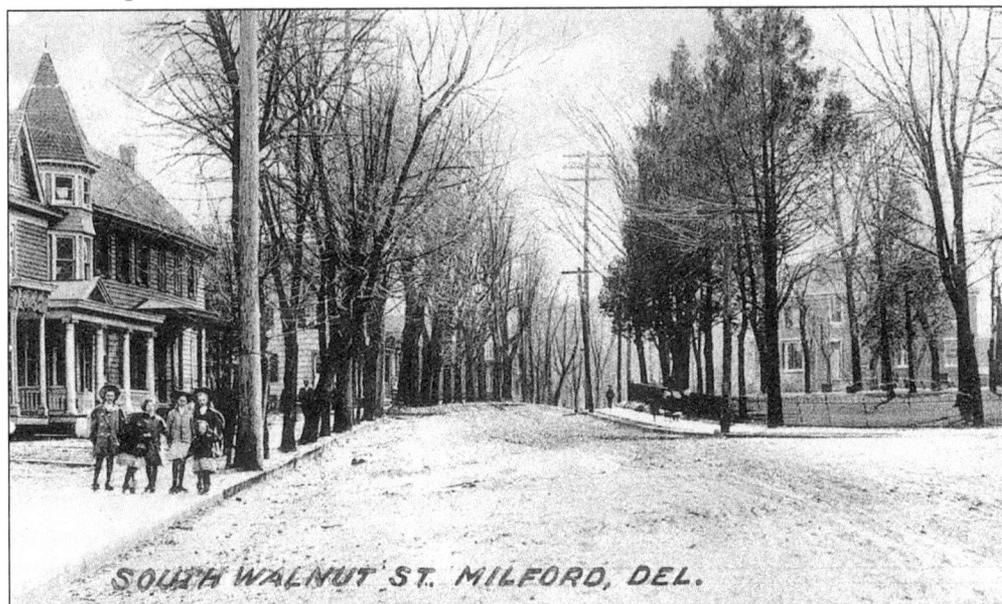

SOUTH WALNUT STREET. South Walnut Street is the focus of this 1908 photo. South Walnut Street was called "State Road" since it was the main highway to Georgetown prior to the 1917 construction of the Du Pont Highway. In 1908 the post office was not yet built and the corner is vacant. To the right is seen the Causey Mansion yard with the brick home built for Causey's daughter, Mrs. Maria Richards on South Walnut Street.

77

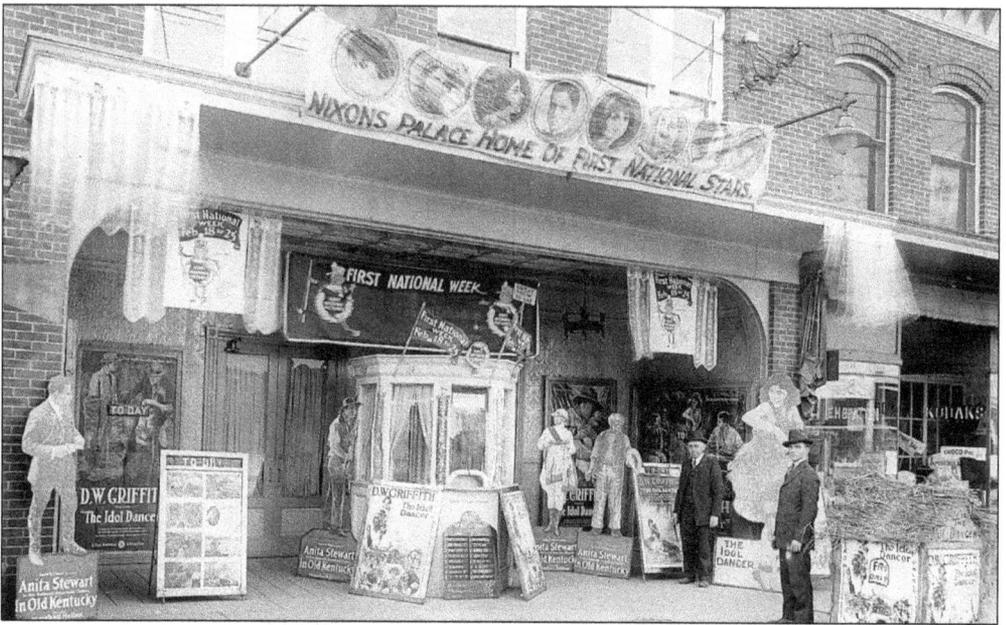

NIXON'S PALACE THEATER. Milford was electrified with the arrival of silent pictures after the turn of the century. Nickelodeons were originally found in stores, but soon the movie-house concept began to dominate. Nixon's Palace Theater was located in the "Jump Block" on the west side of North Walnut Street where the State Service Building is located today. It was replaced in 1922 by the Palace Theater that was built on the plaza that served as a movie and meetinghouse for the entire town.

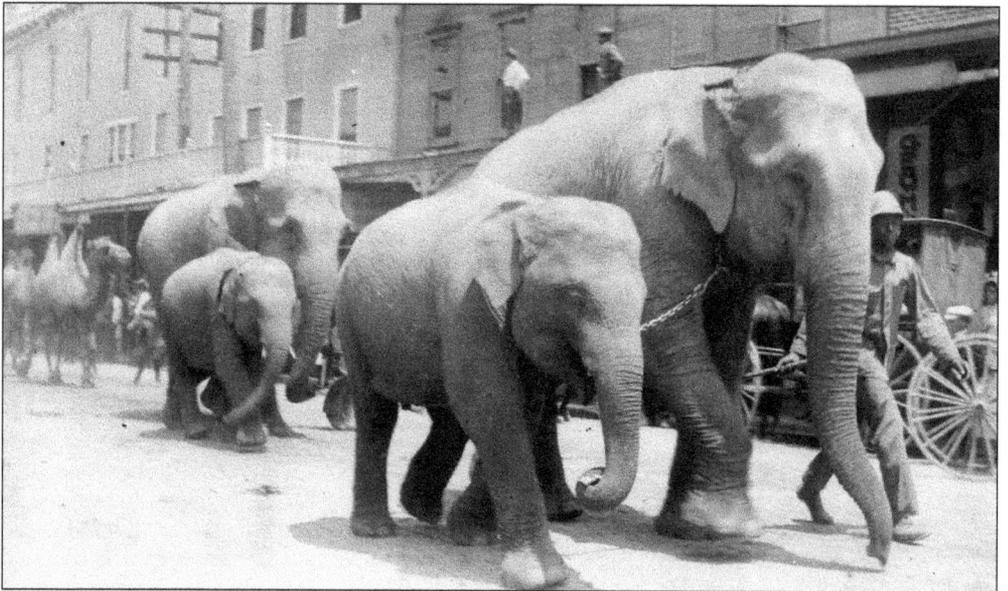

FIREMAN'S PARADE CIRCUS, 1905. The fireman's parade and carnival was the primary fund-raising event held each year in September to benefit the volunteer fire company. The circus arrived via the railroad and exotic animals were paraded down Main Street to generate enthusiasm for the carnival, normally held at the baseball park on Southeast Fourth Street and Montgomery Street.

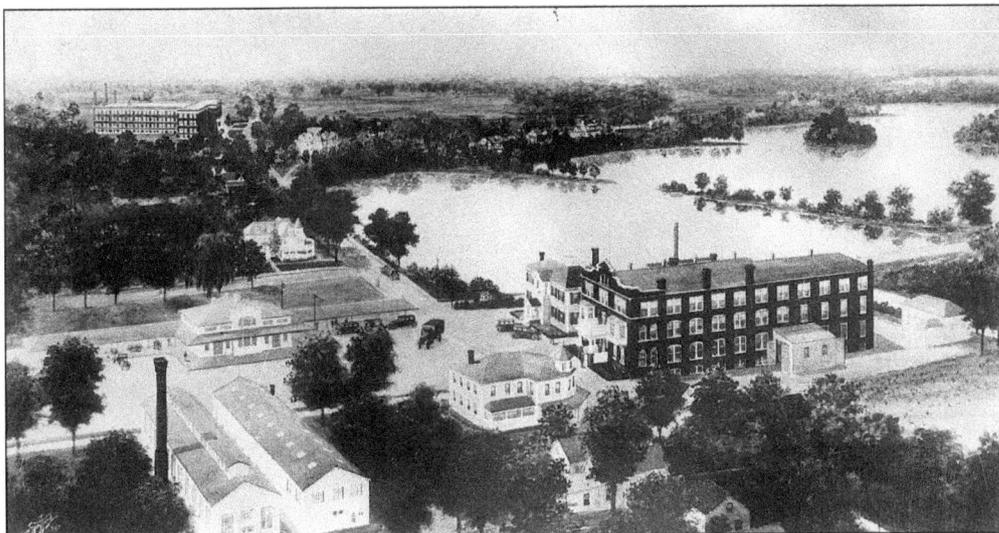

L.D. CAULK CO. AERIAL VIEW, 1935. The invention of 20th century alloy and synthetic porcelain projected the Caulk Company onto the world stage. This view demonstrates the rapid growth of the dental supply company from a backyard business in 1895 to a major manufacturing business by 1935. The original administration building is visible along the railroad track and the first brick manufacturing plant built in 1908. The main plant in the far background was constructed in 1912.

G. LAYTON GRIER, PRESIDENT OF CAULK CO., 1867–1944. Layton Grier was Milford's first corporate tycoon. He was a combination of scientist, physician, financier, and marketing genius. Layton was the oldest son of George S. Grier and Margaret Davis Layton. He graduated from dental school in 1895 and married Ella Vaules. Layton made himself chairman of the company when it was incorporated in 1910 and he remained chairman until his death in 1944. His brother, Dr. Frank Grier, married Florence Caulk and built his home at 301 Lakeview Avenue. The brothers fell out over control of the Caulk Company and the hospital about 1930 and never spoke a kind word again.

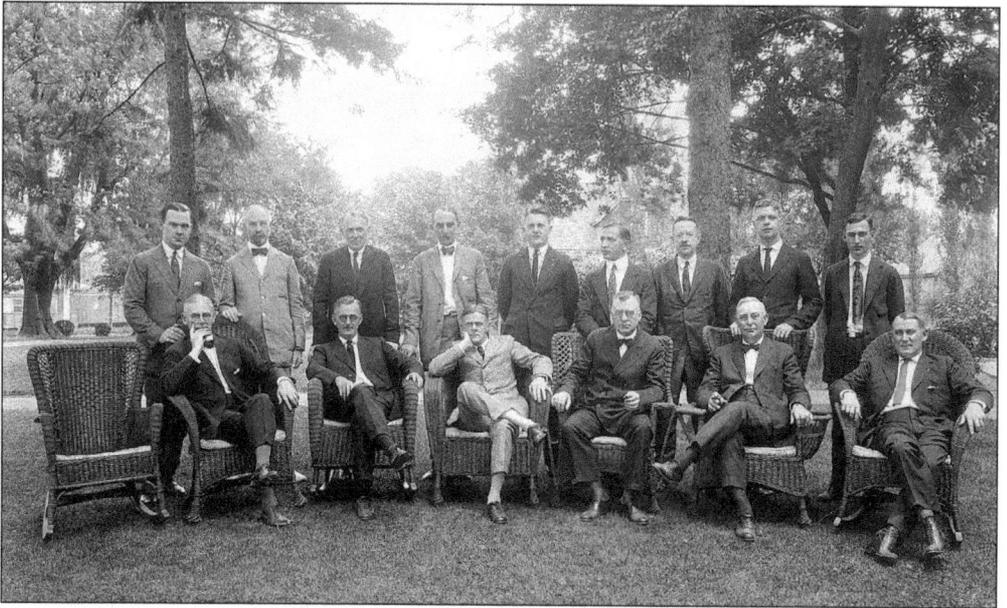

CAULK COMPANY BOARD, 1920 These men ran the L.D. Caulk Co. from 1912 until the death of Layton Grier in 1944. They managed different segments of the dental supply business and were experts in their respective fields. From left to right are the following: (front row) Dr. Frank Grier, Harry L. Grier, George Grier Jr., William Smith, Silas Reynolds, and Davis Grier; (back row) W. Vaules Grier, Dr. Arthur Gray, Dr. Walter Grier, Dr. G. Layton Grier, Dr. Clyde Nelson, Dr. Paul Poetschke, Mr. Snow, Fred Lewis, and H. Conner Mitten.

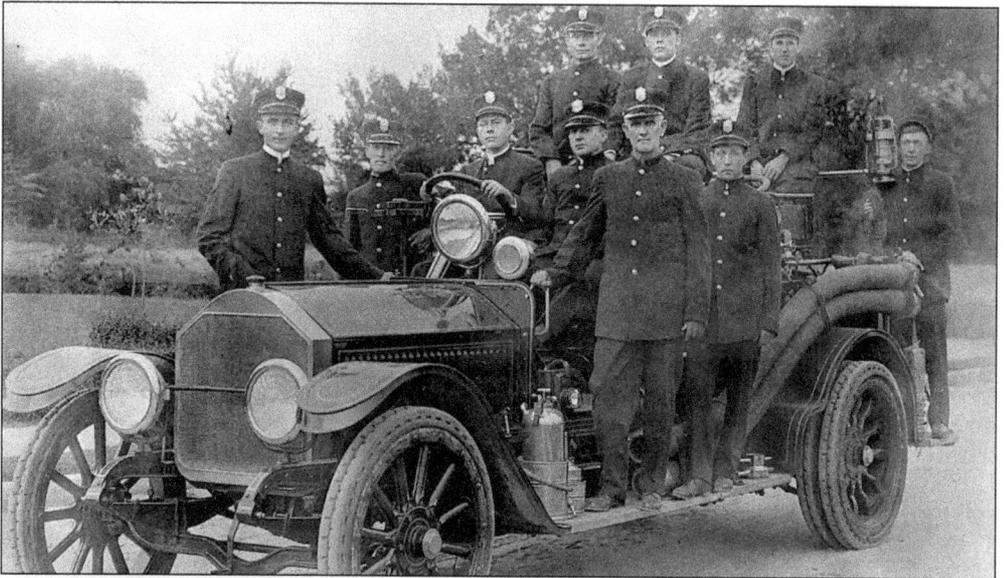

MILFORD FIRE COMPANY'S FIRST FIRE TRUCK. The Carlisle Fire Company traces its roots back to 1805 when the volunteer service used a cart and hand pump to fight fires. After many years of fund-raising via the annual fireman's carnival, the group purchased its first motorized fire truck in 1916 at a cost of $4,345. The members in this 1916 photo are, from left to right, (front row) Charles Varney, unidentified, Agustus Dickerson (driver), James P. Pierce, Benjamin Holston, and Minos Scott; (back row) Charles D. Holzmueller, Lou Ryder, and Lou Chorman.

PARIS T. CARLISLE IV. When Paris Carlisle was killed October 6, 1918, in France during World War I, the fire company was devastated and decided to name the company after their fallen comrade. The group purchased the site of the former shirt factory after it burned in 1921 and began a major fund drive in February 1923 to build the new "Carlisle Fire Company" on Southwest Front Street. The new building was completed in 1925 at a cost of $87,000 and served the volunteers until 1976 when the present building was completed on Northwest Front Street.

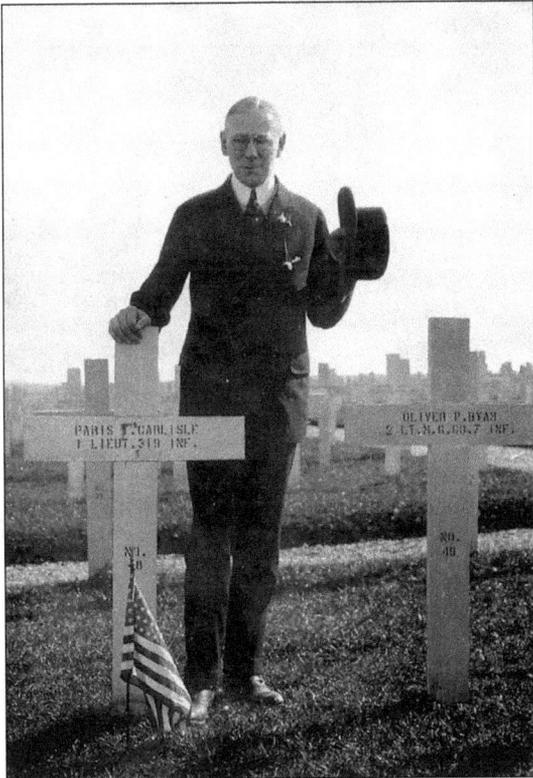

DR. FRANK GRIER IN FRANCE AT PARIS CARLISLE'S GRAVE. The death of Paris Carlisle IV brought home the gravity of World War I to Milford in a personal way. Frank Grier was his best friend and classmate and was profoundly saddened by his loss within a month of the armistice announcement in November 1918. Dr. Grier visited the gravesite of his friend in France in 1920.

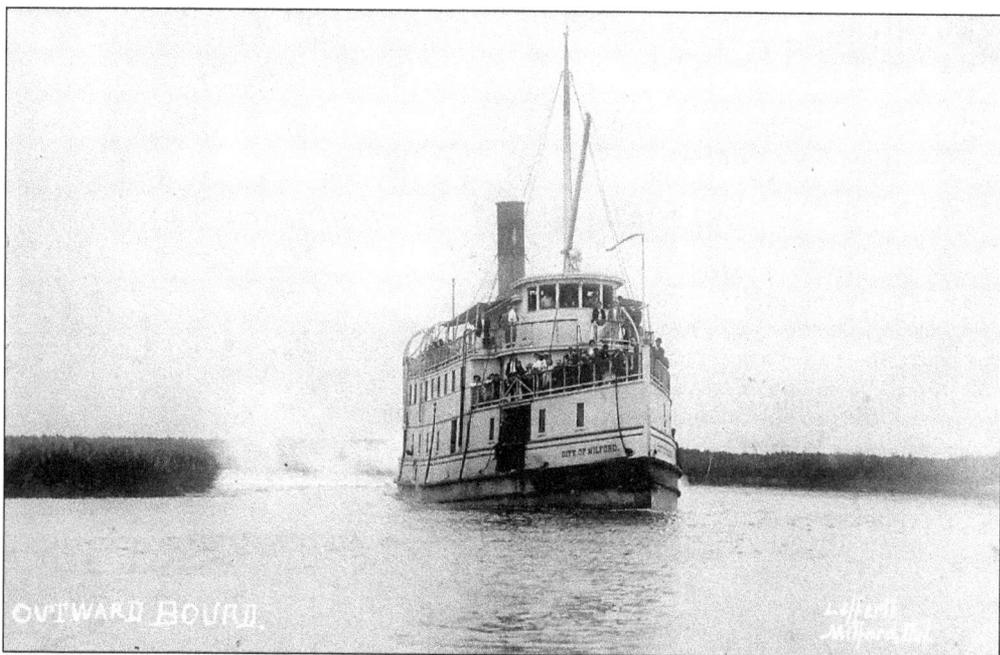

CITY OF MILFORD, 1905. The era of steamboats in Milford began about 1853 when Henry Fiddeman and Daniel Currey "wharfed up" a dock on the north bank of the Mispillion and formed the Milford Steamboat Company. Steamboats were purchased primarily for hauling freight, but passengers were carried on the *City of Milford* until about 1932 when effects of the Depression ended their profitability.

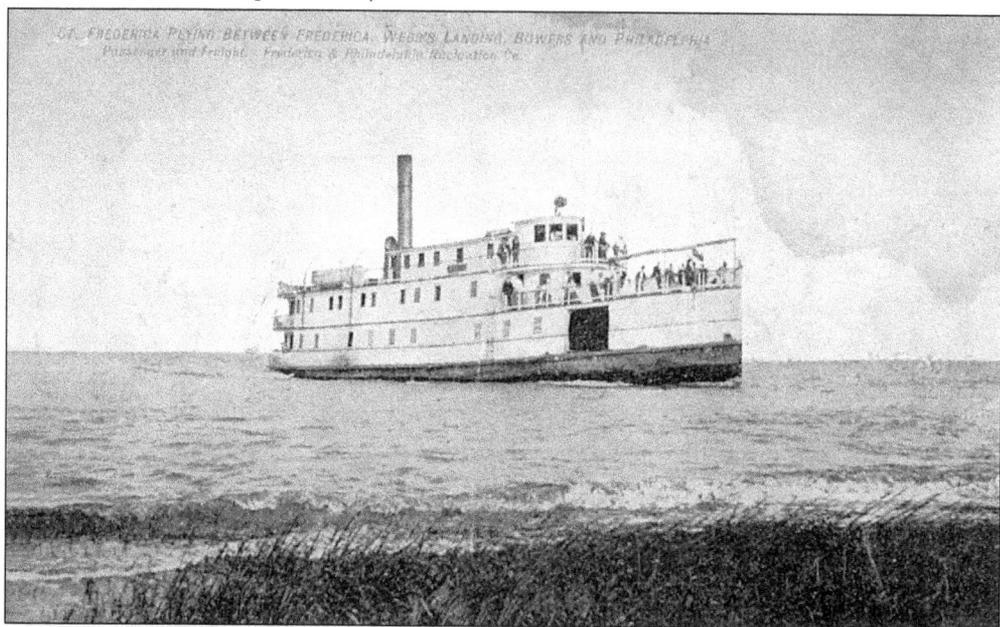

FREDERICA, 1910. Each river town had its own passenger steamer during the early part of the 20th century. The *Frederica* traveled between Frederica, Webb's Wharf near South Bowers, and Philadelphia from 1895 until 1930. The passenger steamers were very similar in style and function as noted in these two postcards.

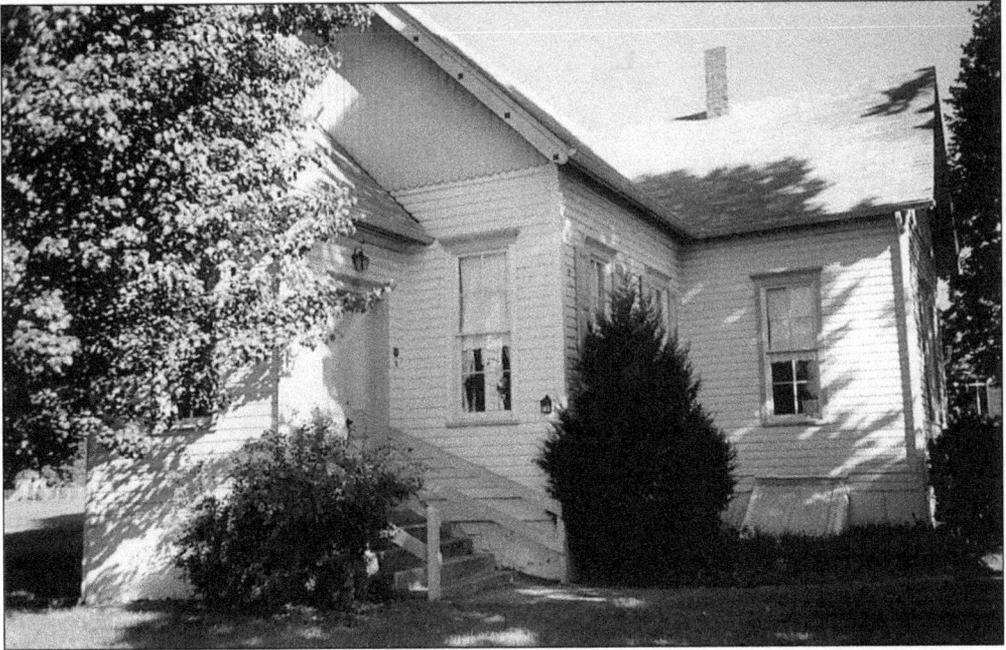

NEW CENTURY CLUB, 1885. The wooden structure was built in 1885 as a home for the Milford Classical Academy, a private school for Milford's prominent families. By 1898 it was purchased by a women's organization formed to promote women's political causes. It serves this purpose today with an active group of women who restored the building during the 1990s and continue with the causes outlined in its original charter.

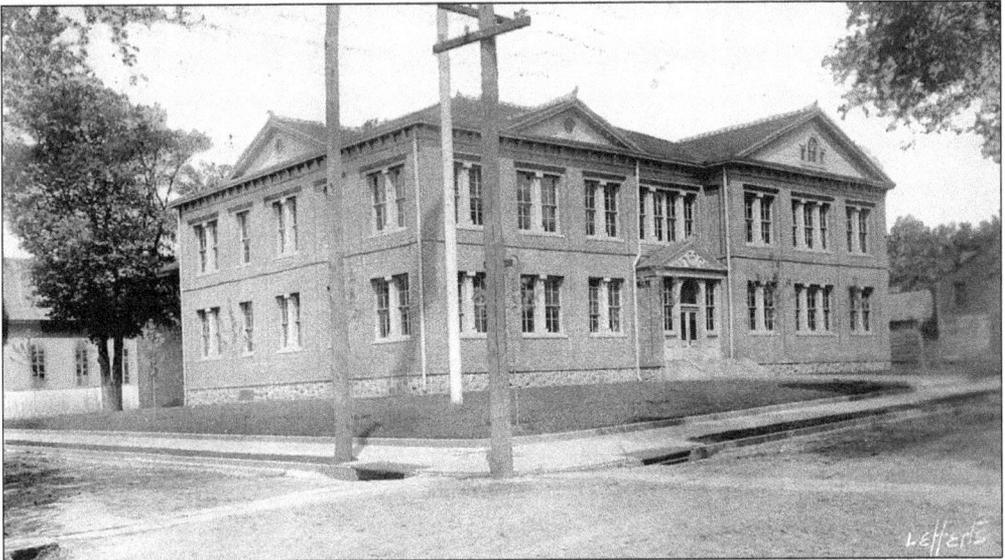

MILFORD HIGH SCHOOL, 1905. The state legislature passed the school consolidation act in 1899 that provided for Milford to have one high school. The South Milford school was closed and its 300 students transferred to the new brick building on North Street and Northwest Second Street, the site of the earlier academy building. The new high school was attached to the older academy building and both were used until the new high school was built in 1929 on Lakeview Avenue.

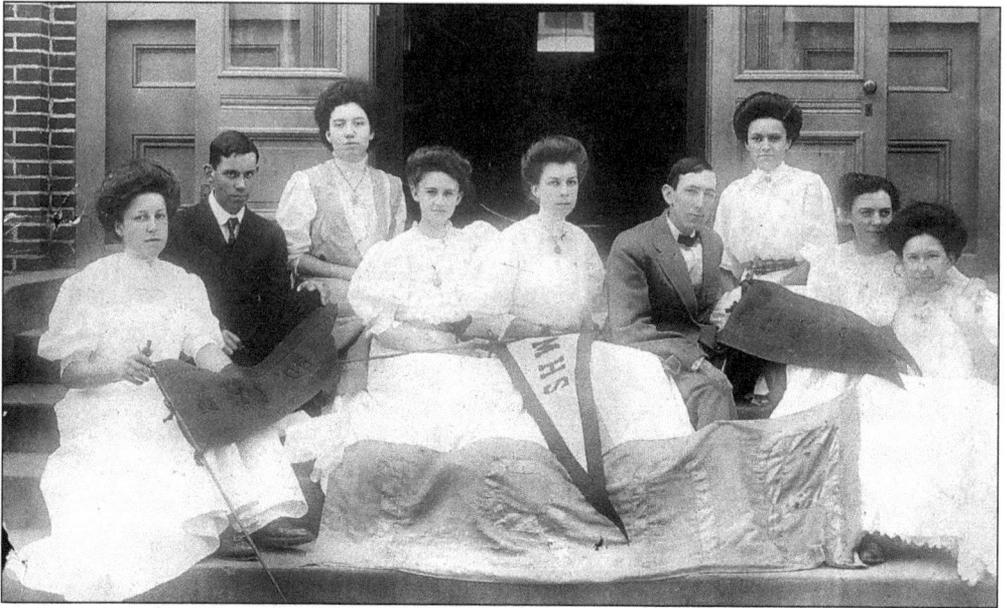

MILFORD GRADUATES CLASS OF 1908. Most students from rural farming areas only attended high school until eighth or tenth grades. By the time graduation arrived there were often less than 10 students who completed the entire curriculum to earn a diploma. From left to right are May Ellis, R.D. Prettyman, Sarah Banning, Lucy Arnold, Dorothy Burn, Ada Roach, Marshall Townsend, May Kinder, and Yensie Vibbert.

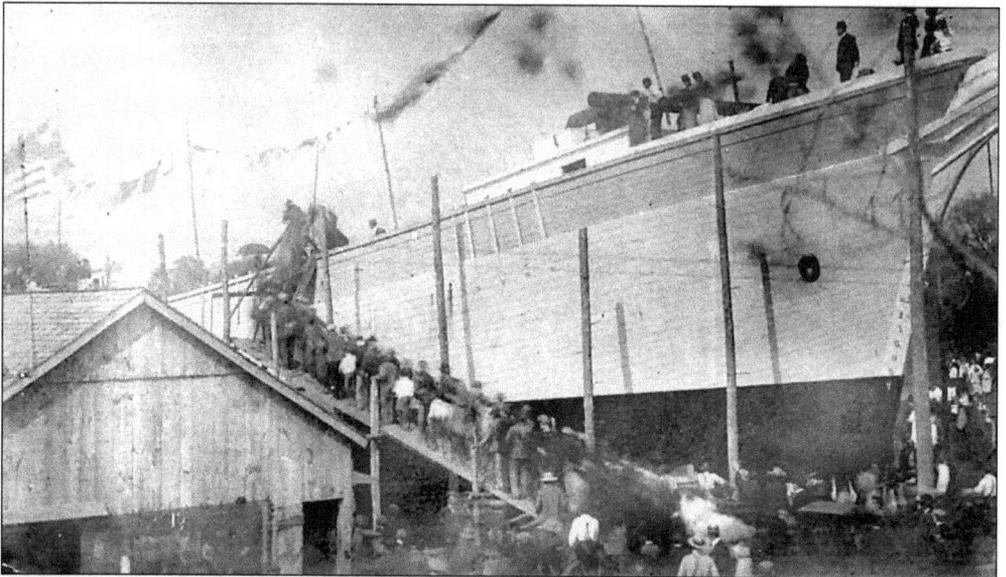

LAUNCH DAY. This ship is possibly the *Charles J. Dumas* launched by William G. Abbott's shipyard on September 28, 1904. This ship was a four-masted schooner, the second built on the Mispillion. About 1,200 spectators ascended the makeshift wooden ramp to hear the launch ceremony. The scaffolding built for the crowd collapsed killing 9-year old Ralph Simpson and injuring 10 others seriously. Marshall Townsend, Al Nutter, Thomas Simpson, John Davis, Gardner Williams, and Nye Matthews were among the injured that never forgot the launching of the *Dumas* in 1904.

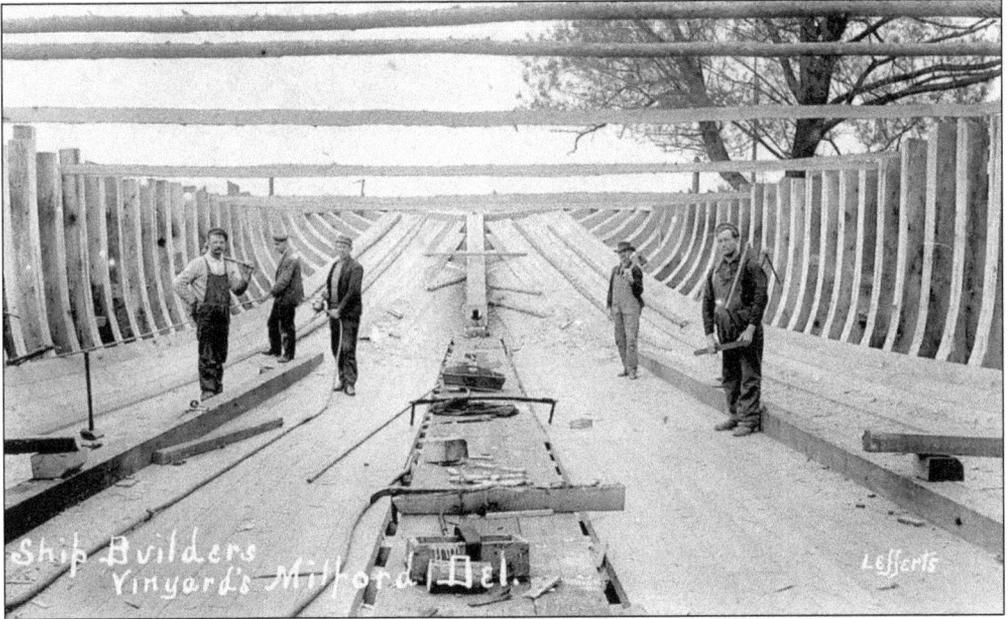

VINYARD SHIP, 1907. This postcard shows a close-up view of the early stages of construction on a wooden ship over 100 feet in length. The keel was laid and ship carpenters set the ribs in place using temporary supports. The "steam box" was used to permanently bend ribs into the curved shape necessary to form the skeleton of a sailing ship. This postcard is marked "Vinyards," although Capt. Wilson M. Vinyard specialized in motorized ships. This ship appears to be a sailing vessel.

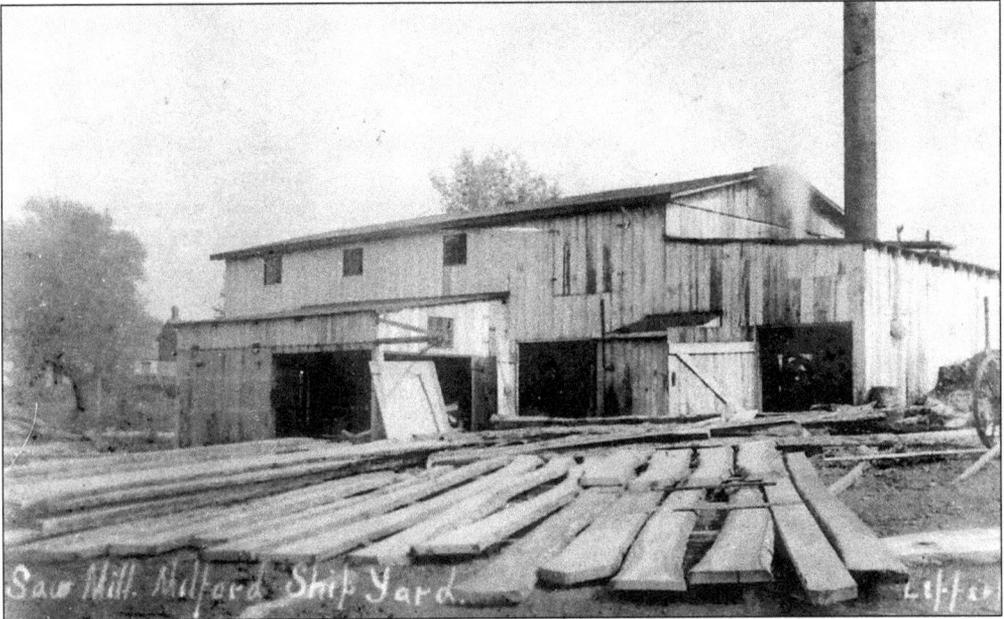

ABBOTT'S PLANING AND SAW MILL, 1909. Steam power was used by the shipyards to saw white oak trees into suitable planks for shipbuilding. The work was hard and dangerous, but provided employment for hundreds of workers who made their homes in South Milford along Columbia, McColley, and Marshall Streets.

"PICKANINNIES AT HOME," 1906. Blacks were kept poor and uneducated during the early part of the 20th century as a result of Milford's segregation culture held over from the era of slavery and reconstruction after the Civil War. Very few postcards depict the lives of the poor and lower classes. This ramshackle wooden structure was obviously home to this family of blacks descended from slaves just a generation before.

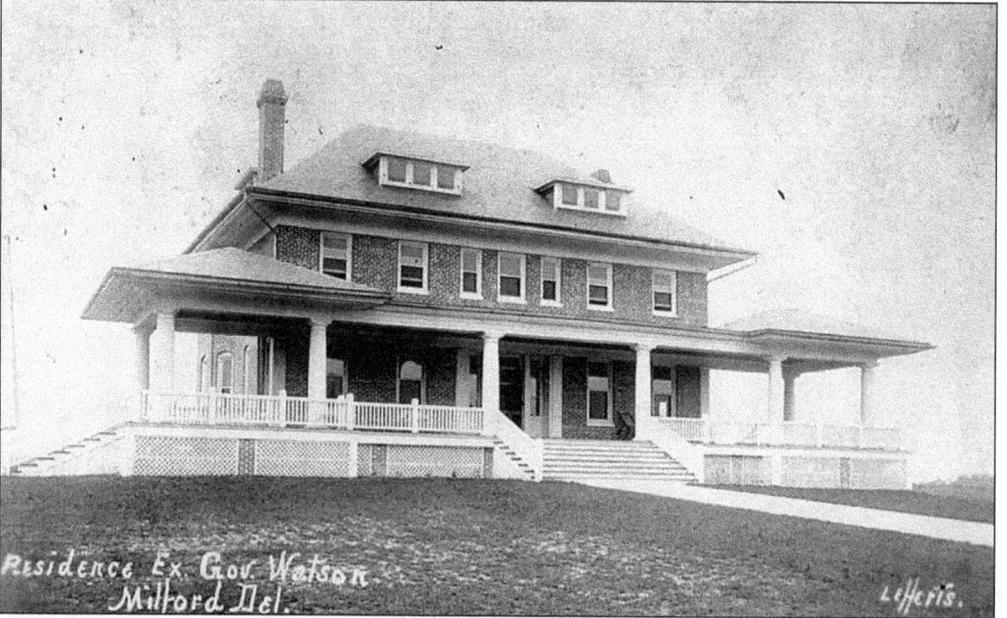

WALNUT KNOLL. The photograph showcases the home of Gov. William T. Watson located at 600 N. Walnut Street. The house later became the home of Louis Pack, controller of Sussex Poultry Company from 1945 to 1960 then owned by Dr. Portz and his family, and later by Dr. Charles G. Wagner.

Gov. William T. Watson (1849–1917). Governor Watson assumed the office of chief executive after the death of Gov. Joshua Marvel on April 8, 1895. He was the son of Bethuel Watson and was involved as a director with the First National Bank and the DMV Railroad prior to election to the state senate in 1892. He built the stately home known as "Walnut Knoll" at 600 North Walnut Street in 1906.

Col. Theodore Townsend (1855–1936). Theodore Townsend was born on his family's farm at Townsend Landing in Cedar Neck. He left the Delaware farm to apprentice as a jeweler's assistant in New Jersey and later served as a reporter for a New Jersey newspaper. He returned to Milford and founded the *Milford Chronicle* newspaper in 1878 with several partners. He joined the "Torbert Guards" as part of Milford's local militia and rose to the rank of colonel in the state guard. He died in 1936 after serving as chairman of the Milford School Board from 1928 to 1936.

THAD WINDSOR (1881–1950). Thad Windsor was the epitome of a Milford boy. His family operated the Windsor Hotel in South Milford beginning in 1890. When Frank Kramlich sold the Central Hotel in North Milford in 1908, Thad Windsor purchased the hotel in 1912 and named it the "New Windsor" Hotel. Here he is shown with his friends, Lawrence Baynard (left) and Will Hollis (center), following a successful raccoon hunt near Milford, c. 1920.

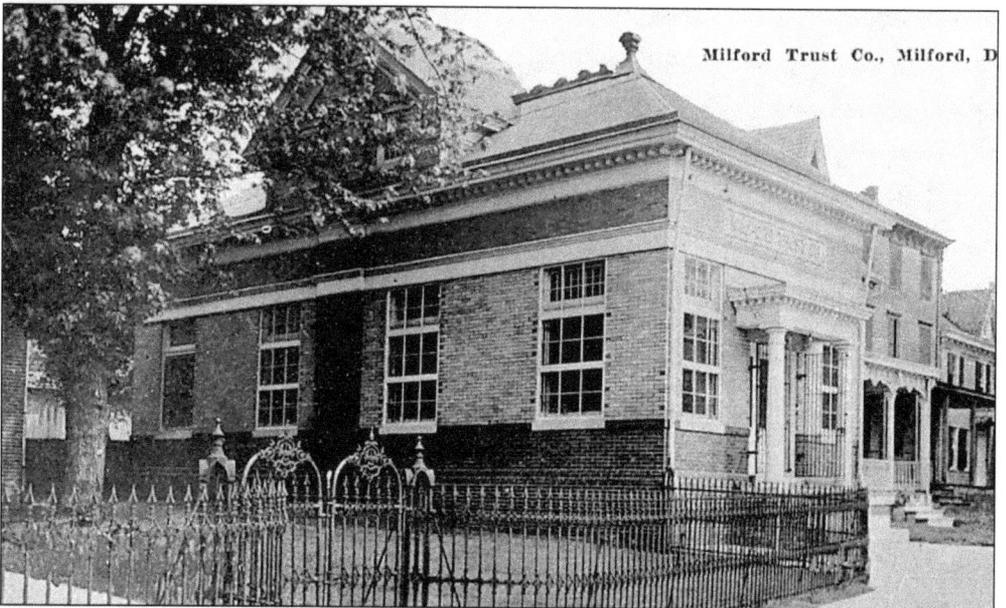

THE MILFORD TRUST COMPANY, 1901–1930. The second bank to serve Milford was built in South Milford beside the Presbyterian Church on South Walnut Street. It was formed by Alfred Powell, Col. George H. Hall, George Reed, and Louder Hearn, but effectively controlled by Layton Grier and his extended family. The Grier family resented the closed banking circle represented by the First National Bank that was controlled by powerful families in North Milford. This bank was replaced by the present brick structure in 1930.

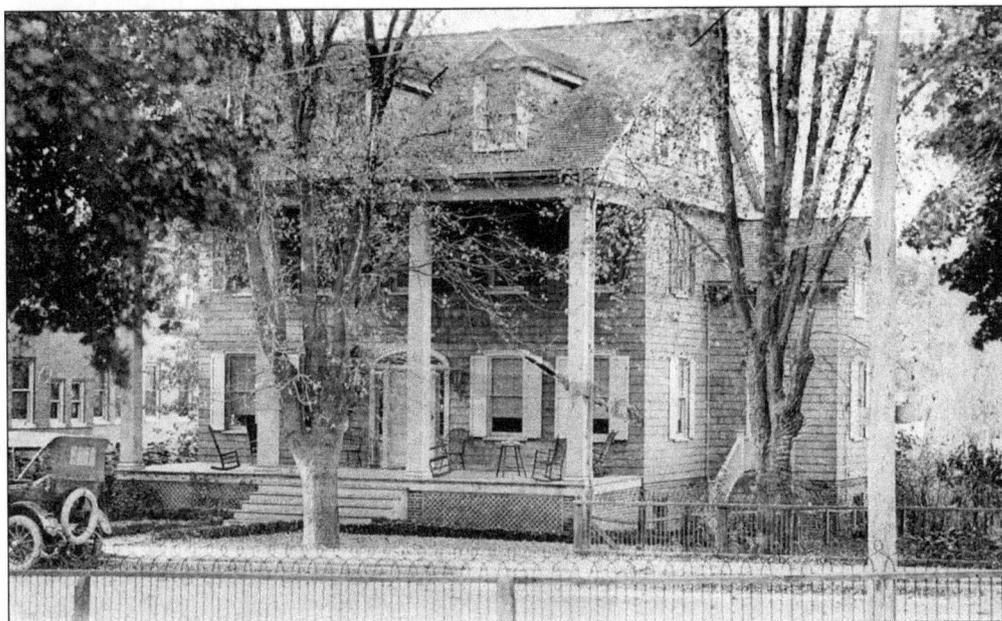

JOHN CAUSEY HOME. Congressman John Causey built this home in 1907 but died shortly afterward in 1910. Dr. S.M.D. Marshall acquired the home in 1917 and lived here until his death. It was purchased by a social service agency as a halfway home in 1995. The building now serves as the Milford Museum.

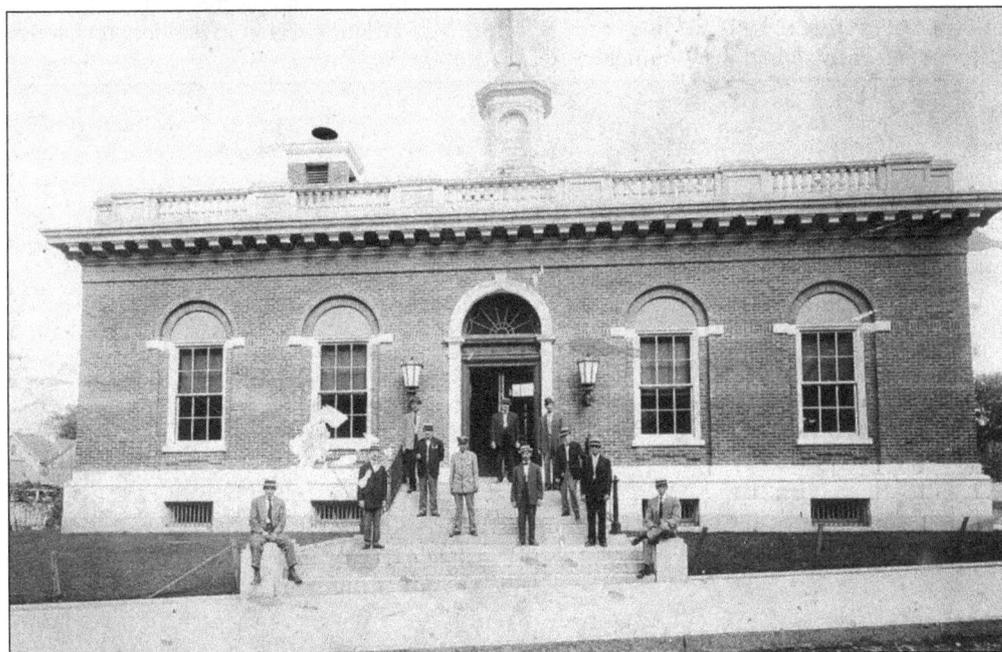

THE MILFORD POST OFFICE, MAY 1, 1910. City mail delivery was inaugurated in May 1910 after completion of the new brick building. Staff members from left to right are Charles Kespert, William Joseph, William R. Hudson, George Russell, Robert Wyncoop, Frank W. Davis (Postmaster), Harry Lynch, Jay Foulk, Imly S. Abbott, George Manlove, and George R. Bennett. The building now serves as the Milford Museum.

J.H. LATCHUM'S STORE. This 1919 photo shows Harry Latchum and his young son, James Levin Latchum at the store owned by the Latchum family in 1919. Grocer Dorsey Bowen, a long-time resident of Milford, owned the store to the right. The small boy, Levin Latchum, attended Milford schools, served in World War II, and completed a law degree at the University of Virginia. He rose to be U.S. District Judge for the Mid-Atlantic region in Wilmington. Judge Latchum recently retired in Wilmington.

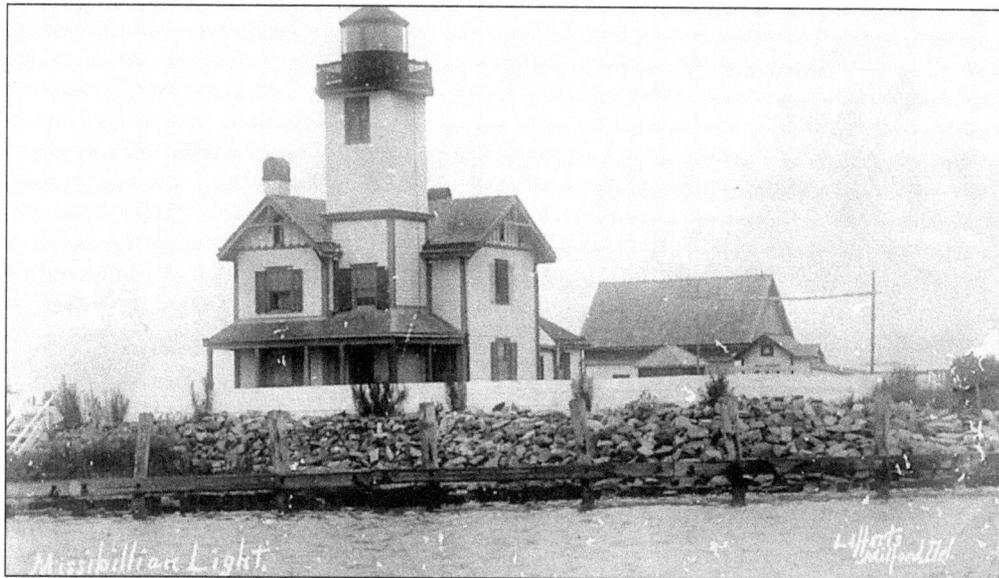

MISPILLION LIGHTHOUSE. The Mispillion Lighthouse was completed in 1873 and still stands today. This photo taken in 1908 shows a stone bulkhead erected to ward off the many "nor'easter" storms that have threatened the wooded structure over the past 13 decades. The lighthouse was deactivated in 1932. It is awaiting preservation by a local group known as the Lighthouse Preservation Society formed in 2001.

THE CROW'S NEST, 1907. Dr. Frank Grier erected this wooded-deck structure in 1895 when he built his new home called "Lakelawn." The Crow's Nest was constructed around an old beech tree located on Kings Highway opposite the Grier mansion. Local couples met here to carve their initials in the tree and watch the sun set over Silver Lake and the peninsula. The structure fell into disrepair after the death of Dr. Grier in 1937 and the formidable beech tree fell victim to a summer thunderstorm in August 1963.

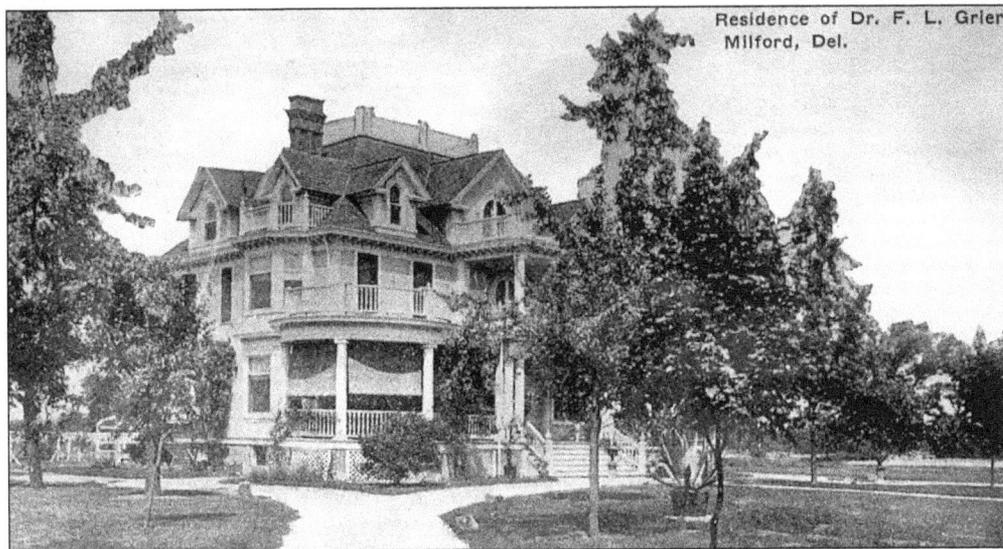

LAKELAWN. This large mansion was built in 1895 after the wedding of Dr. Frank Grier and Florence Caulk, daughter of Levin D. Caulk. Dr. Grier had started his dental practice in Smyrna, but moved back to Milford at the suggestion of his brother, Dr. G. Layton Grier. Dr. Frank Grier became vice president of L.D. Caulk Company and general manager of all manufacturing operations when it was moved to Milford in 1900 after the death of Dr. Caulk in 1896.

L.D. CAULK CO. The Caulk Company was so successful between 1900 and 1910 promoting and selling its new 20th century alloy and synthetic porcelain that they had sufficient financing to build an entirely new manufacturing plant on land acquired along Lakeview Avenue in 1912. This expansion coincided with incorporation of the company under the direction of Drs. G. Layton and Frank L. Grier. The brothers encouraged their younger brothers to join the enterprise. By 1920, Davis, Harry, Walter, George Jr., and Vaules Grier were all working as executives at Caulk.

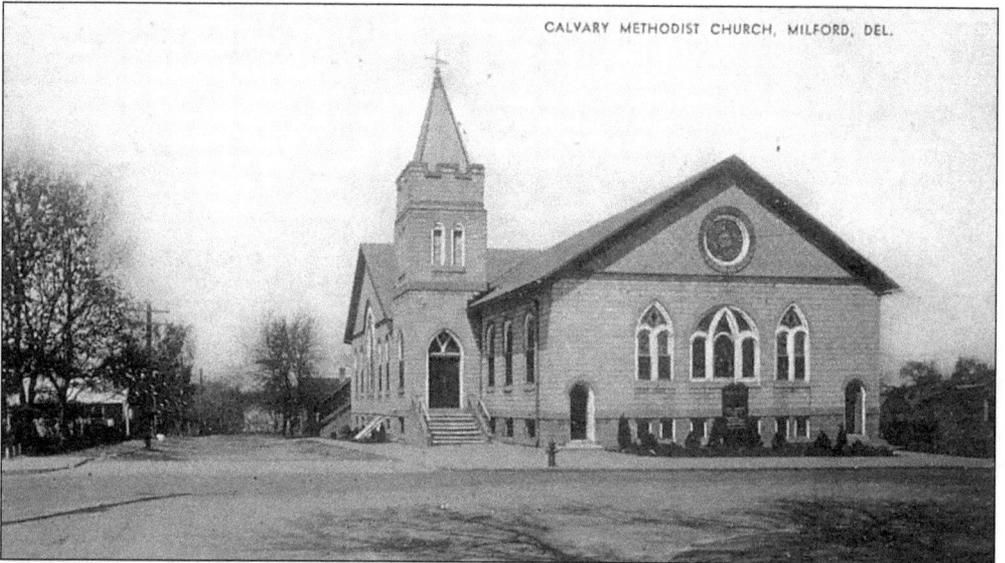

CALVARY CHURCH. The working-class families living in South Milford built the original Calvary Church in 1911. The drive to build Calvary was initiated by Rev. Louis Bennett, an itinerant evangelistic preacher who came to Milford in 1910 with a tent meeting. A small frame structure was built as a temporary church prior to the completing of the main structure in 1912 at the corner of Southeast Front and Franklin Streets. This church burned in a major fire on March 3, 1951, but was rebuilt with a brick church on the same site in 1955.

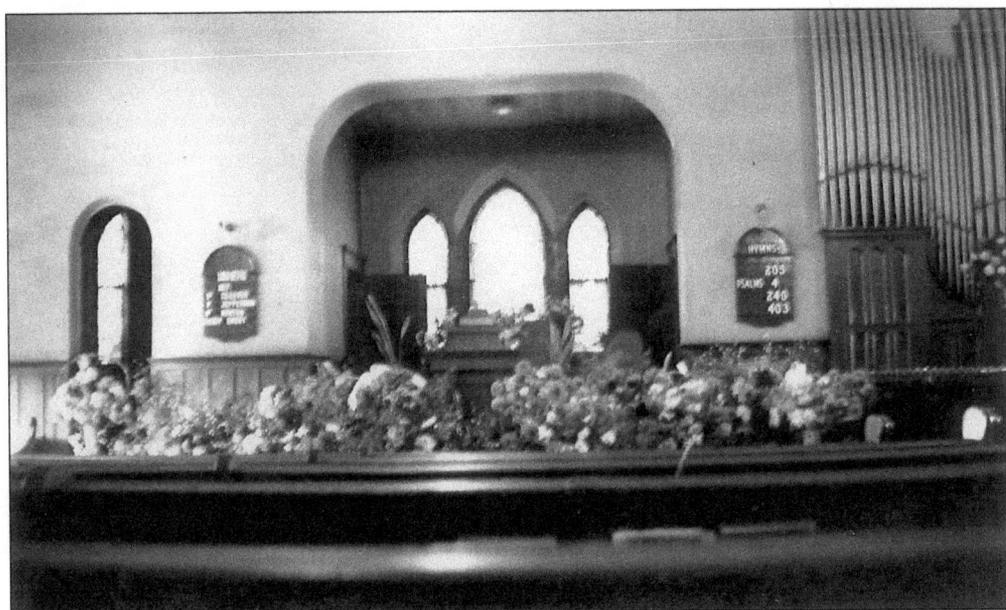

CALVARY CHURCH, 1915. Many older residents remember the interior of Calvary Church prior to the fire in 1951. The old pews, stained glass windows, and organ were lost in the fire.

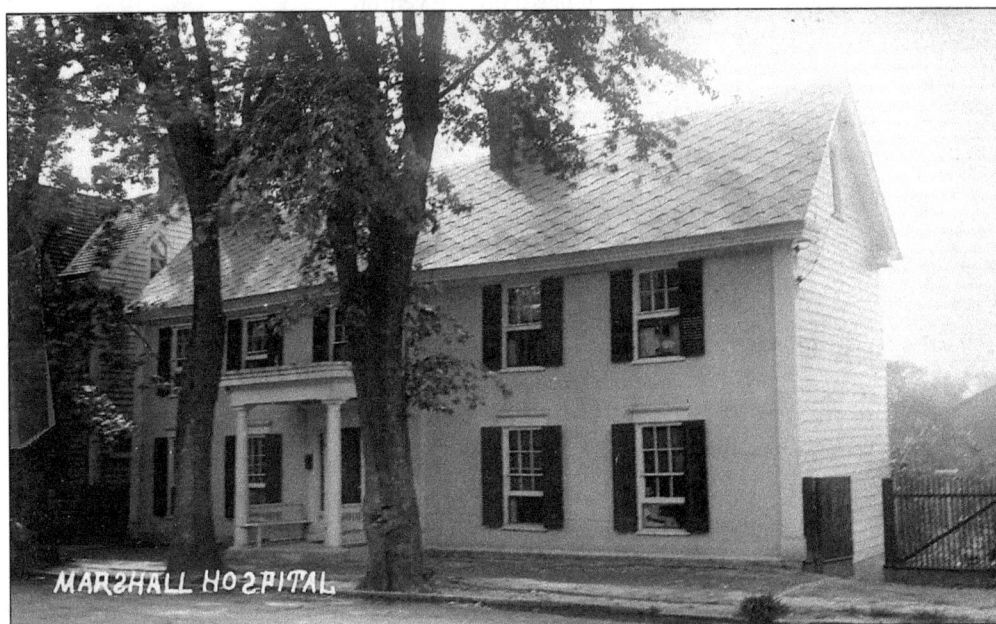

MARSHALL HOSPITAL, 1914–1918, 1922–1935. Through the efforts of Mrs. George W. Marshall, Milford made several attempts to open and staff an emergency hospital for its citizens. The state legislature enacted a bill creating the Milford Emergency Hospital in 1913. Mrs. Marshall's sons, Dr. William and Dr. Sam Marshall, offered the use of the former Lofland home located at 110 Northwest for the hospital. The hospital functioned well until the outbreak of World War I in 1918 when both Marshall brothers were called to serve. It was re-opened in 1922–1935.

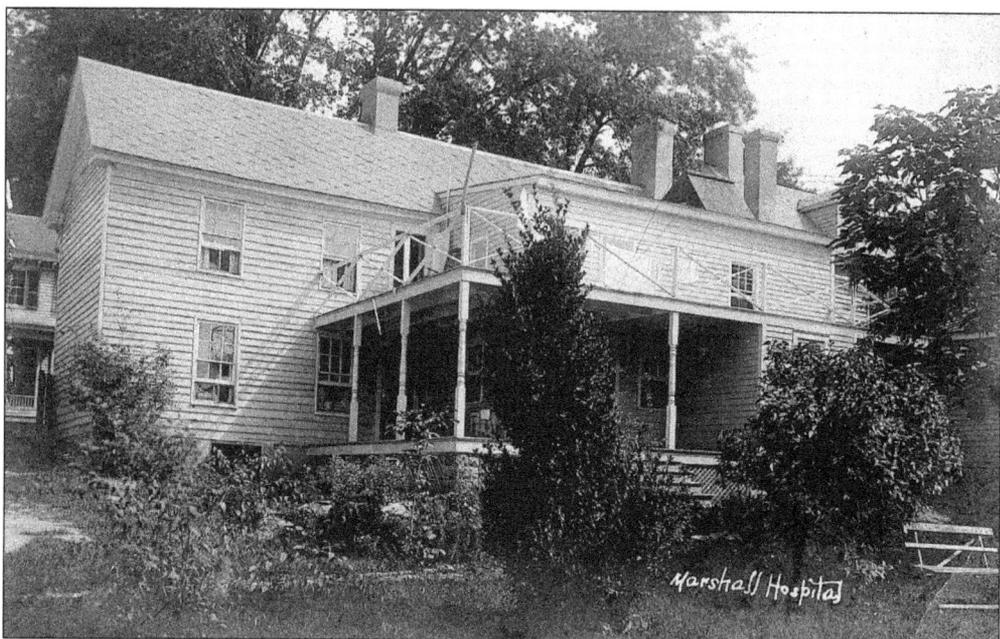

MARSHALL HOSPITAL REAR VIEW. The rear of the Marshall home served as a visiting area and a sun porch for patients from 1914 to 1918. The hospital reopened from 1922 until 1935 when the Marshall brothers opened the hospital as a private venture.

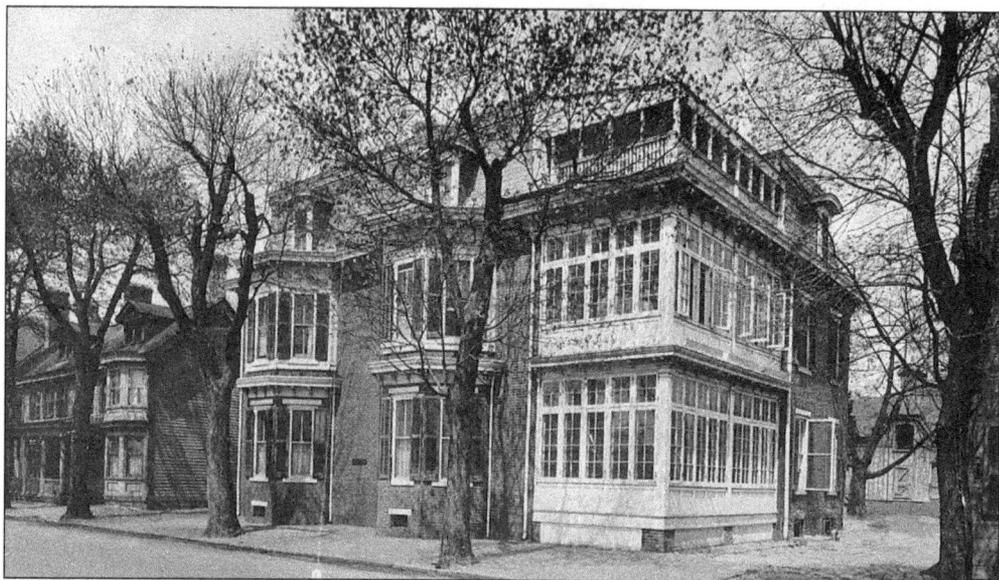

MILFORD EMERGENCY HOSPITAL, 1921-1938. The second location for the emergency hospital was located in this converted residence that opened July 1, 1921. The home was formerly owned by Reynear Williams and was sold to the trustees by the Roudebush estate. The hospital had 43 beds and served the community until the construction of Milford Memorial Hospital on Clark Avenue in 1938.

DR. S.M.D. MARSHALL AND DR. WILLIAM MARSHALL II. These two brothers were sons of George W. Marshall and Mary Louise Marshall, the visionaries behind the formation of a hospital for Milford. Dr. Sam was an ear, eye, nose and throat specialist while Dr. William specialized in dermatology and broken bones.

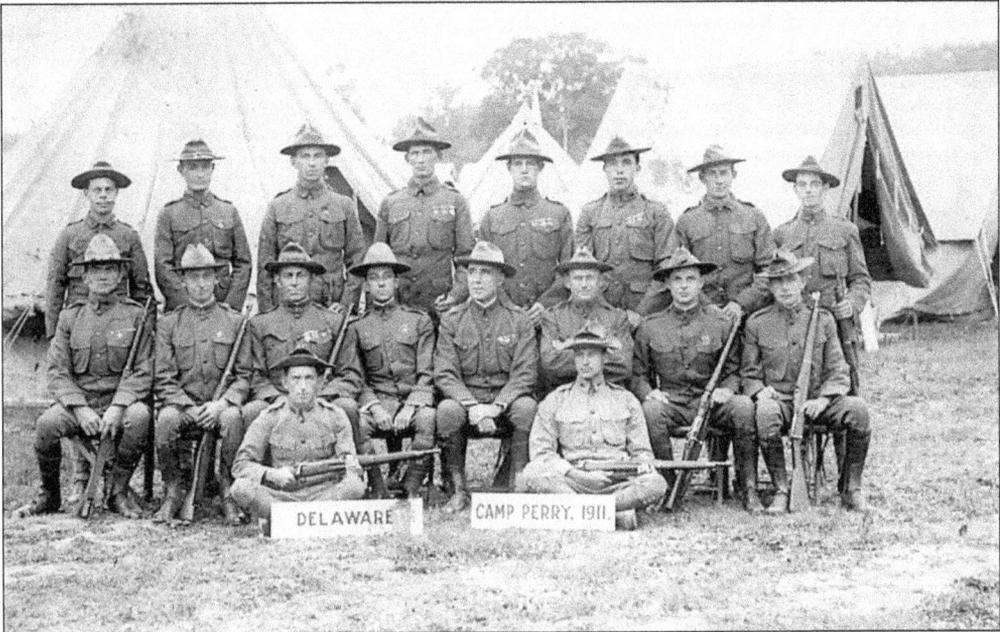

COMPANY B-DELAWARE REGIMENT. The State of Delaware began to get serious about a National Guard Regiment during the Spanish American War in 1898 when Company B was called to service in preparation for a long war with Spain. This photo shows Capt. William E. Lank, commander with his detachment at Camp Perry, Ohio, in 1911.

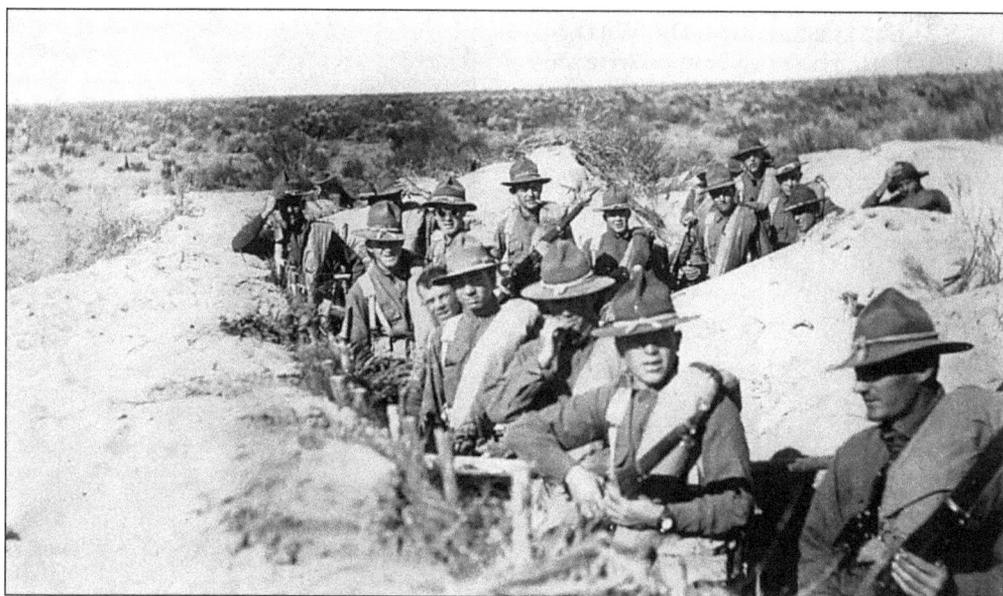

COMPANY B CHASING PONCHO VILLA. The local militia was called to duty in 1916 during the uprising in Mexico when Poncho Villa raided ranches in New Mexico. Milford boys served with John J. "Black Jack" Pershing in Deming, New Mexico, for about six months.

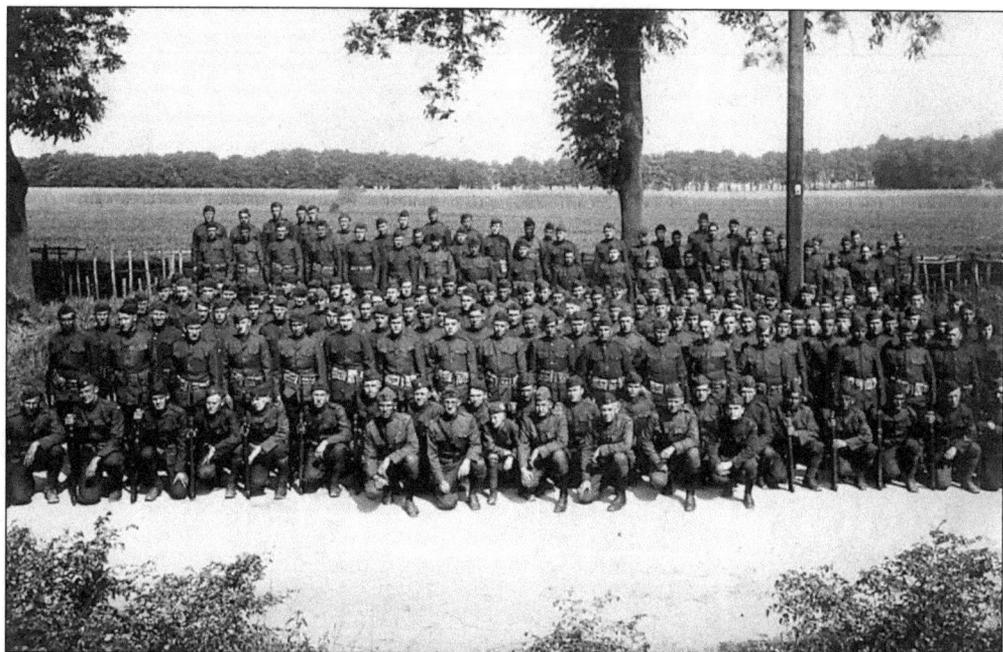

CO. B. 59TH PIONEER INFANTRY REGIMENT. The Milford troops were federalized in 1918 and sent to France to fight with the American Expeditionary Force during World War I. Company B was led by Maj. James W. Cannon and served a year overseas. They were mustered out in 1919 and returned home after helping to defeat the Kaiser and German allies in the trenches of France.

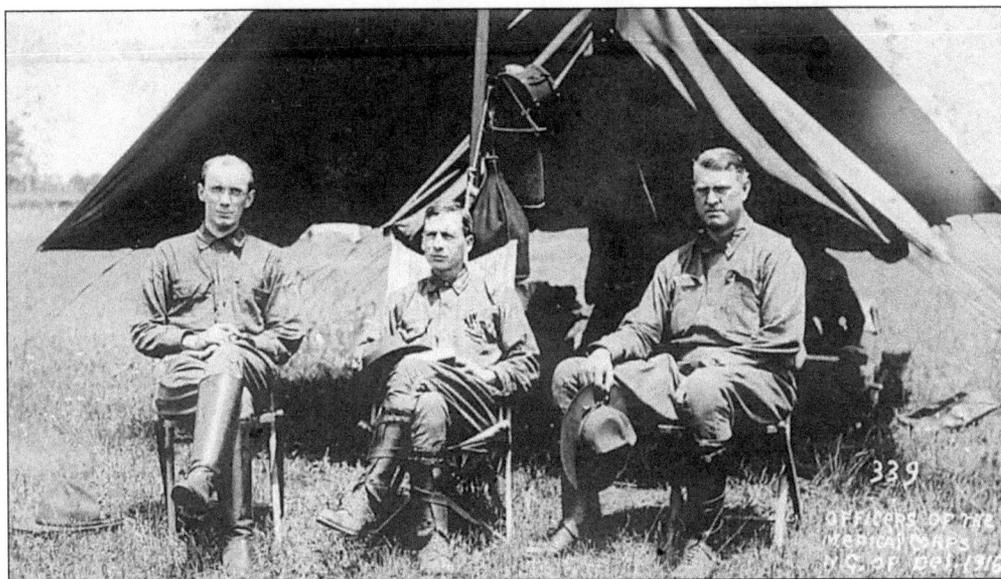

DRS. WILLIAM MARSHALL, 1916 MEDICAL CORPS. Small towns were very patriotic in the early 20th century. Every man felt an obligation to serve in the military and never hesitated to answer the call when the country mobilized. The Marshall brothers left a lucrative medical practice in Milford, and marched off to war without hesitation. They were in the ranks from 1916 until 1920.

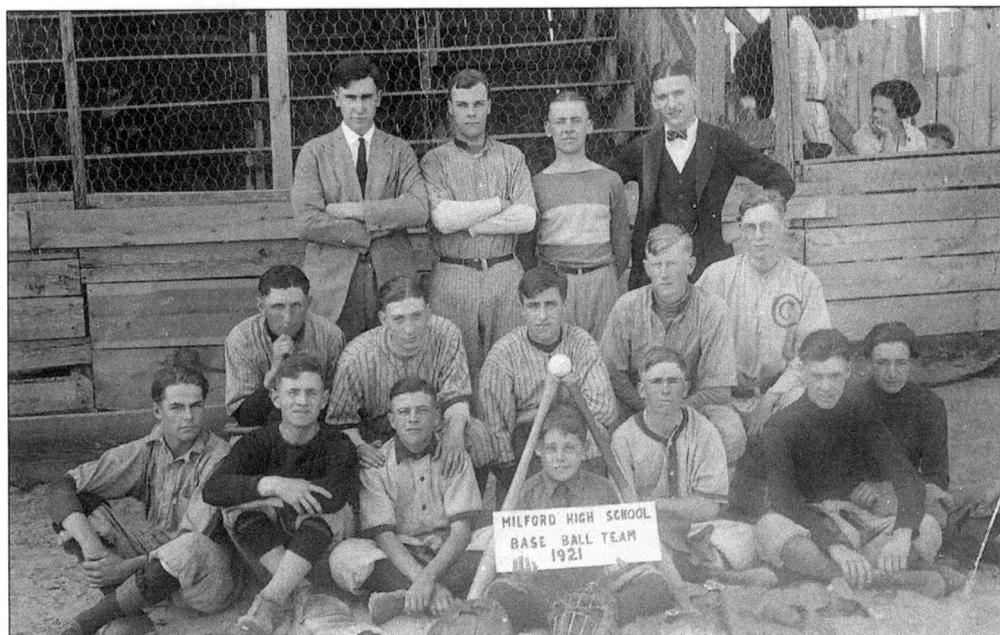

MILFORD BASEBALL TEAM, 1921. From left to right are (front row) John Ireland, unidentified, Nelson Roberts, James Holzmueller, Ralph Scott, two unidentified, and Left Smith (mascot in front); (second row) Richard Wilson, unidentified, Harold Nutter, unidentified, and Frank Grier; (third row) Holland Prettyman, Theodore Hudson, William Denney, and Mr. Gross (coach).

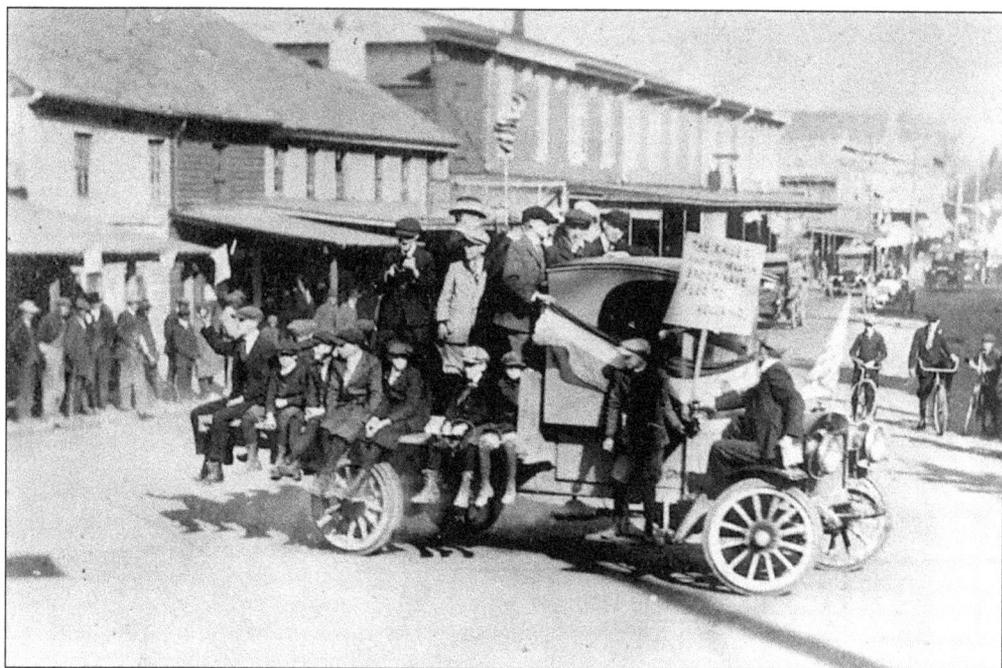

ARMISTICE DAY—VICTORY OVER THE GERMANS. Milford citizens turned out on Main Street following the defeat of the Kaiser on November 11, 1918. Joy was everywhere as America felt it had won the war and saved the world in the name of democracy.

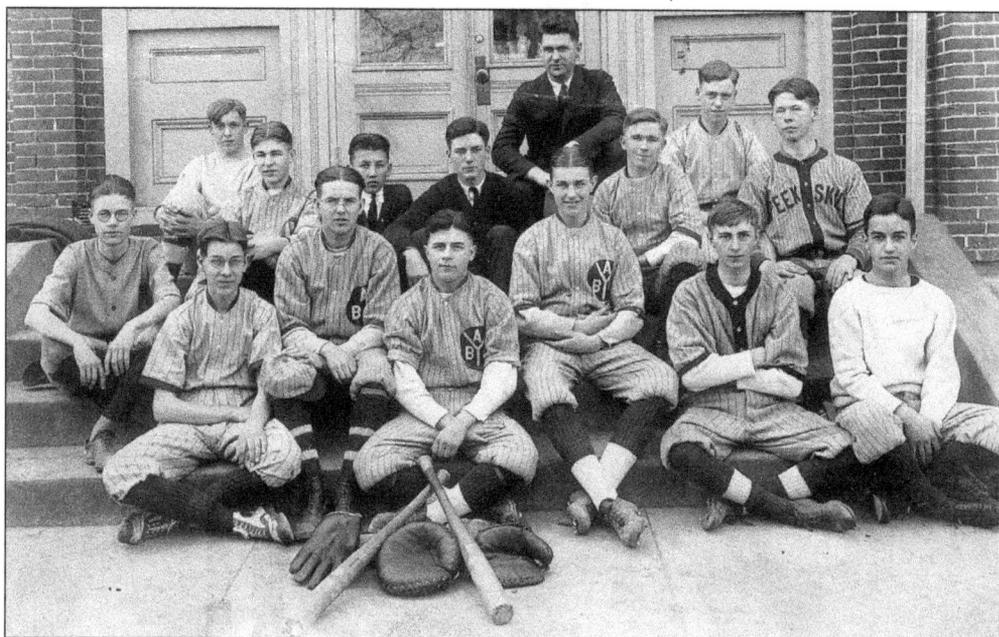

MILFORD HIGH BASEBALL TEAM, 1922. From left to right are (front row) Walter Johnson, Ralph Tyler, Roland Walls, Jimmy Holzmueller, unidentified, Frank Sapp, and Gene Pratt; (second row) Jay Manlove, Bill Smith, Leslie Greenly, Reese Hitchens, Ralph Scott, George Reed, Smith Chism, and Coach Frank Barsby. The team is pictured on the steps of North Street School (1905–1930).

Five

THE 1920S AND THE
DEPRESSION ERA
1920–1940

The period following the first World War was a time change for Milford. When the troops returned from France they had seen death and destruction on a grand scale—the innocence they knew during their formative years in Milford was gone forever. The Industrial Age had brought the automobile and electricity to Milford and the Caulk Company and local canneries provided employment for a work force not strapped to small farms and low prices. Sailing vessels were breathing their final gasp and shipyards would wither and die unless they could find a link to the future. Vinyard shipyard was able to make this transition with motorized boats and steel-hulled vessels. Trucking started a process of displacing railroads as the primary means of transportation of farm products to Baltimore, Philadelphia, and New York. The 20-year period leading to the outbreak of World War II was a transition period. Modern methods were replacing the old horse-and-buggy ideas. Small towns are resistant to change and make every effort to cling to the time-tested methods of the past. Milford made these changes slowly. Improved highways and bridges from 1924 to 1945 enabled families to branch out to Rehoboth and Wilmington in their business ventures as well as leisure-time activities. The photos in this chapter capture Milford and its citizens as they lived through two decades following World War I.

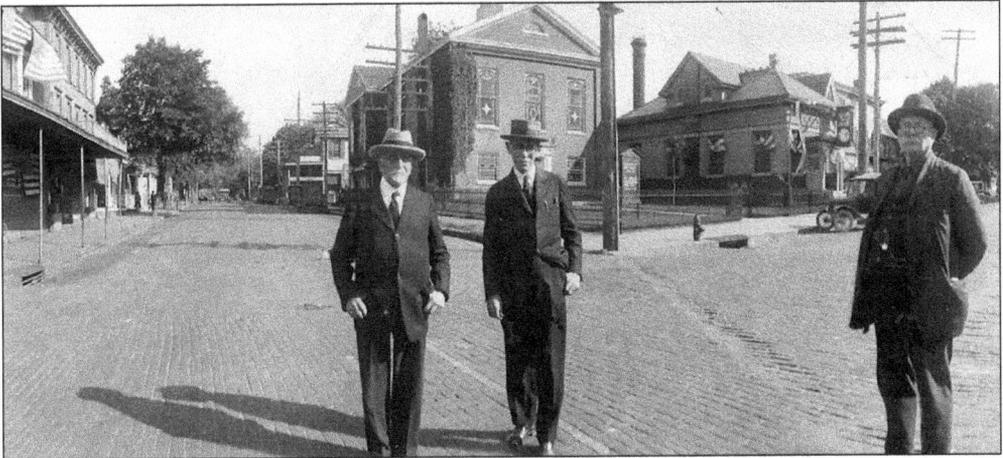

SOUTH WALNUT STREET, 1920. This photo typifies the spirit of Milford in 1920. Walnut Street has been paved with brick and the Presbyterian Church and Milford Trust Bank represent the hopes and dreams of a small town on the move. Rev. Henry L. Bunstein, left, was minister of First Presbyterian Church for 47 years, from his arrival in Milford in 1880 until his death in 1927. Samuel C. Evans Jr., center, was owner of a jewelry and watch repair shop on South. Walnut Street. The photographer was Andrew Komorowski, who skillfully adopted a time-delay camera to allow him to insert himself into his photographs as a bystander.

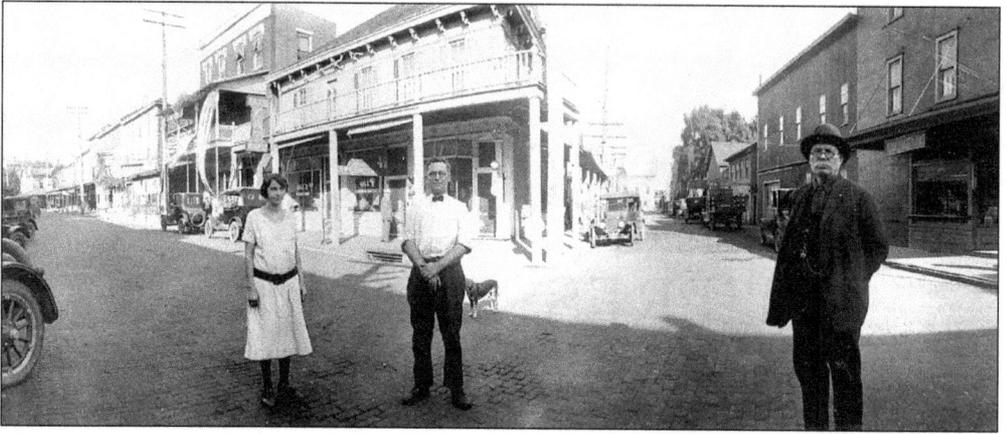

NORTH WALNUT STREET, OCTOBER 1925. Andrew Komorowski, right, took this photo as the delayed shutter captures Milford's bustling activity on the north side of the Mispillion. Henry Hill and a local waitress operated the restaurant and apartment building in the background. Humes Hardware store is visible at the right. Cars can be seen lining North Walnut Street in a diagonal parking pattern that was adopted by town council in an attempt to modernize downtown in 1920.

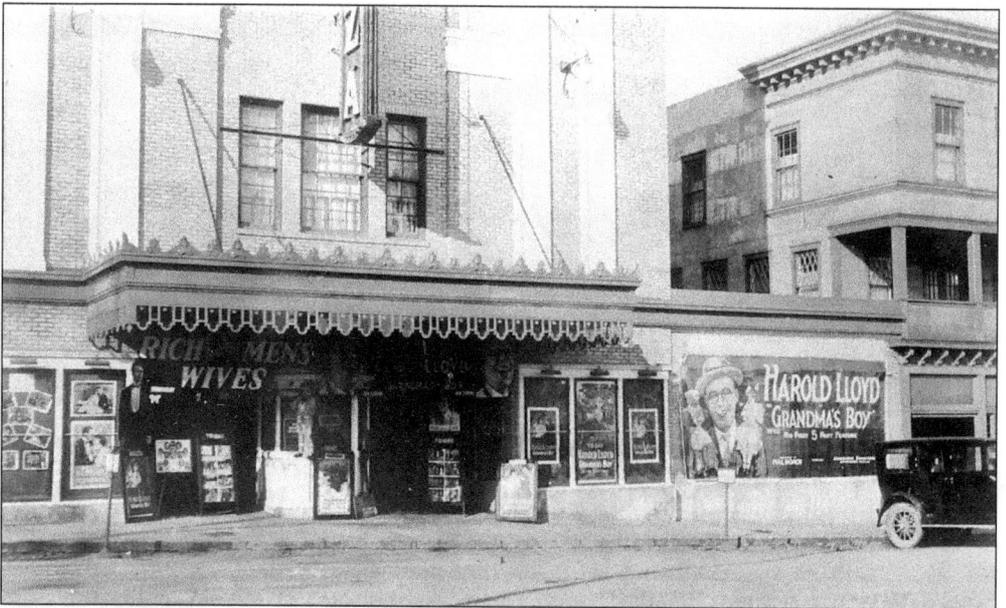

THE PLAZA THEATER, 1922. This building was the first large theater and meeting hall in Milford. Will Warren opened the Palace on North Walnut Street about 1915. A newer theater moved to the center of South Milford in February 1922 to open the premier movie house in Milford. The brick theater had space for 1,000 seats. It burned the night of September 23, 1946, in a spectacular blaze long remembered by local firemen. The theater was rebuilt and opened in July 1948, as the Shine Theater seating 1,800.

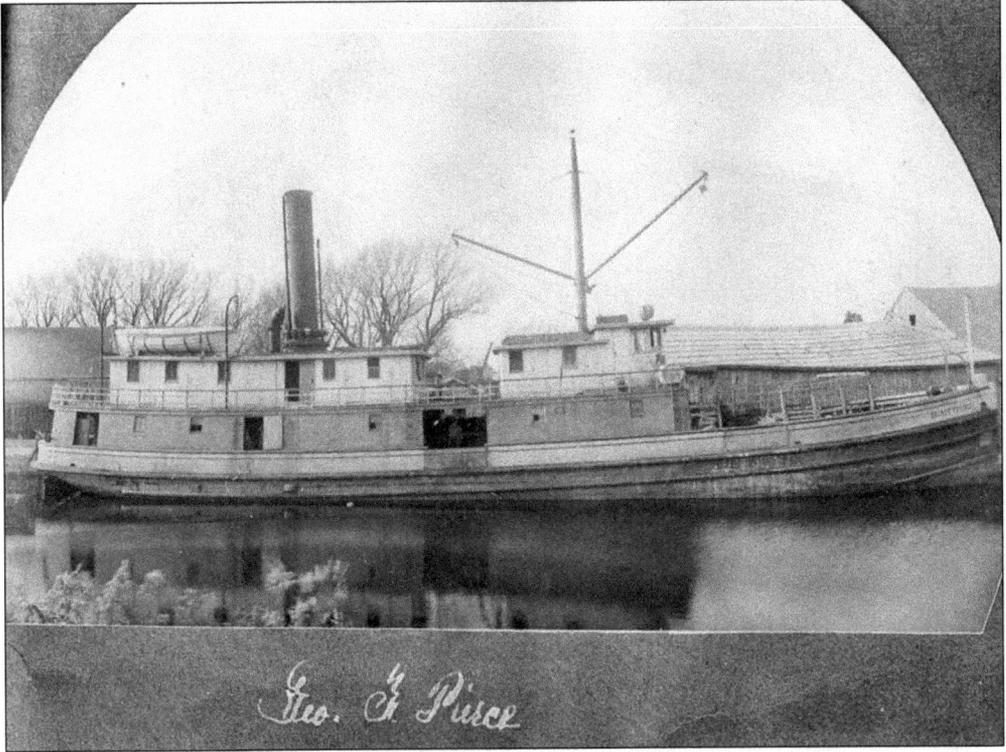

GEORGE F. PIERCE STEAM FREIGHTER, 1912. The freight steamers of the early century could still be seen carrying coal, fertilizer, and heating oil up the river as late as 1938. George Pierce was engaged in all types of bulk shipments and this boat was a common sight to many Milfordians of that era.

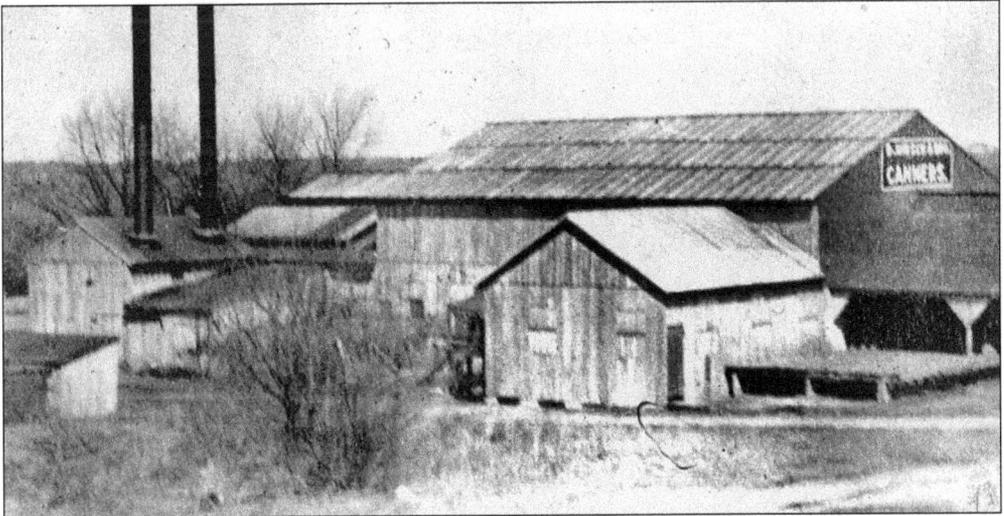

HIRSCH CANNERY, 1894–1921. Dan Hirsch owned this cannery located on the north end of Marshall Street and just east of Abbott's shipyard. He was a partner with David Reis of Baltimore until Reis's death in 1903, after which he continued until 1921 with his brother Lee Hirsch. Hirsch later became a director in the local bank and left a legacy that provides an endowment for local scholarships for deserving Milford students.

Shirt Factory, Milford, Del.

THE BARTO SHIRT FACTORY, 1900–1921. This three-story building was located at the southeast corner of Church Street and Southwest Front. This was the first known effort to establish a textile operation in Milford. Unfortunately, the building burned to the ground in a fire in 1921. The newly formed Carlisle Fire Company purchased the site in 1922. They completed the Carlisle Fire House in 1925 and occupied this building until moving to the present site in 1977.

DRAPER & COMPANY CANNERY, 1921. The fire that destroyed the Barto Shirt Factory in 1921 provided an unobstructed view of the major cannery in Milford owned by David Reis until 1903 and then purchased by George H. Draper Sr. in 1904. His son, George H. Draper Jr. managed the cannery from 1920 until 1959 when it was sold to Draper Foods Inc. and ceased canning operations. This cannery had its own water tower for packing vegetables and a major steam boiler for cooking vegetables prior to canning. In 1898 David Reis added the brick packing building that extended from Southwest Front Street to the Mispillion.

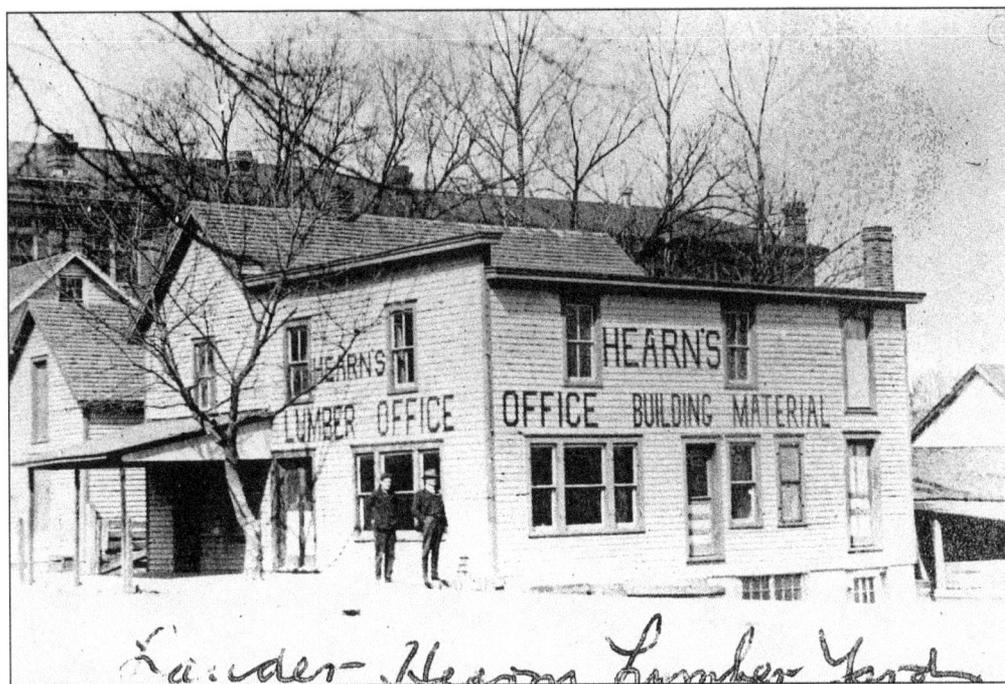

HEARN'S LUMBER YARD, 1925. Louder Hearn and his nephew, I. Dolphus Short, both came to Milford from Georgetown. They were originally partners, but separated into two lumber companies located along Causey Avenue between Church Street and Maple Avenue near the railroad depot. When Louder Hearn died in 1937 his business was purchased by Logan Grier and became Grier Lumber until 1980 when Riverbank Associates purchased the site and converted several buildings into office space and stores. Louder Hearn was a bachelor and lived his entire life in the New Windsor Hotel. He left a scholarship legacy for college-bound students graduating from Milford High School.

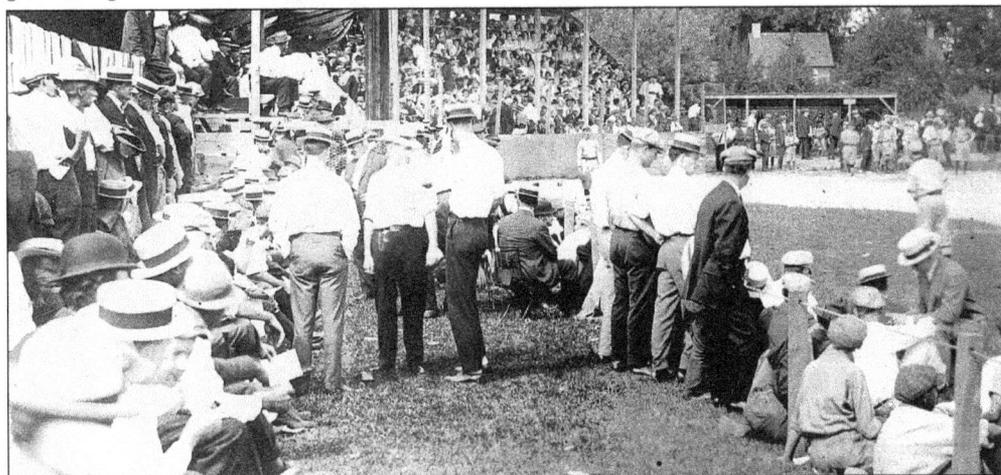

MILFORD BALL PARK, 1928. Dr. Walter Grier was the driving force behind baseball in Milford from 1910 until 1949 when the semi-pro Milford team was finally disbanded. He purchased, in 1913, a 4.5-acre tract of land along Southeast Fourth and Montgomery Streets to serve as a home for his local team. The L.D. Caulk Co. sponsored the baseball team made up from a loose group of retired pros, talented locals, and athletes between jobs.

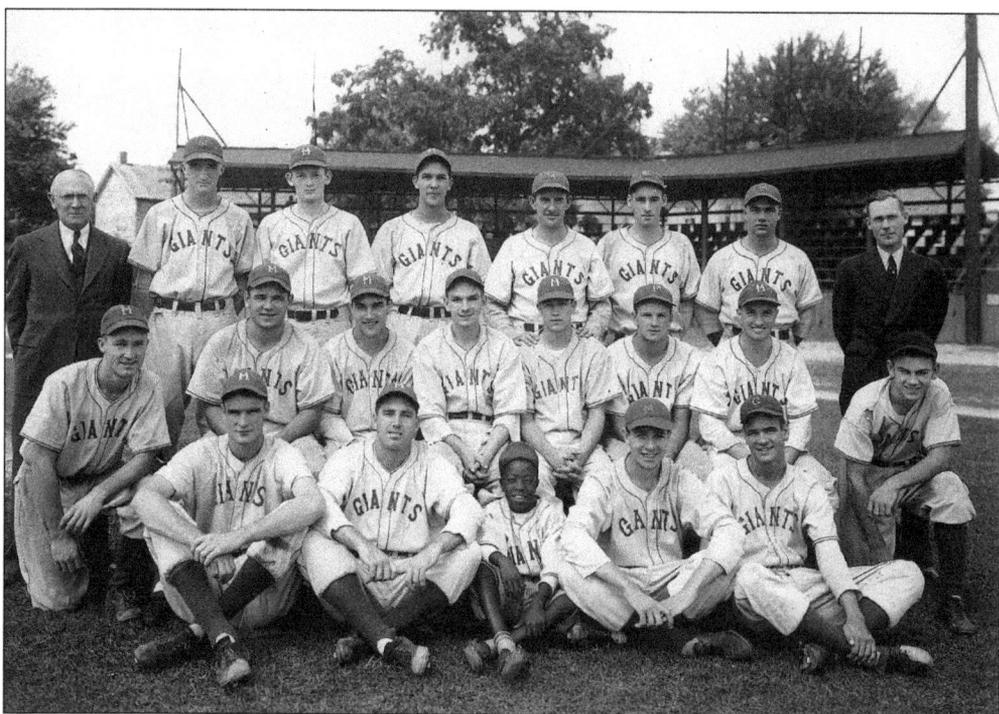

THE MILFORD GIANTS, 1940. Dr. Walter Grier managed all of Milford's Eastern Shore League teams from 1913 through 1949. His assistant was his son Frank R. Grier shown in the rear right. The catcher, Art Gunning, shown in the rear row (third from right) settled in Milford and worked for Grier Lumber and followed his son Steve Gunning's career as a star athlete for Milford football, basketball, and track teams during the 1960s.

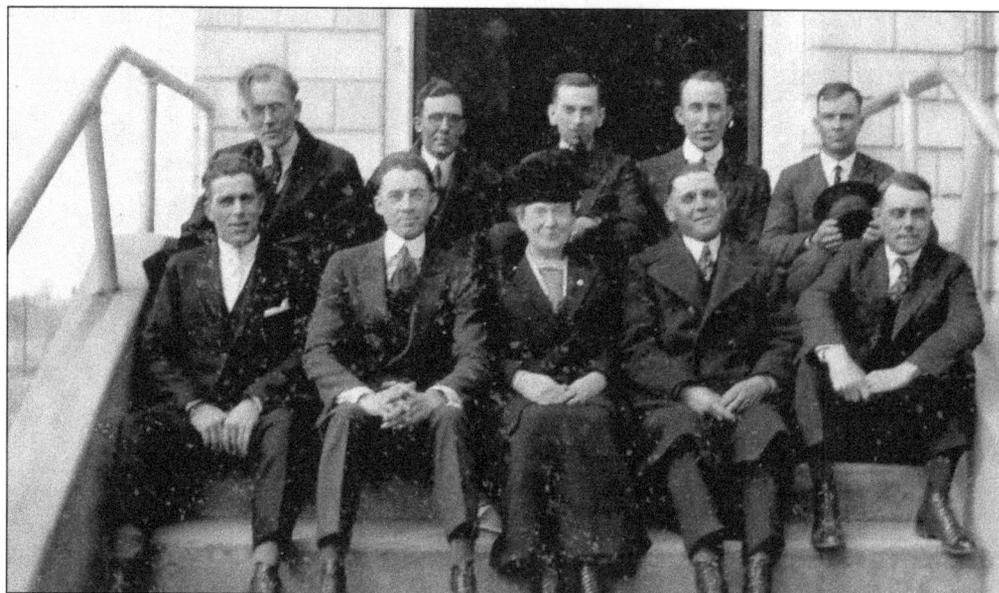

SALLY WILSON'S SUNDAY SCHOOL CLASS CALVARY CHURCH, 1930. From left to right are (front row) unidentified, Clarence Davis, Sally Wilson, Grover Denny, and Charles Swain; (back row) unidentified, William Kenton, Roy Pettyjohn, Harry Emory, and Harold Clifton.

104

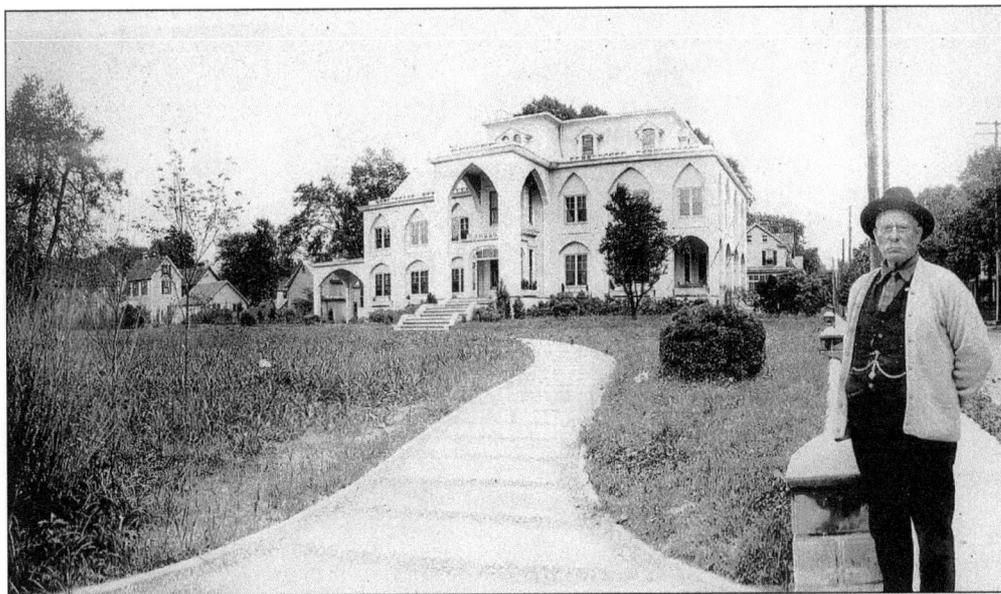

RUBY VALE MANSION, JUNE 1928. Ruby Vale (1874–1961) came to Milford in 1896 to teach school at the Milford Classical Academy on Church Street. He met and married Elizabeth Williams, daughter of Col. Robert H. Williams. Ruby and Elizabeth reconstructed the former Williams residence in an Italian stucco style. Andrew Komorowski, whose trademark was to include himself in his photos, captured this image. The home burned on the night of December 28, 1952. Ruby Vale became a distinguished corporate lawyer based in Philadelphia and wrote several textbooks for corporate lawyers. (Courtesy of Mr. and Mrs. Robert Lingo.)

RUBY R. VALE AND ELIZABETH WILLIAMS VALE. The Vales lived in Milford from 1896 until their deaths in 1961. Their legacy provided funds to build city hall on the site of their former home at the corner of Southeast Second Street and South Walnut Street. Mr. Vale was a prominent corporate lawyer for the Standard Oil Company for much of his life.

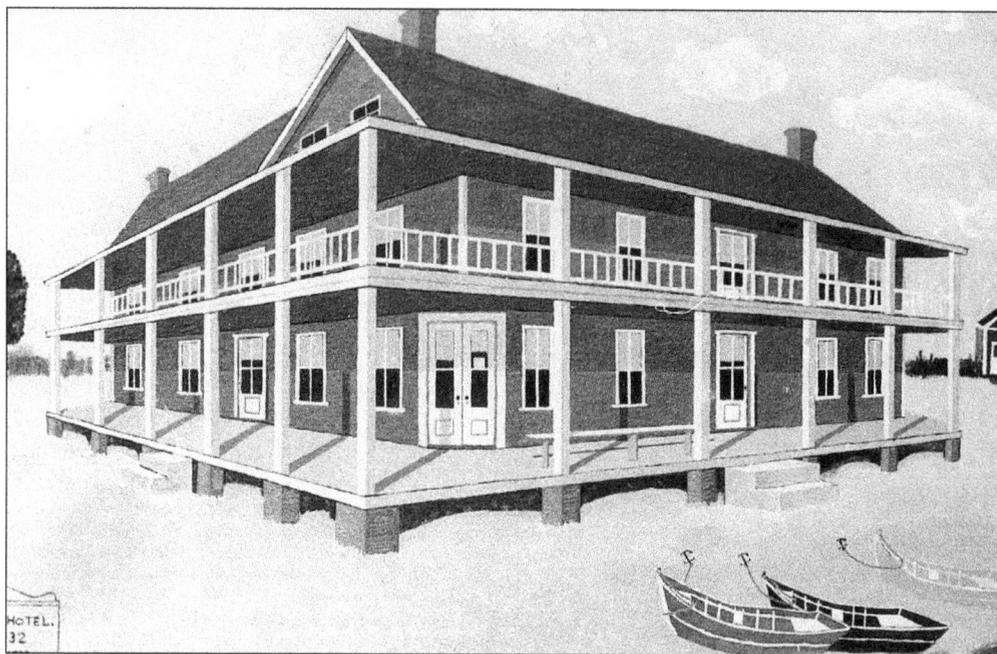

CEDAR BEACH HOTEL, 1930. This old hotel stood on the north end of Slaughter Beach in a grove of trees near Bill Passwaters's cottage known as Cedar Beach. It burned in 1932 after a long and colorful history. Heirs of William N.W. Dorsey built the hotel after his estate was divided in 1884. Passenger steamers that sailed between Milford and Lewes Breakwater formerly serviced it. The hotel was used as a point to smuggle contraband liquor to Milford during the era of Prohibition (1919–1932) and finally as a hangout for watermen.

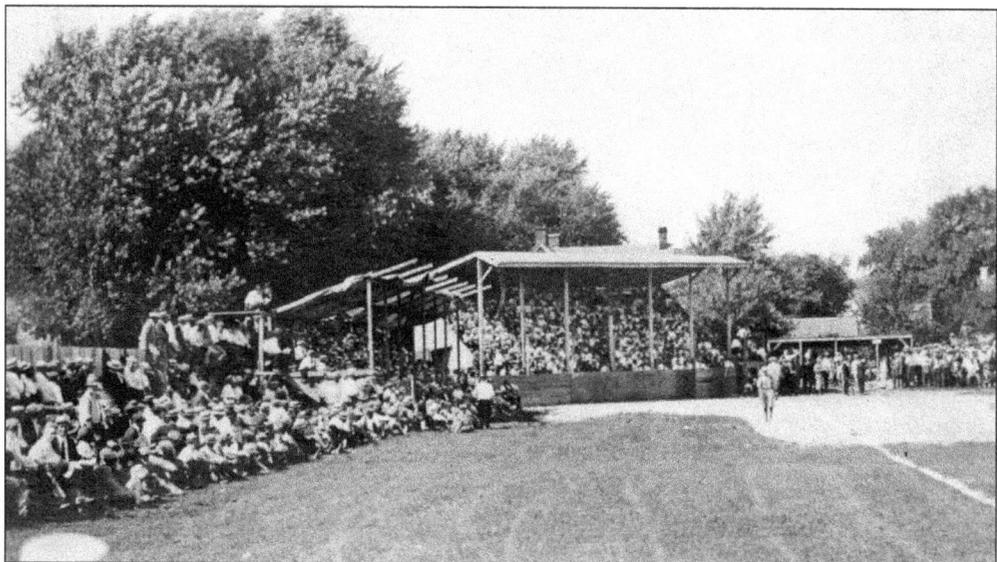

MILFORD BALL PARK, 1930. The baseball team provided local entertainment in Milford when travel was an extravagance and spare cash for fun was non-existent. The ballpark also served as the location for the annual fireman's carnival that raised funds each September for the Carlisle Fire Company. Circus acts, booths, and high-diving stunts were the order of the day during carnival week.

106

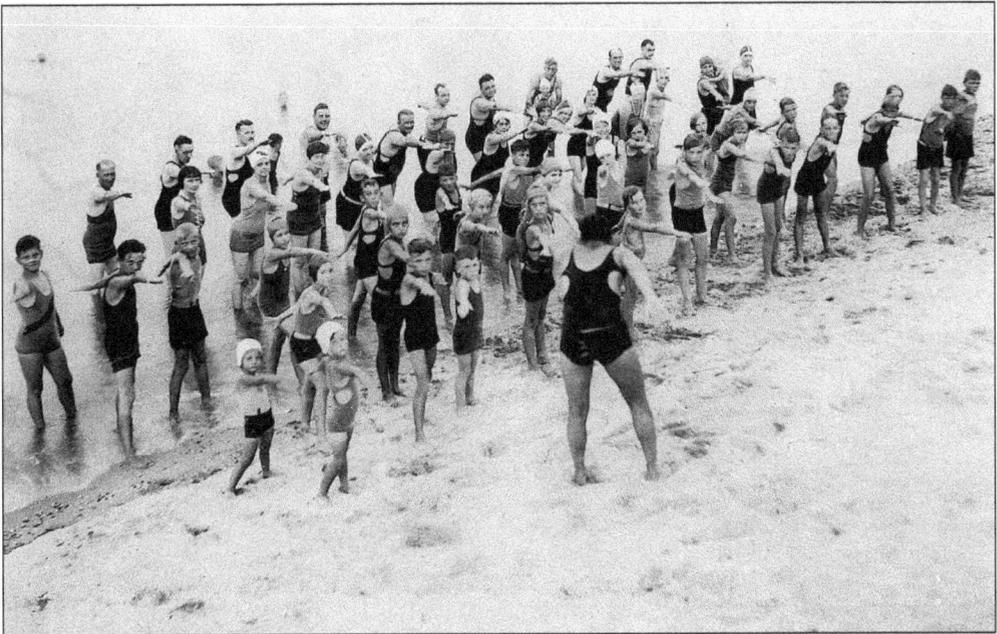

RED CROSS SWIMMING LESSONS, SLAUGHTER BEACH, 1930. Before World War II, Slaughter Beach was the vacation resort for many prominent Milford families. The Red Cross sponsored swimming lessons near the main pavilion at the center of the beach. Mr. Potter is the instructor in the foreground demonstrating the free-style stroke. The small children are, from left to right (front row) Elaine T. Dickerson, unidentified, Sam Marshall Jr., "Sis" Simpson and Donnie Holzmueller; (second row) Nelda Tropea, Marian Simpson, and Ruth Ann Holzmueller; (third row) Pres Hammond, Jack Burris, and Esther Hammond; (fourth row) Edna Simpson, Laura Draper, Lydia Toadvine, Mrs. Earl Atkins, Steve Toadvine, and Lankford; (fifth row) Dr. Clyde Nelson, Don Holzmueller, Earl Atkins, and George H. Draper Jr.

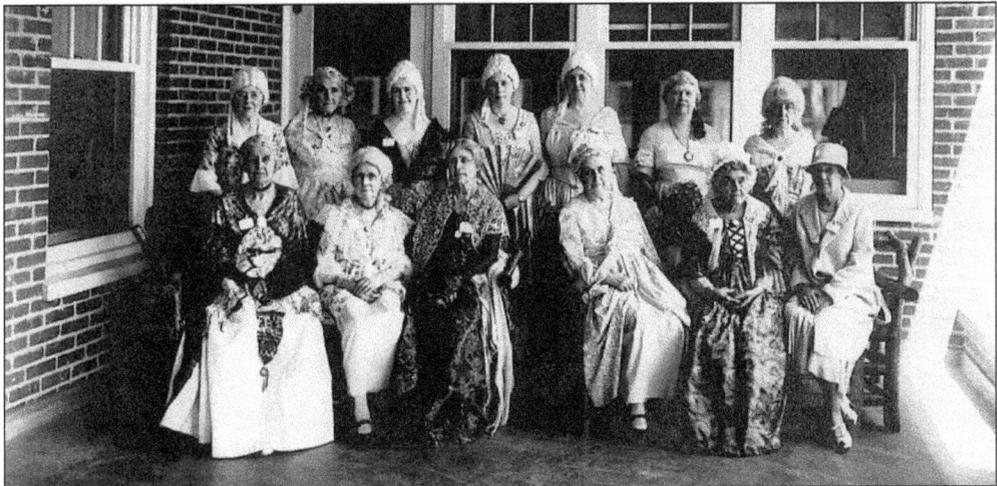

CENTURY CLUB LUNCHEON, 1931. The Century Club was the primary political and social gathering place for women during the 20th century. Here they attend a luncheon at the home of Mrs. A.D. Warner. From left to right are the following: (front row) Mrs. Cann, unidentified, unidentified, Mrs. A.D. Warner; (back row) Dr. Delema Draper, Mrs. George W. Marshall, Mrs. Clarence Fraim, Mrs. McCabe, and Mrs. Green.

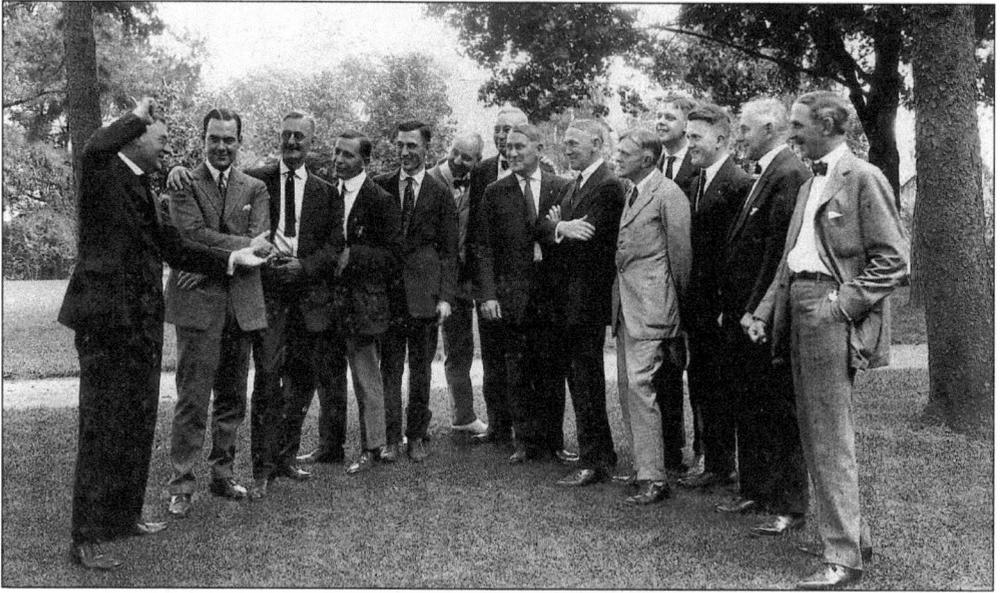

CAULK COMPANY MANAGERS MEETING, 1931. By 1930 the Caulk Company was internationally prominent and its local executives were wealthy and successful. From left to right are William Smith (marketing), Vaules Grier (vice president), Harry Grier (plant), Dr. Poetsky (research), Conner Mitten (finance), Dr. Gray (research), Silas Reynolds (treasurer), Davis Grier (sales), Walter Grier (manufacturing), George Grier (plant), Fred Lewis (administration), Clyde Nelson (research), Frank Grier (vice president of operations), and Layton Grier (president).

DISTINGUISHED CLASS OF 1923. The freshman class of 1923 became Milford's leaders during the second half of the century. From left to right are (top row) Mildred Greenly, Lila Wall, unidentified, Virginia Grier, Edith Nunn, Eleanor Roosa, Myra Ackerman, Phyllis Griffith, and Delema Walls; (second row) Walter Johnson, Oliver James, unidentified, Robert Griffith, Smith Chism, and unidentified; (third row) Ralph Tyler, unidentified, Dick Abbott, Lawrence Lack, Lowell Farber, and unidentified; (bottom row) Leslie Greenly, unidentified, George Reed Jr., Chester T. Dickerson, and Howard Vreeland.

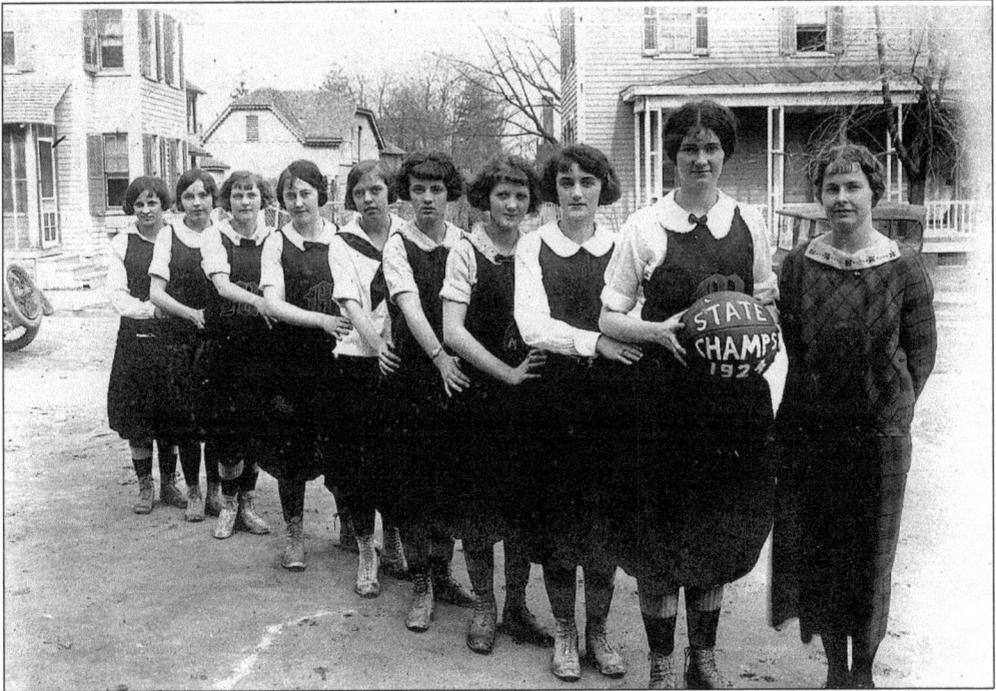

STATE BASKETBALL CHAMPS, 1924. Helen Pierce Jones coached the Milford girls to a championship in 1924. From right to left are Virginia Smith Grier, Lillie Cook Mason, Myra Ackerman Boddy, Helen Morris Deputy, Phyllis Griffith Phelps, Lila Hudson Wall, Katherine Horton ?, Edith Nunn ?, and Dorothy Scott Johnson. (Courtesy of James Townsend.)

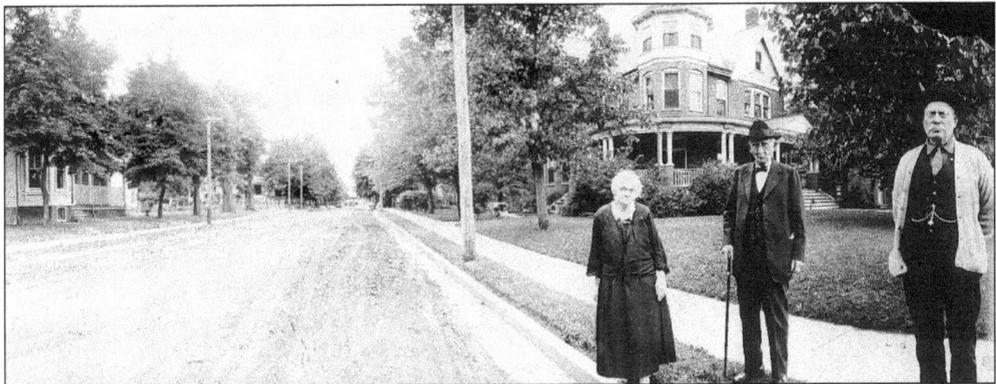

MR. AND MRS. GEORGE H. DRAPER, 1925. George H. and Ellen Draper moved from their Slaughter Neck farm to 100 Causey Avenue in 1885 to start a new cannery on Southwest Front Street at the Mispillion River. Mr. Draper retired in 1920 and turned over the management of Draper Canning Co. to his son, George H. Draper Jr. The photographer, Andrew Komoroswski, is positioned in the photo using a delayed shutter mechanism that allowed him to insert himself into his photos.

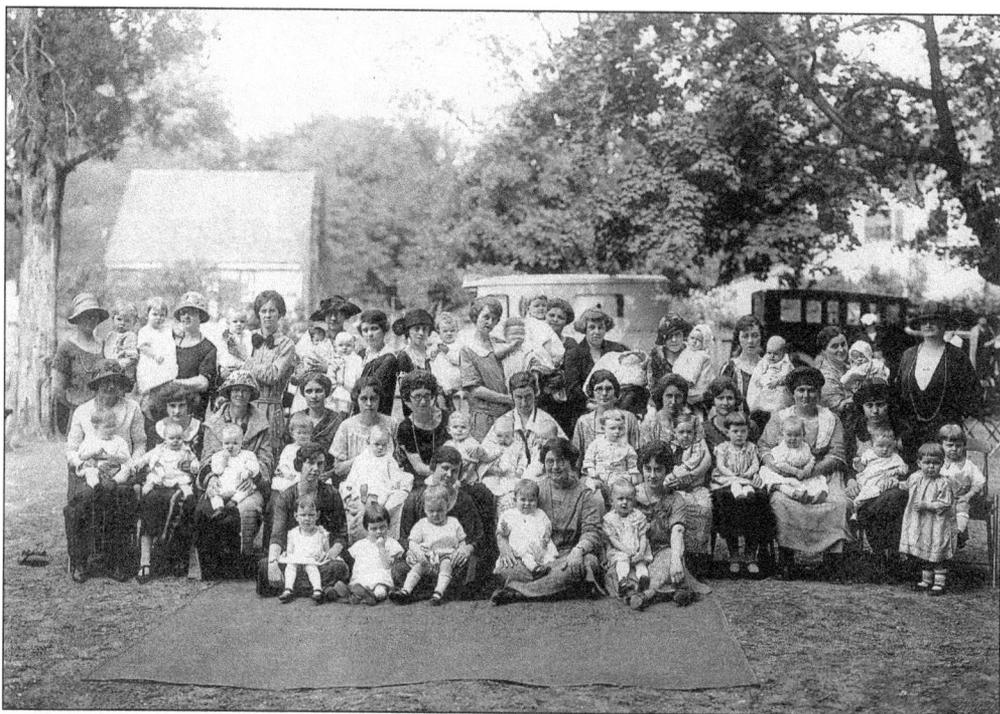

BABY DAY AT MILFORD EMERGENCY HOSPITAL, 1925. Milford was growing during the post-World War I period. The new Milford Emergency Hospital sponsored a "Baby Day" each year to show-off the babies delivered in the hospital. This photo was taken in the rear of the former Annie P. Williams home that was converted for hospital use in 1921. Local *Chronicle* editor, L. Hayes Dickerson, is visible elevated in the center-rear of this photo with his mother, Laura Murphy Dickerson. He was three years old and rose to prominence during the Cold War as a photo reconnaissance flyer for the Air Force.

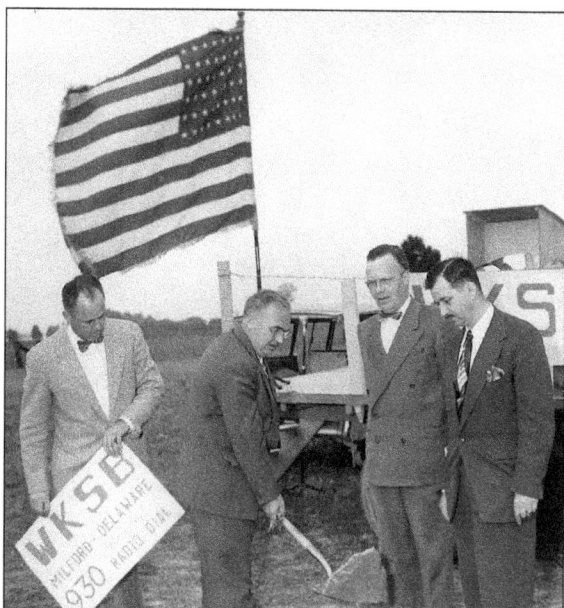

WKSB SIGNS ON, 1953. Milford's first radio station began broadcasting on October 30, 1953. City Manager Calvin Ball and Mayor Edward C. Evans dig the first ground for the new station while owners Herbert Griffith Jr. and Charles Lundstedt (Pocomoke City) look on. This station was purchased in 1971 by Thomas H. Draper and launched his career into broadcasting that includes WBOC-TV and Draper Communications today.

PRESIDENT HARDING VISITS MILFORD. The last time a president visited Milford was on June 9, 1923. Warren G. Harding was inducted into local Masonic Lodge #49, Tall Cedars of Lebanon. Harding came at the request of Dr. Walter Grier and his brothers. After a trip downstate from Wilmington, he made a whirlwind tour of the Milford Ballpark and a parade held in his honor on Walnut Street. The president dined at the home of Dr. Frank L. Grier and drove to Lewes that evening to meet the presidential yacht that carried him back to Washington, D.C. From left to right are Dr. Walter Grier, Sen. Heisler Ball, George Christian (secretary to the President), President Warren G. Harding, and Dr. Frank L. Grier.

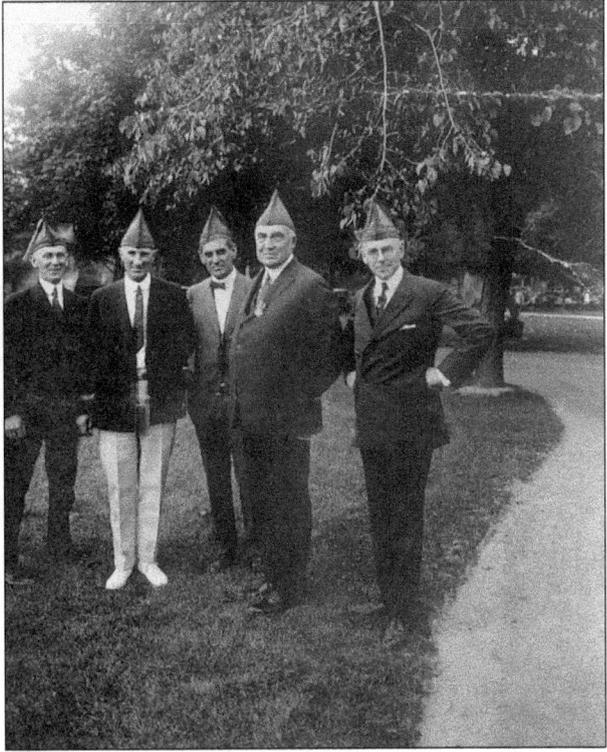

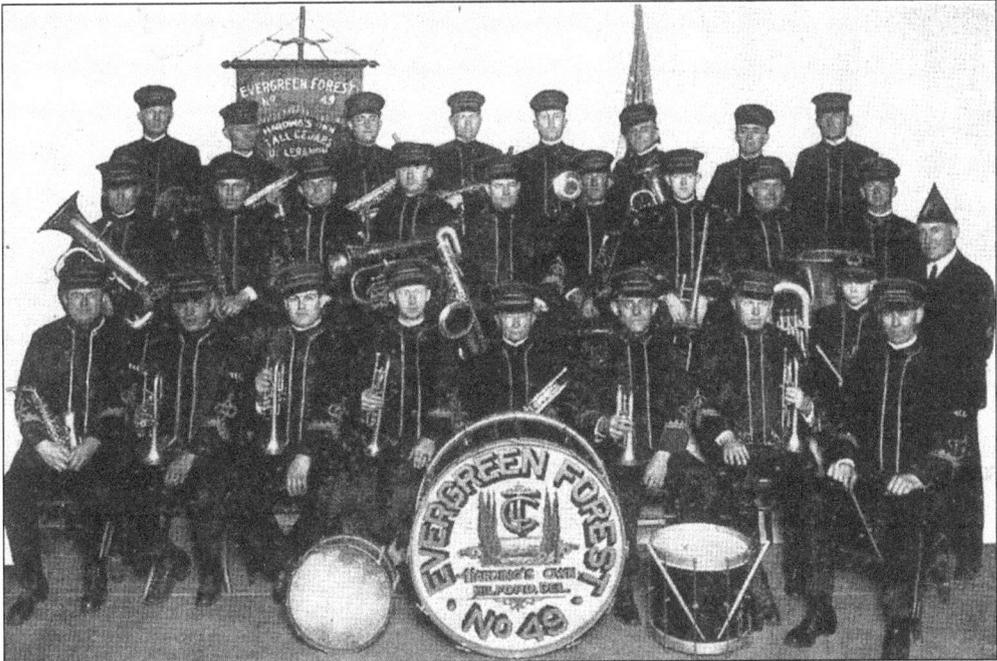

THE EVERGREEN FOREST BAND, 1925. The local Masonic club band was named for President Harding following his visit in 1923. They marched in all local parades and performed in Atlantic City, New Jersey, as late as 1931. (Courtesy of Dean Geyer.)

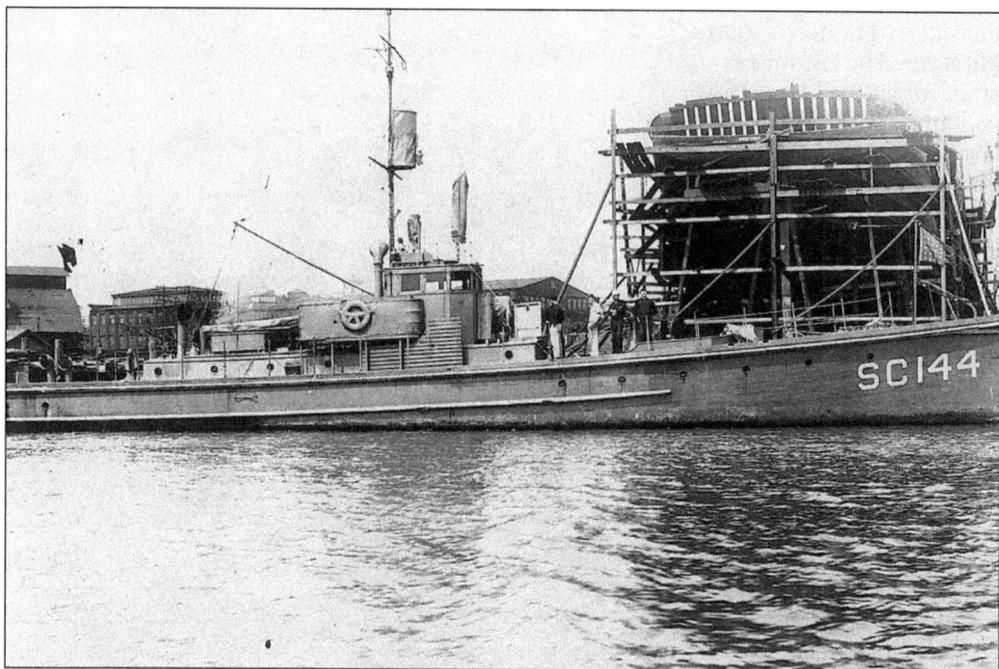

SUB CHASERS BUILT BY VINYARD SHIPBUILDING, 1917. This boat is one of three, 110-foot subchasers built by Vinyard during World War I.

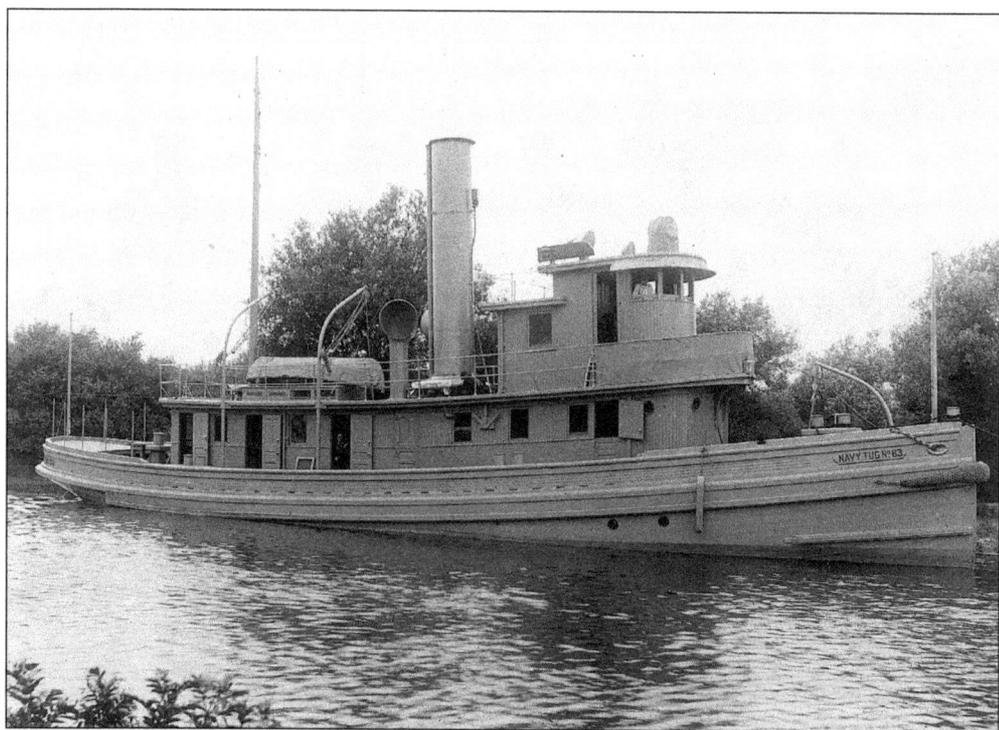

HARBOR TUGS FOR U.S. NAVY, 1917–1918. Vinyard built four, 88-foot harbor tugs during World War I.

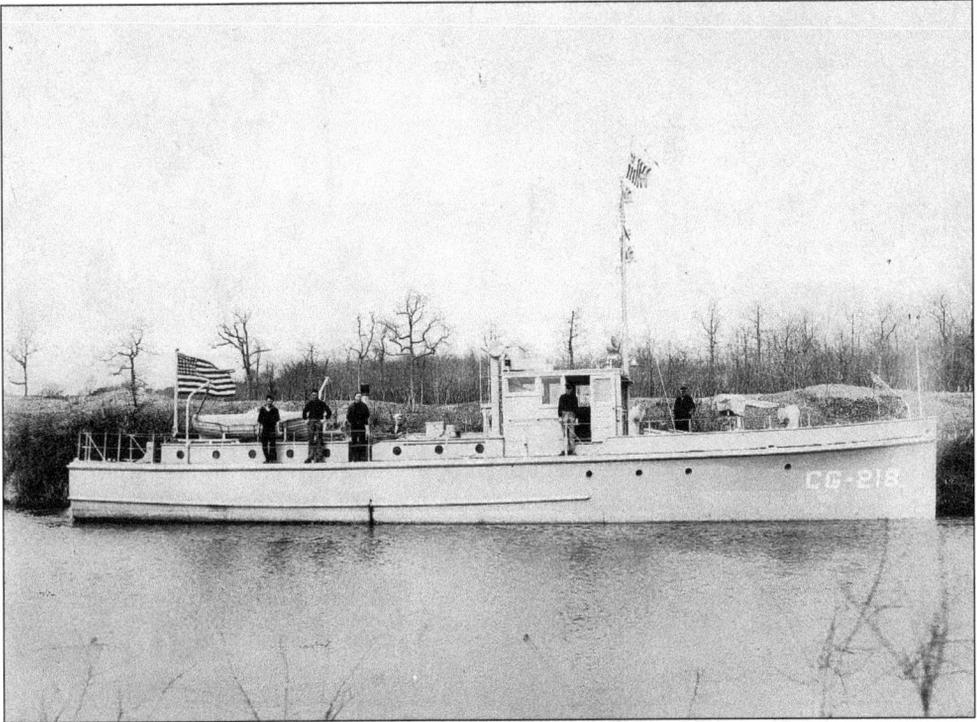

COAST GUARD PATROL BOATS, 1924. Vinyard Shipyards received a new breath of life during and after World War I. This ship is one of 10, 75-foot patrol boats build in just nine months during 1924. The government was mainly responsible for keeping the shipyards alive after 1920 when the last sailing schooner was built.

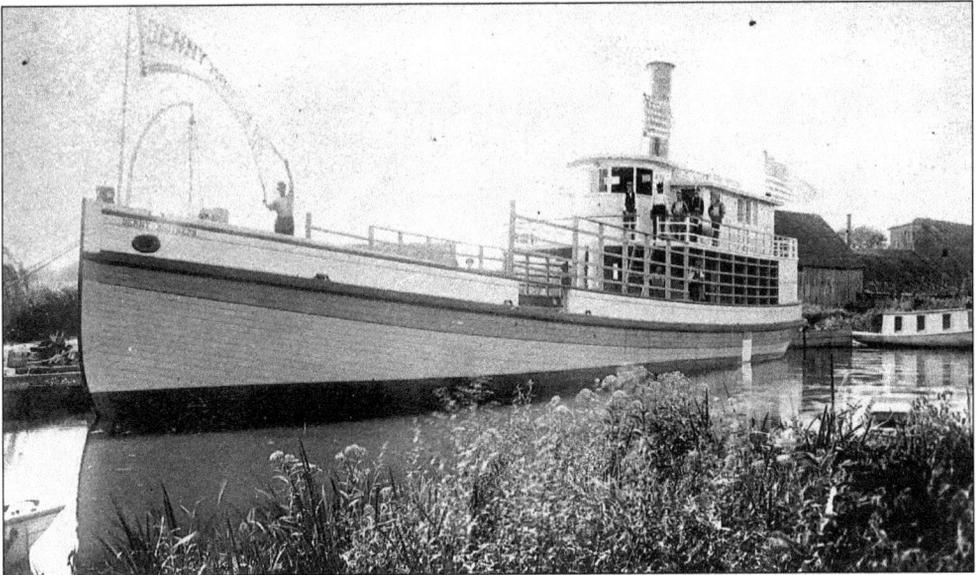

FREIGHT STEAMER DENNY BROTHERS, 1925. Milford continued to accommodate freight steamers on the Mispillion until 1940 when World War II ended the era of the old-style freighters. The "Denny Bros" is shown moored to a wharf behind the fertilizer plant near Walls Service station on Northeast Front Street.

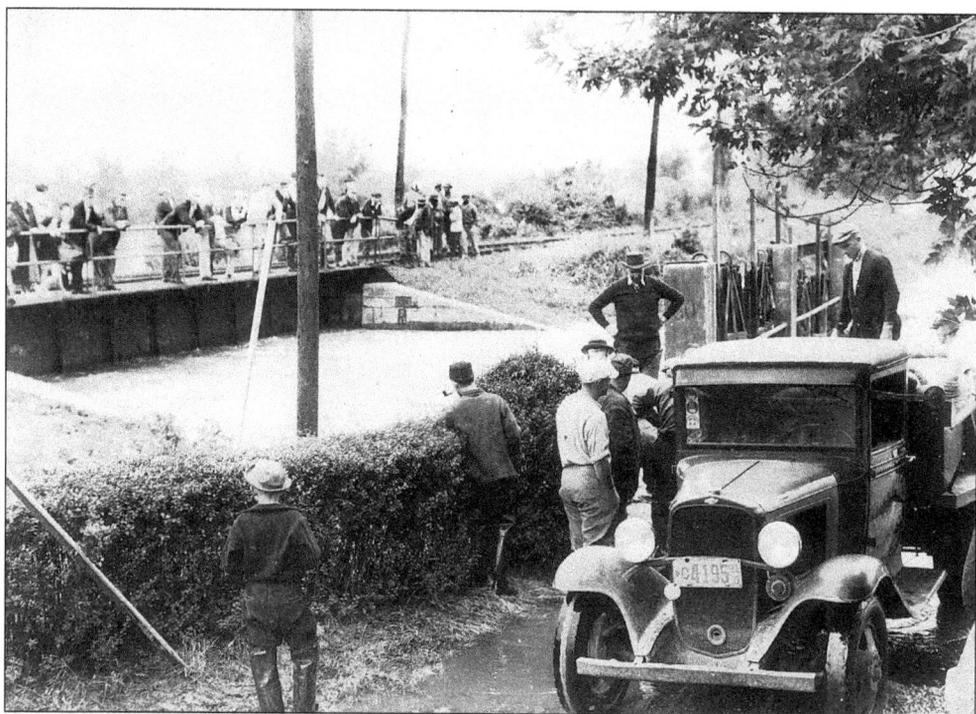

LABOR DAY HURRICANE, SEPTEMBER 6, 1935. Onlookers stare in disbelief at the floodwaters running beneath the railroad bridge along Maple Avenue on September 6, 1935. The Labor Day hurricane hit the Florida Keys on September 3 and progressed northward, hitting Milford with 10 inches of rain in one day. (Courtesy of Bill Brereton.)

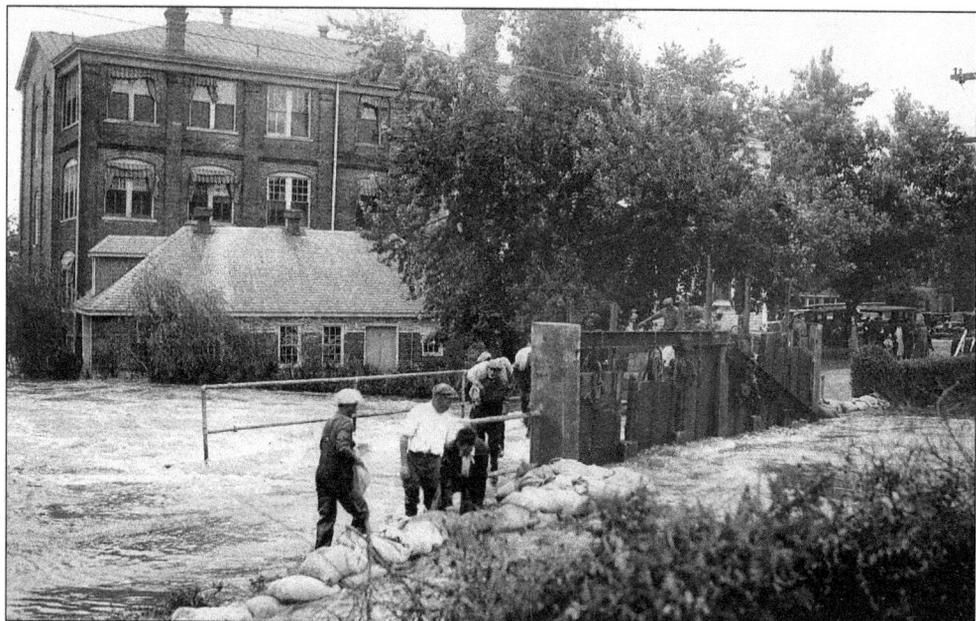

MAPLE AVENUE DAM COLLAPSES, SEPTEMBER 6, 1935. In spite of the best efforts of Milford citizens, the dam at Maple Avenue gave way under the pressure of floodwaters from the Labor Day Hurricane. Caulk Company offices and manufacturing plants were flooded for two floors.

114

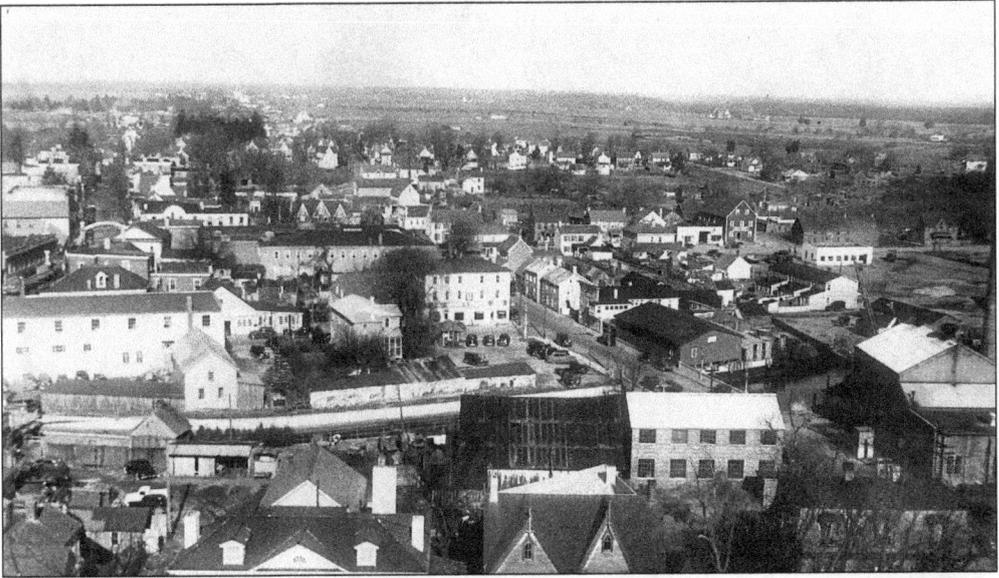

AERIAL VIEW OF MILFORD, 1939. The view of North Milford in this postcard was taken from atop the water tower located on Pearl Alley. The foreground of this photo shows the top of the Windsor home built by Henry Hudson in 1810. Smith & Hurley grocery store was in the frame home to the right with twin gables. The Milford electric power plant (North Washington St.) is shown at the right foreground (brick stack). The Washington Street Bridge was built in 1935. The Coopersmith dress factory is visible in the middle of the photo. The factory stretched from North Walnut to North Washington Street. Zadoc Callaway's flourmill on the northwest corner of East Street (last mill to operate in Milford) and Lou Chorman's blacksmith shop (dilapidated building at the northwest corner of East Street and Northeast Front) are visible in the right center.

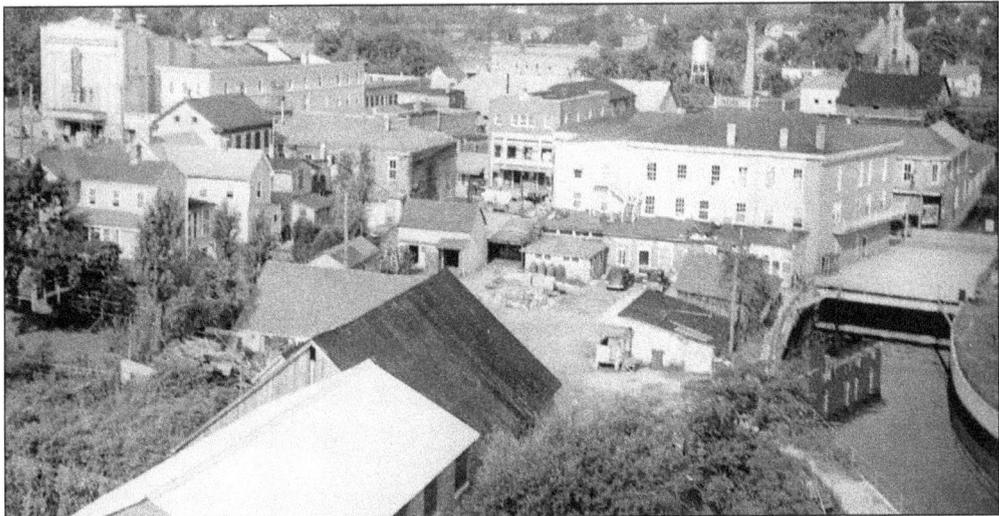

SOUTH MILFORD AERIAL, C. 1930. The Plaza Theater built in 1922 is shown in the background (left side). Pierce Hardware is visible in the center (three-story brick building built in 1928.) The old Methodist Church steeple can be seen in the right background. It was torn down in 1939 and replaced with the stone, gothic Avenue Church built on the same site in 1940.

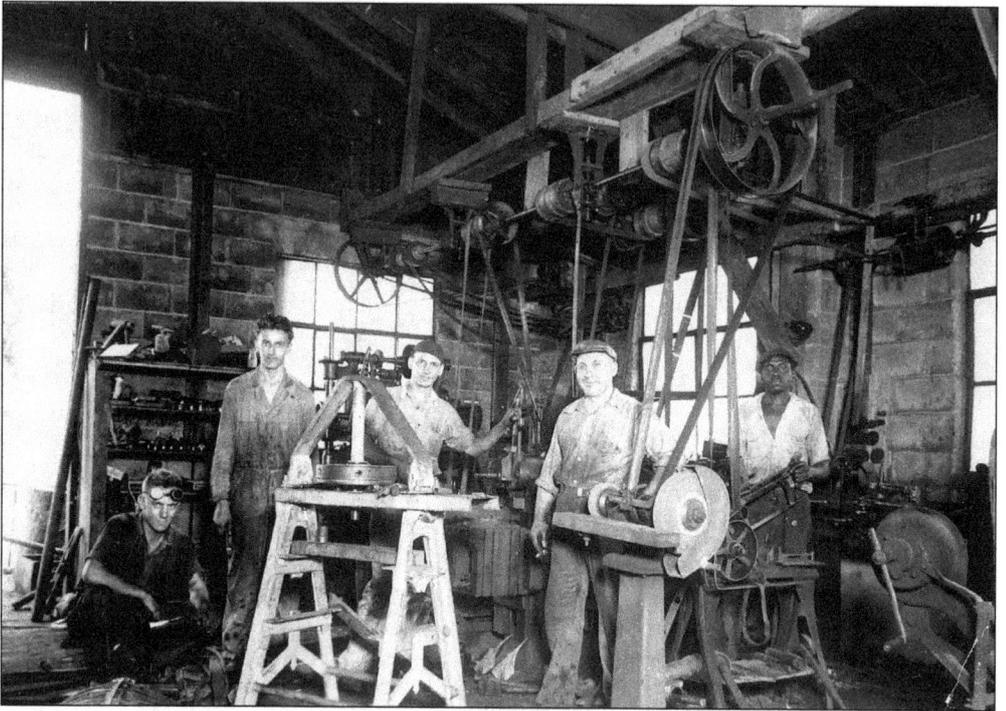

RUMPSTITCH MACHINE WORKS, 1936. Albert Rumpstitch emigrated from Germany to Sussex County in 1920 and opened a machine shop in 1930 at the corner of Cedar Beach Road and Rehoboth Highway. He was an expert in the early art of welding and machinery. He adopted various local boys as his apprentices. From left to right are Bill Kenton, Jack Keefe, Al Paquette, Albert Rumpstitch, and Lou Taylor. The building sits on the corner beside the newer machine shop built in 1946.

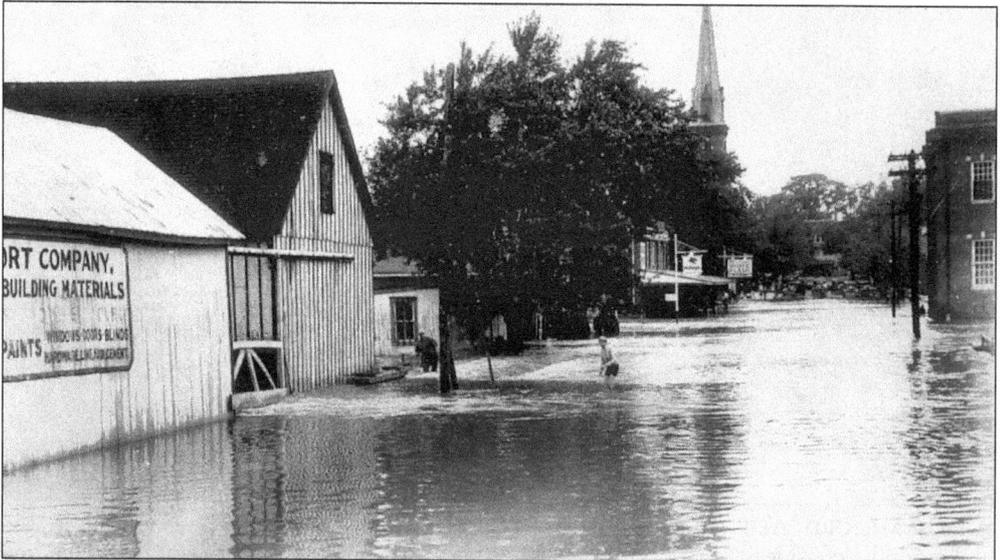

CHURCH STREET, 1935 FLOOD. The I.D. Short Lumberyard is visible at the left on Church Street. The old Methodist Church steeple can be seen past the former Carlisle Fire Co. Water flooded the town as a result of the Labor Day hurricane.

116

NEW METHODIST CHURCH GROUND BREAKING CEREMONY, 1939. When the Methodists decided to rebuild their frame church in 1939, Gov. Richard C. McMullen was on hand to join in the groundbreaking ceremony. From left to right are Governor McMullen, G. Layton Grier, Rev. Frank Herson, Roland Messick, and I. Dolphus Short.

BIRTHDAY PARTY. A birthday party was held on August 16, 1925, for Hayes Dickerson, who lived at 422 South Washington Street. From left to right are (front row) Evelyn Abbott, Elizabeth Kenton, Hayes Dickerson, and Phyllis Wilkins; (middle row) Bill Kenton, Robert Murphy, and Reese Jones; (third row) Mae Russell (Smith), Sara Dickerson (Kirby), and James Murphy.

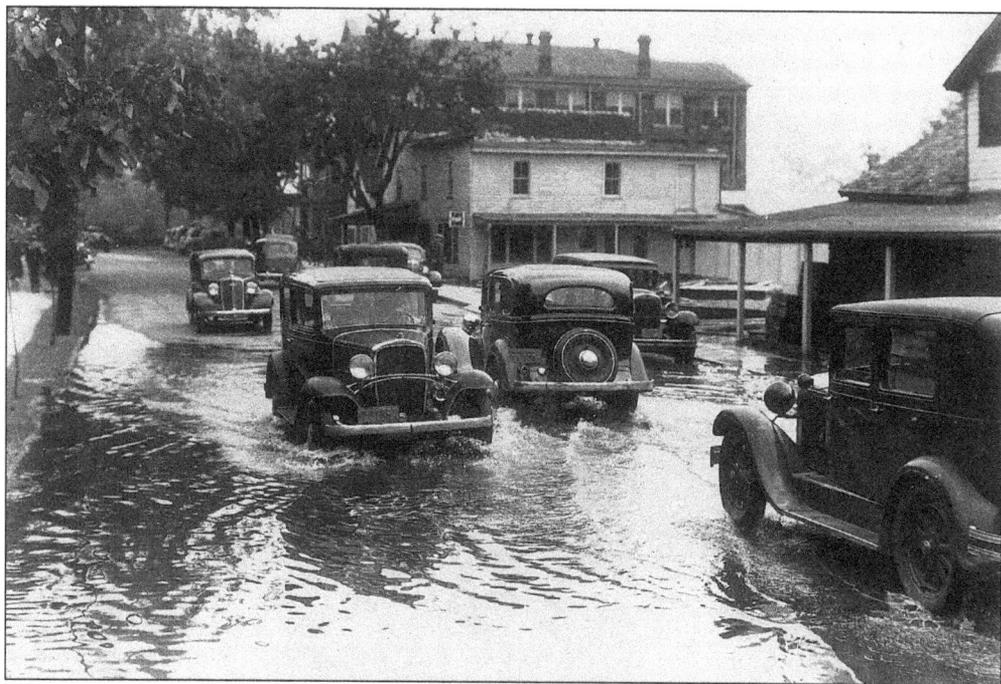

CAUSEY AVENUE. Cars passed through floodwaters along Causey Avenue after the September 5, 1935 Labor Day Hurricane devastated Milford. Louder Hearn's lumberyard is visible in the background next to Caulk Manufacturing Building (Masonic Building today). (Courtesy of Bill Brereton.)

MULHOLLAND SPOON MILL. John Mulholland started his "Bentwood Spoon" mill in 1920 at the north end of Marshall Street. He expanded using the former Hirsch Cannery building that closed after the 1920-canning season. Mulholland perfected the process of making wooden ice cream spoons from White gumwood. His plant provided employment to Milford for 30 years before losing its competitive edge to the plastic industry.

Six

WORLD WAR II AND POST-WAR PERIOD
1940 AND BEYOND

The world changed for Milford in 1940. War clouds on the horizon indicated mobilization was inevitable for the United States. The State National Guard 261st Coast Artillery regiment was federalized in January 1941. Following the attack on Pearl Harbor on December 7, 1941, the entire town converted to a wartime economy. Four Milford boys were on Navy ships when the Japanese attacked and Milford residents received firsthand reports of the casualties. Every able-bodied male between 18 and 35 was drafted for military service, and many women served voluntarily in the women services. An ordinance plant was constructed at "Powder Mill Knoll" on Cedar Beach Road (home of Bonnie Pritchett) to manufacture 40-mm artillery shells. This plant blew up in an explosion on March 16, 1943, killing three women and burning six more. It was part of Milford's contribution to the war effort and no one complained.

The post-war period was a time of progress and reevaluation for Milford. When the post-war period ended in 1960 Milford was a modern city, in every sense of the word.

DONNIE HOLZMUELLER JR. Nothing brought home the reality of war to Milford more than the death of one of its best-known sons. Donnie Holzmueller Jr. was killed June 5, 1942, when the patrol boat he was serving on was sunk in the Atlantic by a German torpedo. Donnie was a star athlete and captain of the high school football and basketball squads. He had been a student at the Naval Academy prior to his enlistment for active duty in the Navy. He was the first combat casualty of the war in Milford.

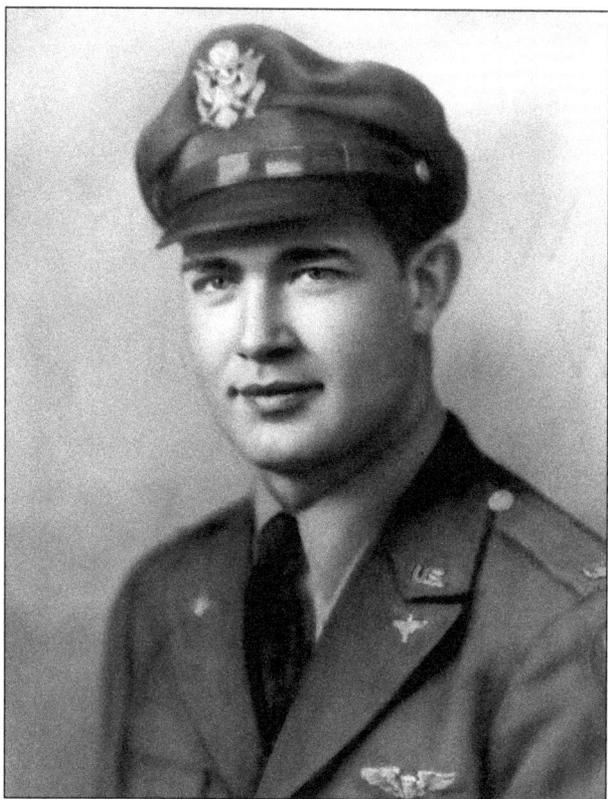

HOWARD WILKINS. Howard Wilkins was a popular Milford boy and the first aviator to die in combat. He was assigned as copilot on a B-24 Liberator flying bombing raids over Hitler's oil fields in Romania. His plane was shot down July 3, 1944, and the crew was killed in the crash. The tail gunner survived by bailing out of the stricken plane.

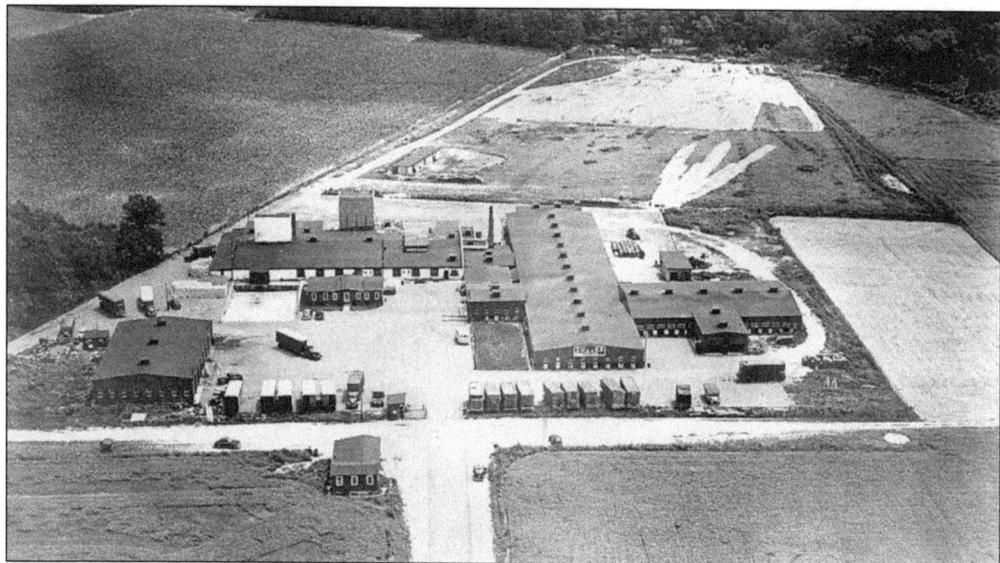

SUSSEX POULTRY COMPANY. The demand for chicken to feed the armed forces as they built-up for the global war after the attack on Pearl Harbor was met by the Pack family and other poultry processors on DelMarVa. Sussex Poultry Company was founded in Milford in June 1941, and produced as many as 100,000 birds per day during the war years. This was equivalent to two million pounds of chicken per month.

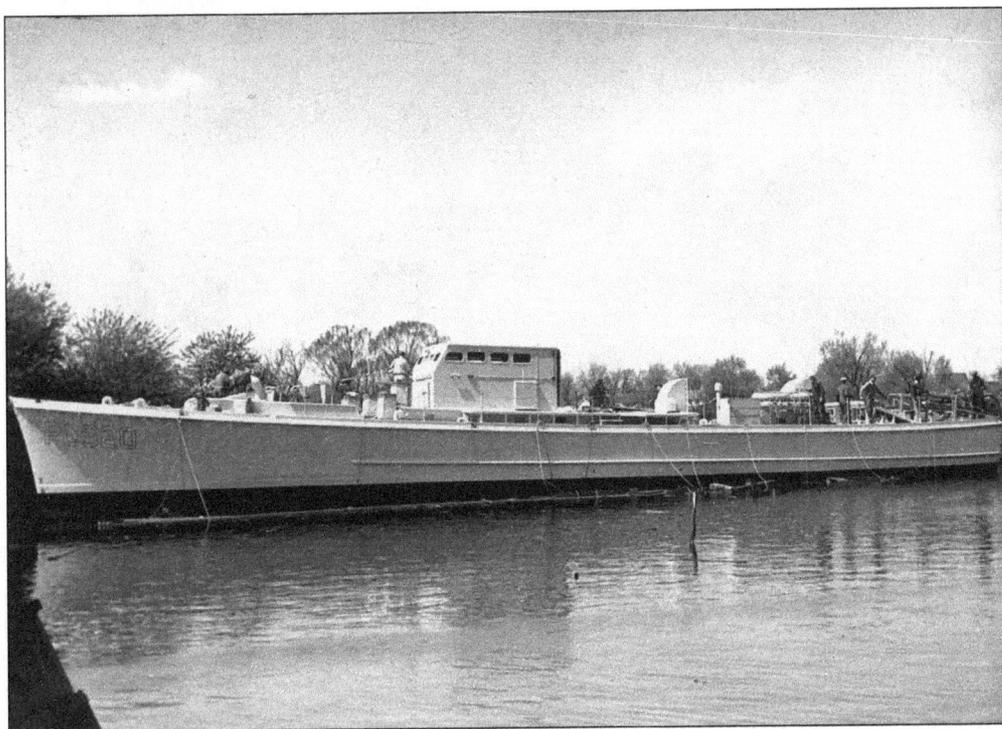

VINYARD SUB CHASERS 110-FOOT. Vinyard built 12 of these 110-foot sub chasers between 1941 and 1943. The shipyard received several citations from the Department of the Navy for outstanding service to the War effort.

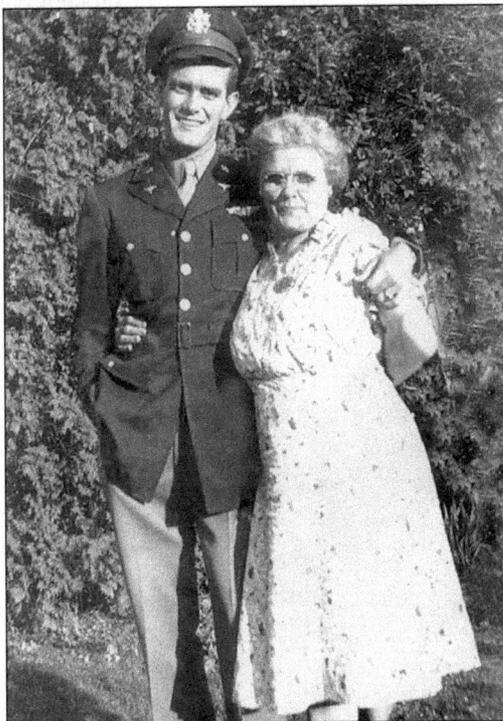

LOCAL MEN ANSWER THE CALL. Milford and other small towns were nearly vacant of young men during the war years. Hayes Dickerson was called to serve in the Army Air Corps in 1945 and is shown in this photo with a last hug from his mother, Laura Murphy Dickerson. She was the daughter of Capt. William Murphy who piloted the *City of Milford* in 1900. Hayes went on to a 20-year career with the newly formed Air Force (1947) and retired in 1969 to assume duties as editor of the *Milford Chronicle* and later as publisher of *The Chronicle* after it was purchased by Chesapeake Publishing.

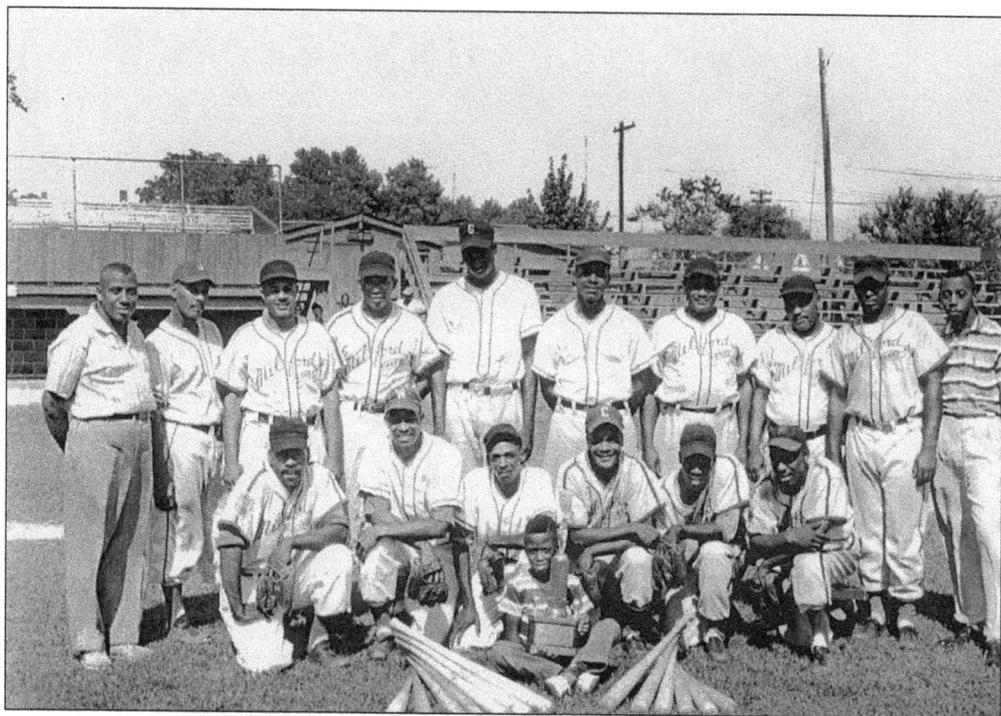

MILFORD YANKEES, 1948. The Eastern Shore League was segregated during the 1940s, but that did not prevent the Negro league from playing baseball. Frank Fountain (far left, rear) managed the Yankees and often recruited players from Delaware State College to play for his semi-pro team. Legend claims that the league brought Satchel Paige to play a game in Milford.

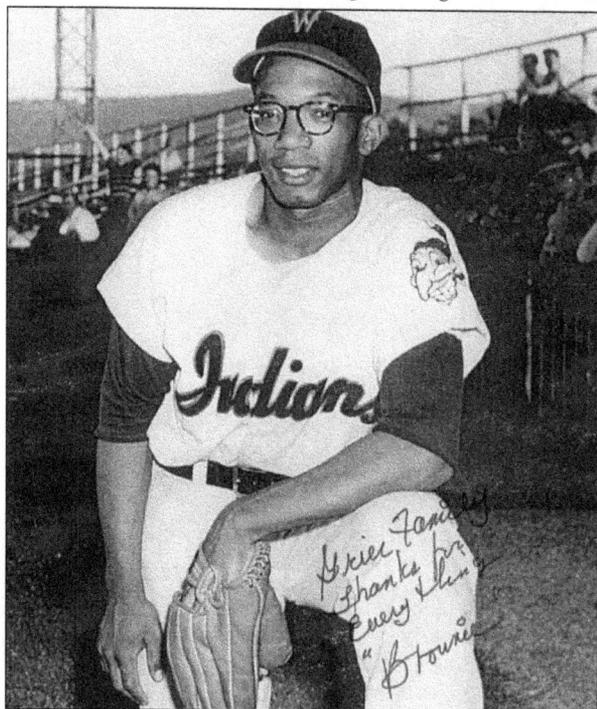

GEORGE BROWN, 1950. Brown was one of the greatest pitchers to play in Milford with the Yankees. He attended Delaware State College and was signed by the Cleveland Indians in 1951. A knee injury received while serving with the Army in Korea ended his baseball career.

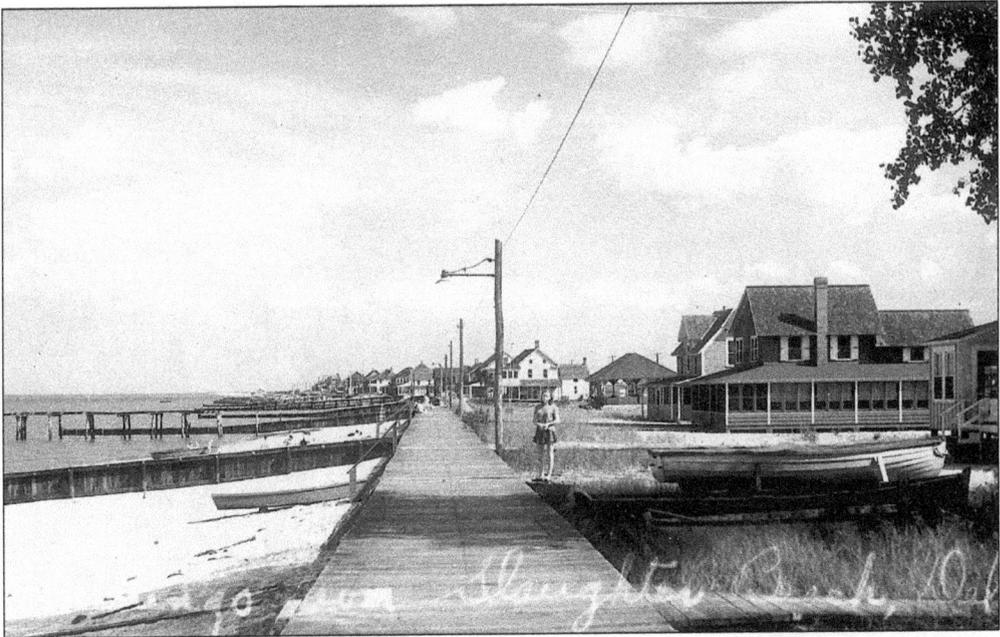

SLAUGHTER BEACH, 1949. Slaughter Beach was still the vacation spot for Milford families during the post-war period. The old pier, shown in this photo, was torn down in 1950. By 1956 the Fire Hall was started about where Dr. Ellegood's cottage is shown in the background by the pavilion. The Downing family owned the cottage in the foreground. It was the first cottage built on the beach in August 1885 by Frank Rickards. Dr. Ellegood's cottage was the second built in 1885 by Dr. George W. Marshall.

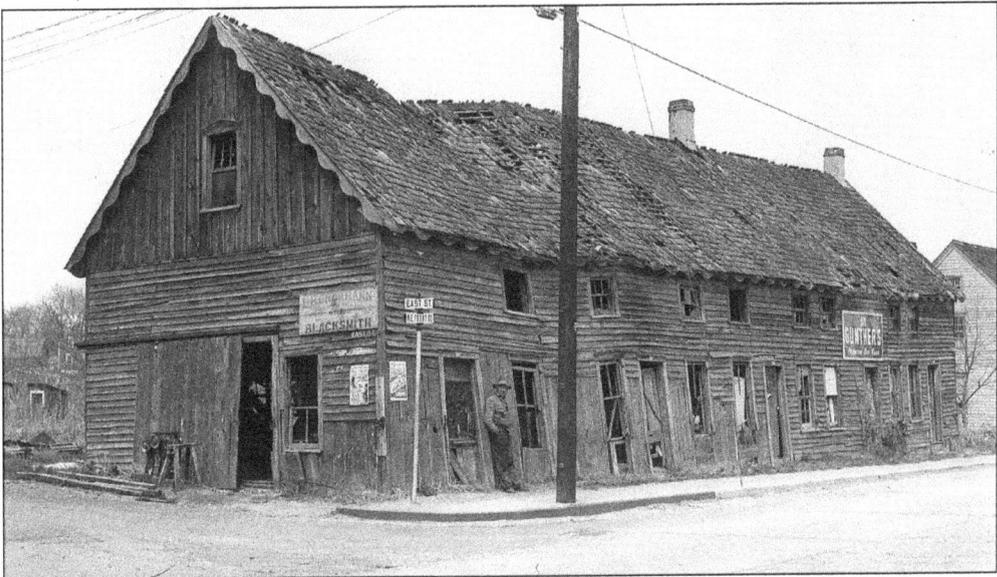

CHORMAN'S BLACKSMITH SHOP, APRIL 13, 1951. This dilapidated structure stood on the northeast corner of East Street and Front Street where O.W. Shockley Insurance stands today. The former blacksmith shop was the last vestige of an earlier age when Milford serviced more horses than cars. Economy Auto Supply replaced the blacksmith shop in 1955. The Shockley building was constructed in 1980.

123

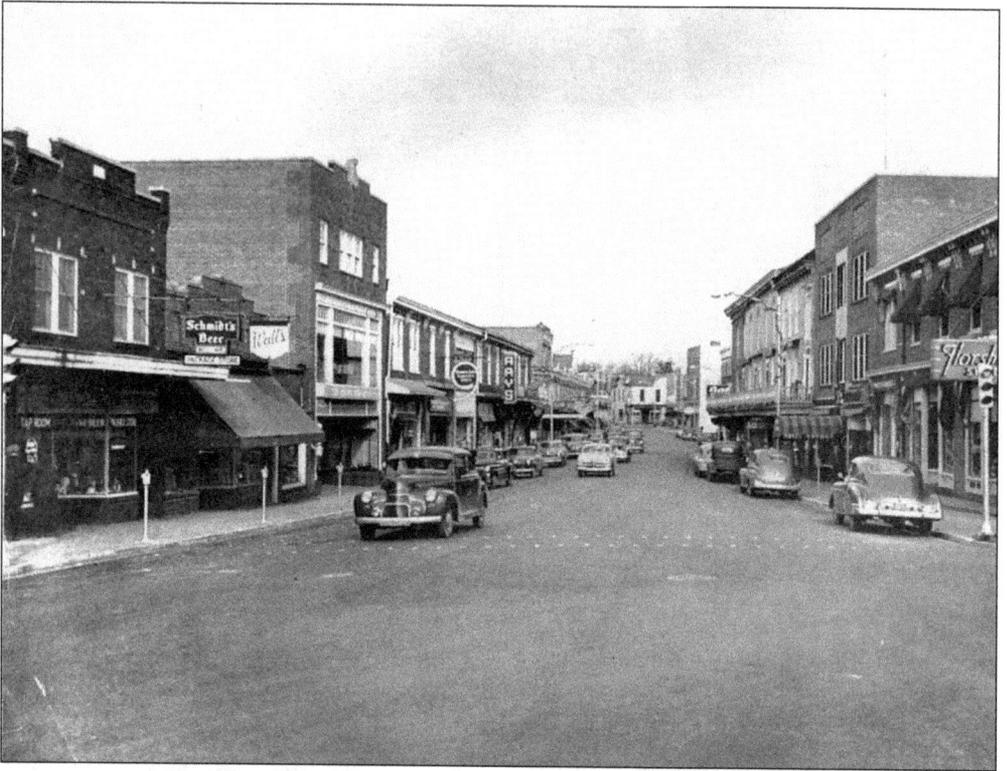

DOWNTOWN MILFORD, 1950. The post-war period in Milford began in 1950 after most active military units had been de-activated and the town returned to the business of business growth and housing for the baby boom generation. South Walnut Street was repaved and the plaza was redesigned with the veterans monument in place of the former round fishpond constructed in 1943.

THE SLAUGHTER BEACH HOTEL, 1946. When World War II ended, so did the era of the old hotel at Slaughter Beach. Automobiles allowed vacationers to travel to more distant locations for summer and the local beach lost its appeal. In June 1944, Mayor George H. Draper Jr. purchased the 70-acre tract of land from the Slaughter Beach Corporation after its members lost interest in the beach. He permitted the "dance-hall" to continue along Bay Avenue, but left the old hotel to deteriorate until the Storm of 1962 sealed its fate. The Fire Company demolished it in the summer of 1962. (Courtesy of James R. Draper.)

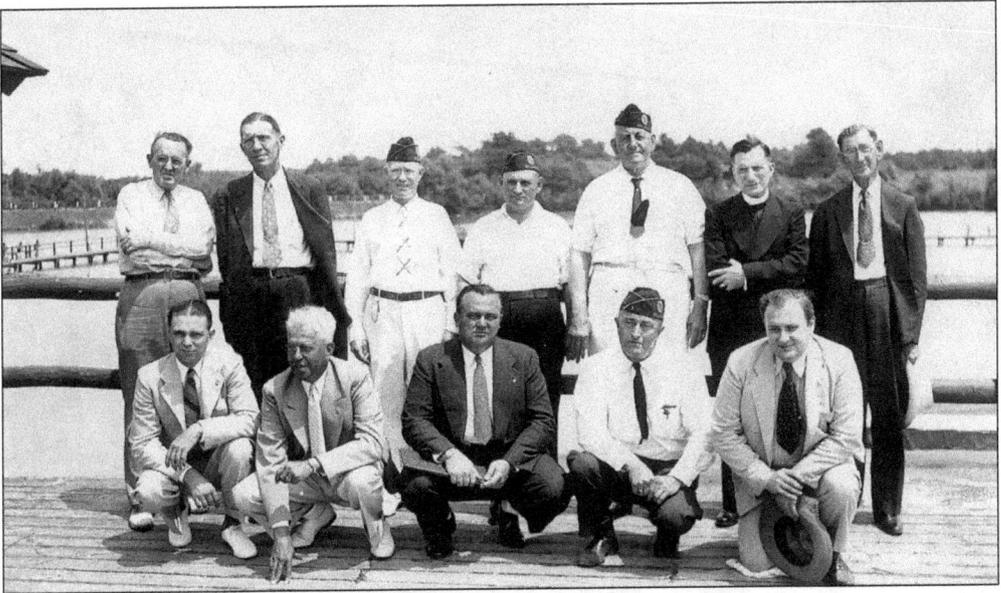

MARSHALL'S POND BATHING BEACH AND PLAYGROUND, 1942. War rationing of gasoline and tires prevented locals from using their automobiles to visit the beach. The City of Milford councilmen dedicated a new bathing beach and playground Saturday, July 18, 1942, to provide a safe place for local residents to swim during the war years. From left to right are (front row) Mr. Wolter, Charles Banning, city manager, Edward Evans, mayor, Mr. Clendaniel, and Robert Yerkes; (back row) Mr. Calloway, Van Nuis Wilkerson, Anthony Summers, Mr. Kuchi (Police Chief), Col. William E. Lank, Rev. Joseph H. Hinks, and unidentified.

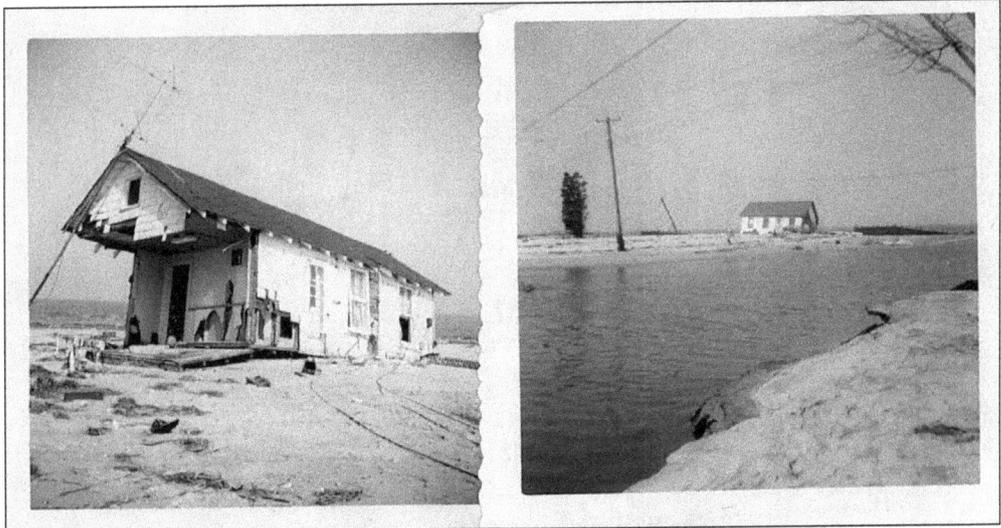

THE STORM OF 1962. The March 6, 1962 storm was the defining event for Milford as the modern period began in 1960. A rare combination of tides, stalled low pressure, and full moon unleashed a nor'easter storm on Slaughter Beach (and the entire Delaware coastline) that destroyed 17 cottages and flooded the surrounding marsh for four days. (Courtesy of Charlotte Swolensky.)

125

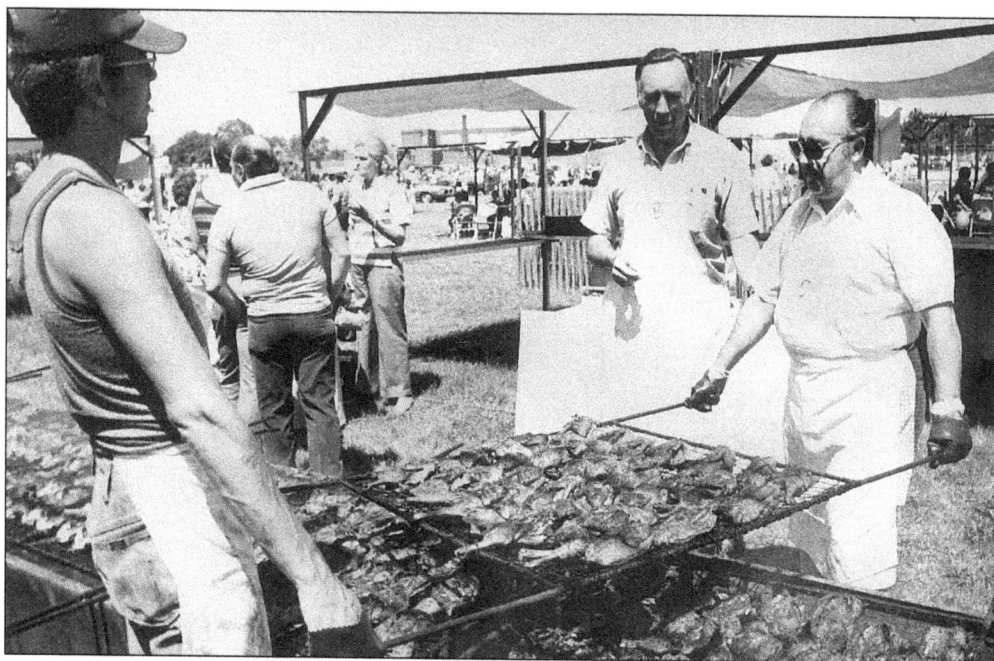

MILFORD HOSPITAL FAIR, MAY 14, 1977. The Milford Hospital Fair began in 1958 when a group of local women led by Mrs. Marty Dobson and Mrs. Edith Masten decided to supplement hospital funds with a local outdoor fund-raiser. Jack and Lillian Burris (background) are shown during the 20th annual event in 1977 cooking chicken donated by Burris Foods, Inc. to benefit the hospital fair. Mr. and Mrs. Burris enlisted the help of their entire family for each annual event in a community-spirited effort.

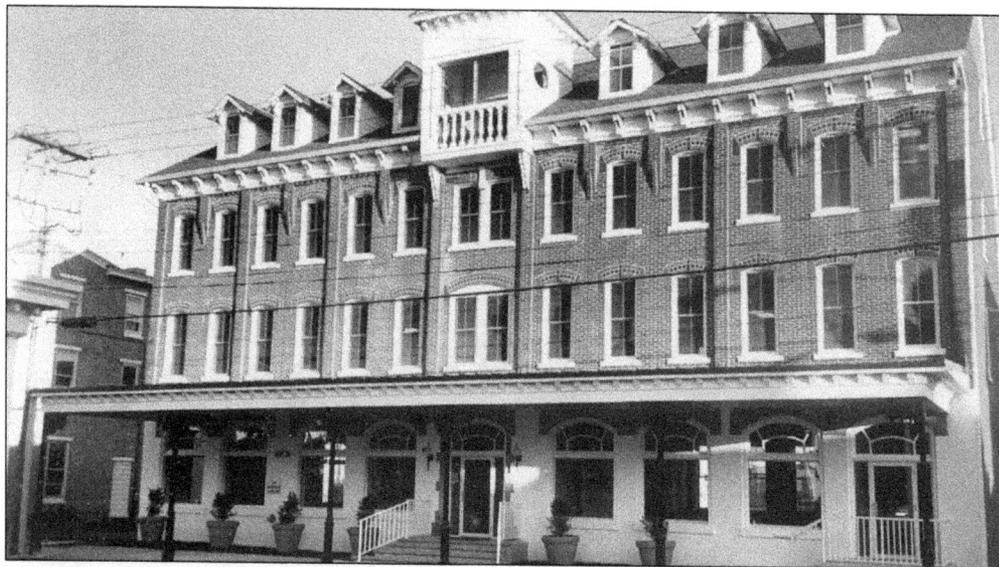

"THE WINDSOR," 1999. Riverbank Associates undertook a major restoration of the former New Windsor Hotel after it fell into disrepair between 1960 and 1998. The brick structure was built in 1892 as the Central Hotel following the devastating town fire in January 1891. Manager, J. Sudler Lofland, gutted and restored the old building retaining as much of the original styling as possible. This photo was taken just prior to its rededication in August 1999.

126

RUTH ANN MINNER, FIRST GOVERNOR FOR THE NEW MILLENIUM. The campaign for governor of Delaware in 1999 saw two Milford candidates square off against each other in a hard-fought race. Mrs. Minner emerged victorious and became the first woman to win the governor's office in state history. She is currently enjoying wide support among all Delawareans and lives at "Woodburn," the Governor's mansion. Milford has not sent a Governor to Dover since William T. Watson served in 1895 following the death of Gov. Joshua Marvil.

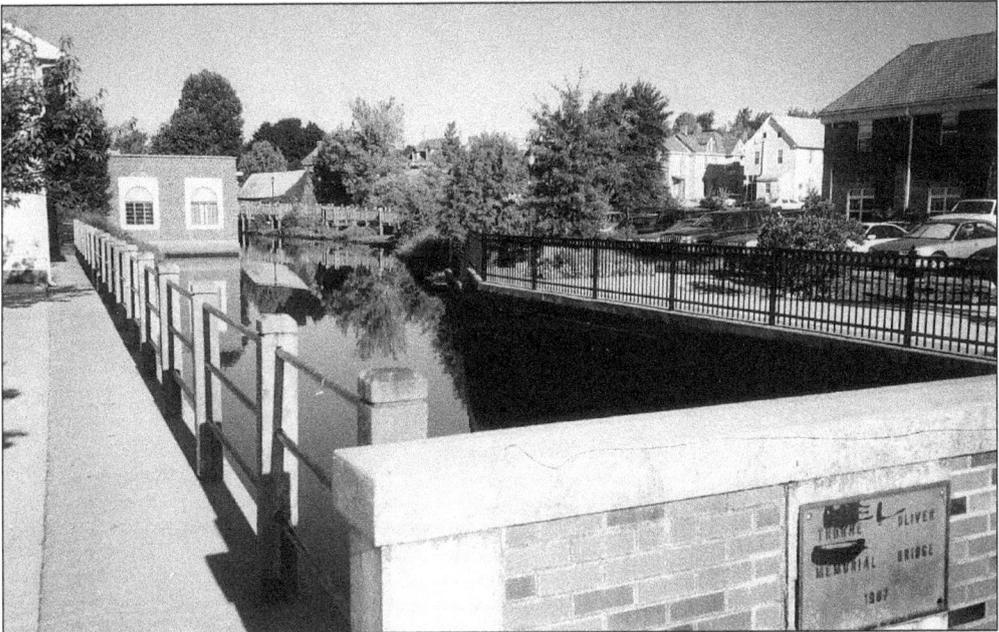

THORNE-OLIVER BRIDGE AND GREENWAY, 2001. The Milford Greenway was extended to the west side of Walnut Street in 1999 and provides a walking view of the site behind Northwest Front Street where Joseph Oliver established his first wharf in 1772. Oliver petitioned the General Assembly in 1791 to build the first drawbridge over the Mispillion to connect Kent with Sussex County.

THE OLD AND THE NEW. The Milford water tower was erected on the site of the former water "stand pipe" built in 1892 following the disastrous fire in 1891 that nearly burned the town to the ground. In the background are modest row homes built in 1855 by Curtis and Bethuel Watson located on South Washington Street. These homes were rented to tradesmen and shipyard workers during the 19th century. They are still serving as rental properties 150 years later.

NEW MILFORD LIBRARY. The Milford Library was built with funds pledged from local residents (60 percent) and a state grant (40 percent). David G. Burton, local businessman, former councilman, and civic activist, led the drive to raise $2 million for the library in the face of daunting odds. The community project is the most outstanding example of Milford's revitalization efforts over the past decade. The library provides a community meeting room and outdoor amphitheater that serves as a focal point for community events. It sits on the site of Henry Hudson's home, built in 1810 that was demolished to make way for the new library.

The Commission on Landmarks and Museums and the Milford Historical Society sincerely hopes you have enjoyed this pictorial history of Milford and the Mispillion River. We have tried to provide a collection of previously published photos along with many new ones that tell the story of Milford during its 215-year history as the town that was built at the headwaters of the Mispillion River in an old land grant called "Saw Mill Range."

Visit us at
arcadiapublishing.com

www.ingramcontent.com/pod-product-compliance
Lightning Source LLC
Chambersburg PA
CBHW050657110426
42813CB00007B/2031